# Erotic by Nature

## A CELEBRATION OF LIFE, OF LOVE,
## AND OF OUR WONDERFUL BODIES

Edited by
DAVID STEINBERG

RED ALDER BOOKS/DOWN THERE PRESS
Santa Cruz, California

**Third Printing, July 1995.**

*Design Consultant:* Brenn Lea Pearson
*Photo Layout:* David Steinberg/Marcia
*Duotones:* D. H. Seavey
*Typography:* Generic Typography and Telecommunications

Red Alder Books/Down There Press
P.O. Box 2992
Santa Cruz, CA 95063

Library of Congress Cataloguing-in-Publication Data

**Erotic by Nature: A Celebration of Life, of Love, and of Our Wonderful Bodies** / edited by David Steinberg.

1. Erotic literature, American. 2. American literature—20th century. I. Steinberg, David, 1944-
PS509.E7E76      1991      810.8'03538—dc20      90-20329
ISBN 0-940208-13-X

Some of the material in this book has previously appeared in the following books and periodicals:

*Beneath This Calm Exterior; The Blatant Image; Desire; Ecstasies; EIDOS; The Erotic Comedies; Fleshfire; Focal Point Gallery; Graffiti for the Johns of Heaven; High Desire; Impetus; The Male Nude in Photography; Men Loving Themselves; Nudes, 1975-1985; On Our Backs; Pleasures; Rapture; Selflove and Orgasm; Sexual Magic; Temptations; Twelve Months of Rapture; Unfinished Business; Word Alchemy; Yellow Brick Road;* and *Yoni.*

"Song of Desire," "Song of Joy," and "Song of Pleasure," ©1988 by Donna Ippolito.

"I Could Die With You" originally appeared in *Satan Sleeps with the Holy,* ©1982 by Carolyn Kleefeld. Reprinted by permission of the author.

"Other People's Houses" and "The Dozen Kisses" originally appeared in *Yellow Silk* magazine. Reprinted by permission of the authors.

"Yellow Pears, Smooth as Silk" is the first section of a six-part prosepoem, ©1975 by Ragnarok Press, reissued as a record in 1976. Reprinted by permission of the author.

"God/Love Poem" originally appeared in *The Love Book,* ©1966 by Stolen Paper Editions. Reprinted by permission of the author and the publisher.

"Thy Kingdom of Come" originally appeared in *The Erotic Comedies,* ©1981 by Marco Vassi. Reprinted by permission of the publisher, The Permanent Press.

For a catalog of other Down There Press books about sexuality, write to Down There Press, 938 Howard Street, #101, San Francisco, CA 94103.

Additional copies of **Erotic by Nature** are available by mail from Red Alder Books, P.O. Box 2992, Santa Cruz, CA 95063, for $45.00 per copy, plus $4.50 first copy, $1.00 each additional copy, for shipping and handling.

Printed in Hong Kong.

# CONTENTS

# Introduction

I have always wanted an alternative to pornography—something strong and sexy, but with a completely different feel: something closer to what interested *me* about sex, something that touched the heart of sexual experience with aliveness, perception, subtlety, and depth.

As a person interested in expanding the various levels of erotic experience in my life, I have been hungry for the support and encouragement of a rich and imaginative erotic culture—the cultural context taken for granted by people interested in classical music, painting, architecture, baseball, or fine wines: stories to read, images to enjoy, a wide variety of public perspectives to stretch the imagination, explore nuance, stimulate movement in new directions.

I have wanted to feel a connection with other people fascinated with the erotic world—to have access to a full range of their thoughts, feelings, and reflections. And so I have looked for erotic material of real quality—material that acknowledged the power, complexity, and mystery of the phenomenon we call sex, rather than reducing it to the silly clichés and grand exaggerations of locker-room chatter.

Unfortunately, whenever I have tried to find such resources, I have consistently been disappointed. In truth, for all its preoccupation with sex, our culture still adamantly refuses to address sexual eros with the simple wonder, open curiosity, and profound respect it deserves. And so we have no complex, imaginative, affirmative culture—written or visual—that is deliberately, honestly, and sexually erotic.

What we have instead is the consequence of relegating the creation of sexually erotic material to a rebellious and often outlawed subculture—the consequence of driving sexual fascination underground. We have material that trivializes not only women and men, but also sex itself—material that presents a narrow range of stylized stories and images, as if these were all that sexual material, sexual fantasy, or noteworthy sexual experience could possibly include. We have material that is produced with surprising disdain for its audience—an audience presumed to be entirely male, lonely, sexually desperate, and oblivious to the interplay of sex, intimacy, and emotional complexity. We have material that draws its power primarily from our sexual frustrations and fears, emphasizing the supposedly unresolvable contradictions between who we know we are and who we think we should be, as sexual beings. We have material that teaches men to be in sexual control of both themselves and their partners, and that teaches women both to subordinate their desires to those of others and to manipulate their partners through sexual temptation and denial. We have material that implies we must resemble glamorous superstars, male and female, in order to be sexually desirable. We have material that suggests that sexually exciting people are never vulnerable, afraid, confused, or uncertain—indeed are rarely so much as playful or silly. We have material that encourages us to separate sexual desire from tenderness and affection, and almost completely ignores the subtleties of surrender, mystery, and wonder. We have pornography.

This book is one person's response to commercial pornography's domination of the world of sexual material—to the absence of high-quality, sexually erotic literature, art, or photography.

I have tried to locate quality erotica, both in the pornographic marketplace and in the world of "legitimate" art. I have looked for pornography that was "better than most"—more flexible in its vision of sexually attractive men and women; more sophisticated, more varied, or at least more honest in its concept of sex itself. There *is* pornography that is more tastefully produced,

less pretentious, less lurid or obsessed with glamor, friendlier, warmer than the rest. But even the "best" of the pornographic spectrum barely touches the core of what I know sex to be about, hardly enough to justify sorting through oceans of predominantly mediocre, and often emotionally offensive, material.

When one gives up on pornography and turns to legitimate media—art photography, literature, collections of short stories and poetry—one immediately confronts the sex-phobic attitudes that permeate our social/sexual landscape. One repeatedly feels an artist or writer proceeding on tiptoe: cautiously approaching (and ultimately yielding to) the rigid, unspoken boundaries of "good taste"—the limitations of what is considered acceptable sexual focus or impact. We are all familiar with the stories and poems that move to the edge of engaging our specifically sexual energies only to stop short, as if to deny or minimize the writer's sexual intent—the works where sexual messages appear only peripherally, as sidelights to more "respectable" concerns. If there *is* a directly sexual portrayal, the attitude is usually titillating, simplified, and superficial. Thus we are taught that the intricacies and complexities of sexual feeling may intrigue us, but do not deserve our more careful and respectful attention.

In the worlds of respected painting, drawing, sculpture, and art photography, one finds the same ubiquitous, implicit prohibitions. Images with hints of erotic feeling may be honored, but those that focus on sexual eros directly—that allow sexual feelings to ripen and become the unapologetic focus of the work—are rarely published or shown in respected galleries. Apparently artists and photographers may invoke the immense power of the erotic, but only obliquely, and only if they disclaim intending to stimulate or encourage sexual feelings in the viewer.

Why does our culture discourage truly artistic work that explores the sexual/erotic realm without reservation or apology, artwork that addresses sex with enthusiasm, celebration, and joyous appreciation? Among the thousands of books that are published every year, why are there so few stories, photographs, and drawings that express explicitly erotic and sexual sentiments with respect for their importance, richness, and power? In these times especially, when our social fabric is stretched taut by the turmoil of rapidly changing sexual values and practices, it is essential that we encourage creative exploration of sexual subtleties and complexities, as an antidote to the simplistic platitudes of both pornography and puritan anti-sex. And yet the more complex, more difficult-to-resolve aspects of sex and eros—the aspects that I, for one, find most important, challenging, and meaningful—are precisely those that are systematically neglected and ignored by pornography and mainstream media alike.

Five years ago, I began to explore these issues seriously and directly. I found myself creating opportunities to discuss my thoughts and feelings on pornography and quality erotica with a wide variety of people: women and men, friends and strangers. I had dozens of earnest talks, with individuals and with people in small groups. I traveled to different parts of the country, conducting workshops on "Pornography, Erotica, and Sexual Fantasy," in order to hear other people's perspectives, and to ask what people would really want if they had viable choices about the erotic material available to them.

I found there were many people, women as well as men, who were interested in quality erotica, but who knew that no such material was generally available. Among men I was interested to find a great deal of embarrassment about the sexual themes and perspectives familiar to commercial pornography. I discovered that many, perhaps most, men purchase pornography not for the particular images of women or of sex found there, but because they enjoy the unapologetic sexual focus unique to that world. Among women I found much theoretical interest in erotic images and stories, especially those that might reflect women's real desires and sexual perspectives, but also a deep disaffection with the caricatured material currently available, whether in *Playgirl* or in male-oriented magazines and films.

Among artists and writers I likewise found more than a few people—some widely known, others relatively obscure—who were interested in creating more directly erotic or sexual work, but who avoided these themes (at least publicly) for fear of being ridiculed or discounted. These people were painfully aware of the absence of appropriate networks through which to publish or display work that would be considered too sexual by mainstream publishers or galleries, and too subtle, complex, or women-oriented by publishers of pornography. What was needed, it seemed, was a way for the artists and their prospective audiences to discover one another. And the audacious thought emerged that if no one else was willing or interested, perhaps I should undertake this project myself.

I began to meet with friends who shared my interest in these issues, and whose political and aesthetic perspectives were close to my own. We talked at length, trying to get a sense of what "alternative erotica" might include. This was surprisingly difficult. We found it easy to specify what we didn't like about pornography, but defining what we *would* like was another matter. The entire concept of wholesome, sexy erotica was new and strangely unsettling. We found ourselves embarrassingly limited in our erotic imaginations. After several months, still having only the vaguest sense of what this collection might become, I decided to begin soliciting material anyway. I hoped that as I reviewed submissions, a clearer sense of what I was looking for would emerge.

In fact this is precisely what happened, although the process was much slower and more frustrating than I expected. The initial submissions were uniformly discouraging. I waded through literally hundreds of stories, poems and drawings, almost all of which I found to be insufficiently erotic, hopelessly cliché, or dominated by sexual points of view remarkably close to those of the pornographic mainstream. Clearly my friends and I were not the only people with stunted erotic imaginations! Gradually, however, I also found—more often from personal acquaintances than from mass solicitations—work that reached

deep inside me in new ways—ways that felt positive, original, strongly erotic, and richly imaginative. From these I began to distill some criteria that I could offer as guidelines to potential contributors.

I knew early on, for example, that I wanted this book to address an audience of women as well as men—an audience I took to be sexually healthy, active, curious, and open-minded. This meant that the book would represent and respect women's erotic desires and perspectives as much as it did men's. I knew, too, that I wanted work that was truly celebratory of sex: that saw sex and sexual desire as beautiful, joyous, powerful, and life-affirming—even awesome and profound—rather than as lewd, **titillating**, petty, or demeaning.

I made a point of soliciting material that acknowledged sexual diversity—emphasizing a broad spectrum of sexual attitudes, interests, and practices rather than trying to reduce "correct" sex to a few familiar perspectives. And I wanted very much for the material in the book to help us all appreciate who we *really* are as erotic beings (*us*, not the Beautiful People), and to encourage us to trust the wisdom and power of our core erotic feelings, sensitivities, and desires.

I discovered that the material I liked best felt familiar even as it was new, striking responsive chords from personal experience even as it might offer new erotic perspectives. I found, too, that the work that most affected me often addressed some of the more unsettling, even frightening, aspects of sexuality—the unpredictability, loss of control, fear of intimacy and supreme vulnerability that are such important parts of sexual experience.

Most broadly, I chose a general tone for the book that was celebratory, encouraging, and uplifting—an affirmation of the incredible potential sex has to bring us deep joy, wonder, intimacy, growth, and wisdom when it is approached with honesty, courage, and humility.

The process of defining these goals and finding the material to fulfill them has taken over five years and has taught me more

than I ever would have imagined, both about myself and about the sexual culture we all live and breathe. It has been a slow and frighteningly vulnerable process. To go public with one's sexual values and beliefs, to explicate a perspective on sexual eros that reaches below the surface and flies in the face of our culture's dominant sexual mythology, is to stand painfully naked in an unknown and potentially hostile world.

The most important process, initially, was to demonstrate that this collection of erotic material would be different from what had been published before—different from pornography. One by one I met with potential contributors and pledged to them that I would neither trivialize, sensationalize, nor dilute the erotic power of their work. "I intend this to be a superior quality publication," I stated in my solicitation flyer, "both in content and in form. The format of the book will in itself be a statement of respect for the beauty of sex."

From the beginning, I have been gratified by the positive and enthusiastic response I have had from contributors, both famous and less widely known. I have had neither public reputation nor generous finances to recommend me. Yet, almost unanimously, artists, photographers, and writers have been so delighted at the idea of a truly erotic and artistic collection that they have responded with overwhelming support and encouragement. People who began by saying they had "nothing really erotic" to offer, ended up showing me work they never thought could be published appropriately. Some contributors took this book as an opportunity to create new work, and found that the existence of a respectful, artistic context enabled them to move into sexual or erotic work more seriously than they had done before. Often they would recommend me to another artist who was also "doing interesting work." And so, around the seed of this book, a loose network of talented and responsible erotic artists and writers has grown.

What has developed from the contributions of these 36 women and 25 men from California to New England, some in their early 30's, some in their 60's and 70's (averaging about 45), is a collective sexual/erotic perspective that is radically dif-

ferent from that of pornography yet no less evocative, stimulating, or engaging. Indeed, I find these works *more* powerful than pornography because they engage our erotic and sexual energies more fully and deeply, touch us more closely, more honestly, and at so many different levels. Where pornography would condense our sense of the erotic to a few stylized, glamorous images, this collection encourages us to expand our erotic sensibilities to include everything from light-hearted play to confronting the deepest aspects of personal identity and interpersonal communication. And where pornography is primarily a means of elaborating masturbatory fantasy, this book's main appeal is to different and more complex desires: the desire to curl up and be intimate with a loved one; the desire to love and be loved; the desire to express who we really are; the desire to open more fully to the wonders of life and the world around us; the desire to become a little more energized, more sensitized, without needing to do anything with that feeling other than relax and enjoy it.

Because pornography has monopolized the sexual marketplace for so long, it has become easy to believe that direct and powerful sexual/erotic material is inherently pornographic. This book demonstrates that it is not. It demonstrates that erotic work can be sexy, powerful, and provocative without being stale, without manipulating men's and women's sexual frustrations and fears, without depicting sex as an arena for men's dominance over women, without denying the full erotic subjectivity of all human beings.

This book offers an alternative to pornography, one that encourages us all to be fully erotic, fully sexual beings without alienating ourselves, our deepest human values, or the people with whom we are most intimately involved. It represents only the beginning of what is possible when erotic and sexual themes are addressed ethically and artfully. Much more work of this sort is possible and needed. Perhaps this book will encourage others to produce and distribute original material reflecting a wide variety of sexually erotic aesthetics and points

of view. Hopefully there will eventually be a wide range of positive erotica to help us trust the goodness, the sanctity, and the wholesome power of this central aspect of who we are; help us celebrate without apology our opportunities to explore this important part of being alive; help us enjoy, rather than fear, the fact that we are, truly, erotic by nature.

<p style="text-align:center">*   *   *   *   *   *   *</p>

The original concept of this book, the definition of its direction, and the collection of its earliest material, was a collaboration with my good friend, Illijana Asara. Without her insight, perspective, and continuous support, this book certainly would not exist in its present form. I am similarly indebted to Michael Hill, who has helped immeasurably in clarifying the purpose of this book, in suggesting contributors and, most importantly, in helping me with my own erotic wanderings over the years by his deep personal support and his unshakable faith in the integrity and sanctity of the erotic force. When it all seemed craziest and I could no longer remember what made sense inside the erotic swirl, Michael and Illijana were there to remind me of the importance of affirming life even when the emotional cost of doing so seems unbearable. Bless you both.

This book also owes its existence to the many people who have contributed information, opinion, resources, enthusiasm, and emotional support during its long gestation. Without their help and continuous encouragement it would have been impossible to maintain the commitment, the vision, the semblance of clarity, and the continuing faith that this project justified the personal upheaval it has brought into my life. For this and more I am deeply grateful to Joani   Blank, Susie Bright, Gordon Clay, Michael Tyson, Jim Vandegriff, Peter Varga, Kenton Parker, Tom Starkey, Jean Vulté, Jeanne Paslé-Green, Natalie Hansen, Arthur Coleman, Libby Coleman, Teven Laxer, Ed Weingold, Rina Weingold, Erskine Duff, Charlie Piersol, Geof Morgan, Fred Jealous, Howie Gordon, Michael Rossman, Lonnie Barbach, Jeff Berner,

Joanne Clapp, George Csicsery, Brenda Tatelbaum, Shepherd Bliss, Glen Fitch, Paula West, Sam Julty, Jan Wiesenfeld, Marc Novak, Don Hall, and Barry Shapiro; and to my thoughtful, cooperative, and co-visionary editors at Shakti Press, Randy Fingland and Bill Merryman.

I am grateful to all of the contributors for the power of their work, for their belief in the potential of this book, and for their trust that I would handle the vulnerability of their work with true honor and respect. I would like to express my particular appreciation to Charlie Clark for his long-standing commitment and personal support, his invaluable advice, and his integrity and courage as both photographer and friend; and to Gypsy Ray for her warmth, caring, and generous understanding, especially when it all seemed to be falling apart.

Finally, my deepest love and thanks to Marcia for her understanding, her perspective, and her valuable collaboration in sequencing and arranging the photographs; and to both Marcia and Dylan for their belief in me and the importance of this work, and for accepting the turmoil this book has brought into all our lives for longer than anyone could deem reasonable.

<div style="text-align:right">David Steinberg<br>September, 1987</div>

# Erotic by Nature

# Song of Desire

We sit before the fire, our bodies dark, eerie and copper by its light. I lean back and you hold me, hands spread over my belly, just touching the underside of my breasts. You take my hair in your hands, untangling, drawing it down, touching a place on my spine to mark its fall. Then you begin to brush, taming my hair. My head bent back lets my hair drop long, and beginning at the crown you caress it, one hand rhythmically following the other. Stroking, you draw hair away from my temples and my head pours into my hair, into your hand smoothing, following the brush, and it is as though you caress the moss between my legs. My fur, my feathers, the skin on my back, grow moist with pleasure, and I turn to you. Letting your touch slip toward my cunt, you open my thighs, and the fire warms my legs which further part.

Gently you roll me onto my stomach, lean to kiss my back, my buttocks, the inside of my knee. You pause to lift my foot, and place your mouth and moving tongue against the arch. I shimmer as your fingertips spiral over the length of my body, as you knead gently the back of my neck, my shoulders, my spine.

Your fingertips are light at the silk around my breasts, the hard nipples, and then I am silk, slipping to the ground, my body lying half over yours. Your penis stirs beneath my hand, beneath your clothes. I touch your cheek, ear, chin, your hair—admiring the soft angle of your shoulder, your chest, so beautifully formed that the breasts are mounded as a woman's.

Your tongue wets the silk of my blouse, my nipples. Between my thighs, your hand lies still, maddening. Near your hand, my cunt is the lightning tongue of a snake while you undo my clothes and lay your mouth against my throat, the crown of my breast. I raise my arms to offer you the underbreast as well. Your mouth trails softly across my bare stomach. I open your shirt and lie again half over you, my breast to your mouth which kisses, wets, burns the nipples. Smother me, you say, and I crush my breasts to your face while your mouth cools me with its wetness.

We lie still, listening to the music, and then I rise and walk into it, my naked back, legs, and buttocks offered to you. I let the music lap at my feet, remain still as it washes higher, rises in me, makes me want to take the sound into my hips, my arms, my hands—to dance for the sake of the music, for my sake, and still dance for you.

Head lowered, fists loose, I am muscle, knotted calves, and the weightlessness of balance. I am a thread of sea grass, my body guileless, revealing its love of self. Rhythmic fringe, I sway, the heat from my cunt already nearly buzzing. I dance while you watch, your tension, your yearning, your anger growing. I dance till you spring from the bed to stand behind me, penis slipped between my buttocks, nestled to touch the tip ends of my pleasure.

Your chest brushes my back, your hands are light around my breasts. I pass my hips against you with a gentle thrust. Legs weak, I move slowly. You move slowly. My nipples flame, and the hard seed of my clitoris lifts upward, hot and throbbing. I reach back to touch your penis, a warm petal now, firm but yielding. We remain so, our hands moving over one another. My breasts become hands that caress your hands. Your hands become breasts that are bell-shaped, whose tips are like lashes opening.

I turn and kiss the shadow that crosses your hip, touch and follow it into your gritty curls, fingers tangling in the hair, then taking the heat of your penis. Very deliberately, I close my hand—softly, less softly, firmly—moving slowly down. My

tongue follows, tasting with rapid flicks the smooth oval tip, and with the same flicks following the shape down and up, swiftly, lightly, all around. Without words, my tongue speaks of tenderness. Without words, my tongue sings the body. The flicks begin to dart and pierce as they touch. I nibble gently at your balls and hair, glad to take the warmth of your penis into my mouth. Eyes closed, you lie still, trembling but not moving.

I lay my hand on your belly, just above the dark hair and the small, involuntary leaps of your penis. My hand seems to grow hot, to flame from your body, as I let it slide lower. I take your penis firmly but lightly, taking it to meet my mouth and my tongue. You shudder, head thrown back.

I smile as your pleasure washes over me, as I watch my hand caress you erect. I moan, hold you, press down slowly with both hands tenderly, cupping, down down down. I watch your face. I pant, demanding that your closed eyes, your ecstatic mouth, shatter and dissolve before me. Now now now. My thigh is flung over yours, and I begin to move softly, brushing the whole of my pubic crest over your warm smooth skin. I go slowly, still watching you.

Your hand moves down the center of my body, tracing the moist curve with a finger that pauses just above my clitoris. There is dilation—my cunt tastes air. My arched breasts, the hungry nipples, strain against your chest. Your worn hand cups one taut breast, your cool tongue flashes at the other. Is it fire? Is it pain? Is it a leaf or rain or sand? Or is it breath? Is it more, is it more, is it is it more and more and more?

The window is open and any sound could be heard from without. I cease repressing the single, endless chord. I moan for the eddy, the thrill in my nerves which gape like beaks. I moan for the sake of moaning. I babble, murmur my senses, and the voice excites, while the voice of your fingers and your warmth and your thighs is silent and wild.

Always you are silent, but for the tiny shouts at my first touch of tongue or hand or fingers, at first entry into my body, at the split second before you break, coming. Now I sing for us both,

direct your movements, direct mine. Oh yes, yes and there, and there and there. Be there, be there and please answer me, sing with me, lift with me, wing with me.

I caw, I croak, and always you are silent.

My body ravenous, I lie back, let your head move down, down to the streak of fire from my cunt. I lie back and open my thighs to your mouth, to the dance of tongue, to the tip which pries gently, opens me. The wind, the sound of rustling trees, enters with your tongue. My cries are the whispers of leaves. My body soaks up damp earth.

Your lips, your tongue against my clitoris, your tongue inside my cunt. Is it a childish pleasure, this sigh that relaxes my whole body, then sets it moving? My voice finds mournful little sounds, like a hawk calling far off. I am the skin of a drum, stringed to vibration, quiet and deep.

A small knot lifts my clitoris. I feel it swell, simmering, vibrating, hot. My hips move like fins—supple, strong, and fluid. My hips move of themselves to the throb of my clitoris and its echo below, parting my thighs, opening my lips. I hear cries, tiny sobs in my throat, on my lips. I gasp in surprise, laugh softly. I laugh again, louder, for the pleasure which lifts my hips, tosses my head from side to side. I whisper no, oh no no no, I am not deep enough to go so far, so dark, so near where she lies, so near where she lies, the snake, where she lies gleaming, poised to strike. Leave her, oh leave her, leave her lie. She is death, is dark, swirling to draw you in and in and in to the eye, beyond the eye, ever darker, drawing you in until I can hear the dark roaring, like the sea in a shell.

Don't give me poetry: I want you vulgar, want you to curse me as you strain to be closer, deeper in me, as you get lost in the cave of my insatiable desire. I want to devour you. At the moment you come, I want the thrusts of your body to name me as the only possible woman, the only living woman.

Sliding down to the bed, I draw you over me, take you fragile but erect inside me, and whirling my hips I end with a stab

against you. I spread my legs, feel myself open like a greedy mouth. I whirl again, stab, stop, whirl and stab. Over me you are helpless and heavy, while I turn my hips like a rushing wheel which can do nothing but wildly spin. I pull back my legs and brace before I lift and nearly throw your body off with my thrusting.

Again, again, again, and I know you weaker and weaker against me. You moan, moan again, gasp. I go faster, know my strength, gleefully bounce you higher, harder and harder. You utter little sounds of surprised ecstasy. All the while my cunt grows deeper, still deeper, and you begin to move too.

I am exultant, then begin to rock, to let your stabs rock me while I make room for you inside. I meet your thrusts with my own, first going joyfully counter-time, then joining your rhythm, letting my hips dance against yours. I am open, air burst from a bubble, and know there is more, still more space for you within me.

You stop, holding your thighs, knees, legs and feet tightly clasped together, pressed hard into me, holding me very still. I wait, out of breath, and smile into your hair. You do not speak, and I revel in the hardness of your body, the tension by which you stand between your strength and my body, its webs all torn.

You cry out in delirium and I begin to move. My hips whirl, spin, wind. My hips thrash at yours, now lashing back. You raise yourself slightly, look at me, then throw back your head at the same moment you begin to thrust into me, at the same moment my hips rise, my legs spreading further apart to meet the thrusts, the ramming almost, that grows faster, more abandoned. You sweat, you frenzy, you shriek in whispers. You burst against me, shaking my head and arms and hands crazily as you plunge. Yes, my body shouts, yes I can contain you, I am deep enough and more. I pull at your sun-dried hair, saying fuck me, yes now, yes yes now.

Donna Ippolito

## Photographs I:
## *Body Forms*

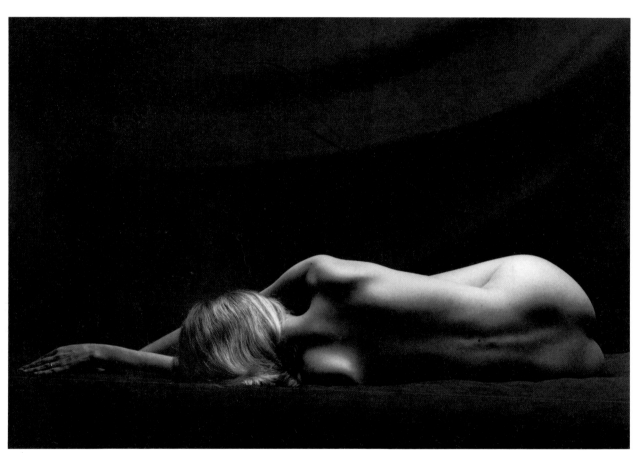

Morgan Cowin

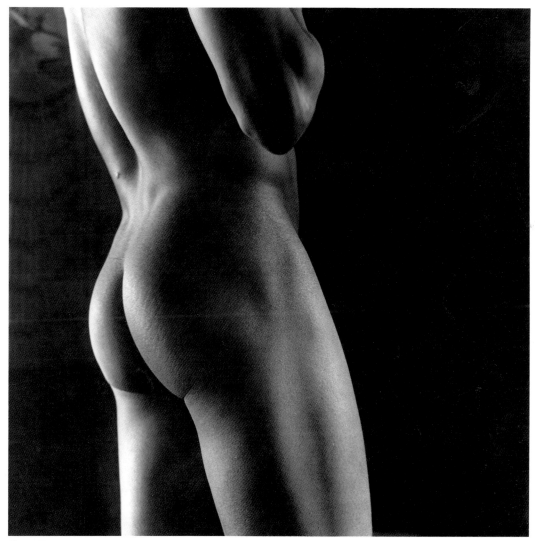

Greg Day

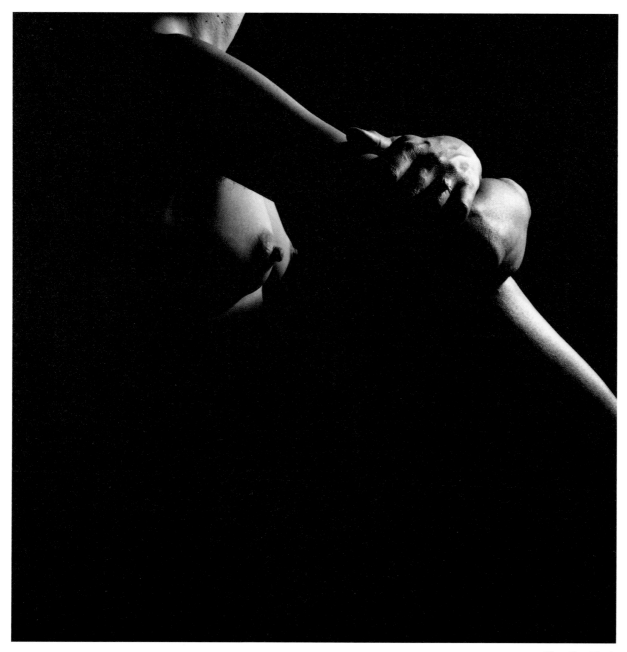

Charlie Clark

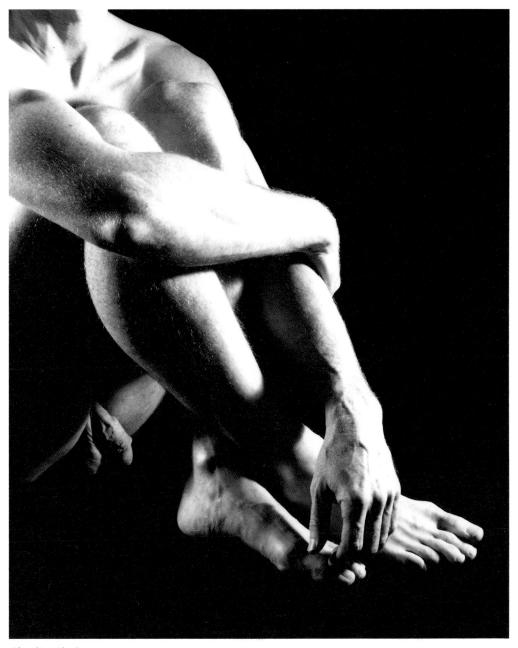

Charlie Clark

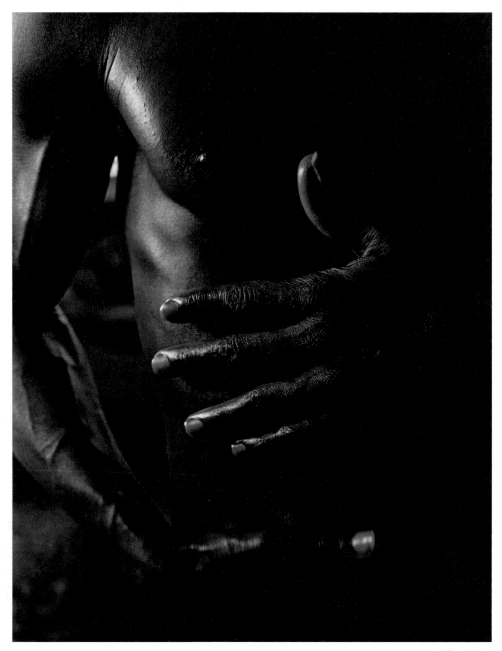

Jack Morin

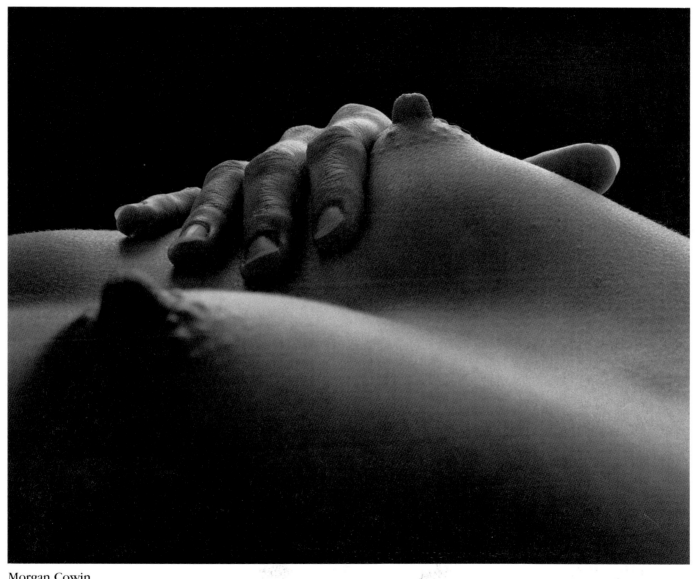

Morgan Cowin

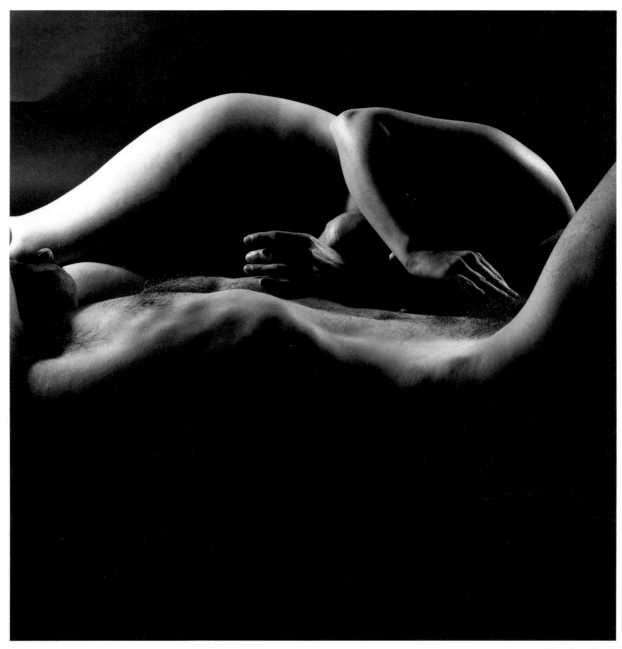

Charlie Clark

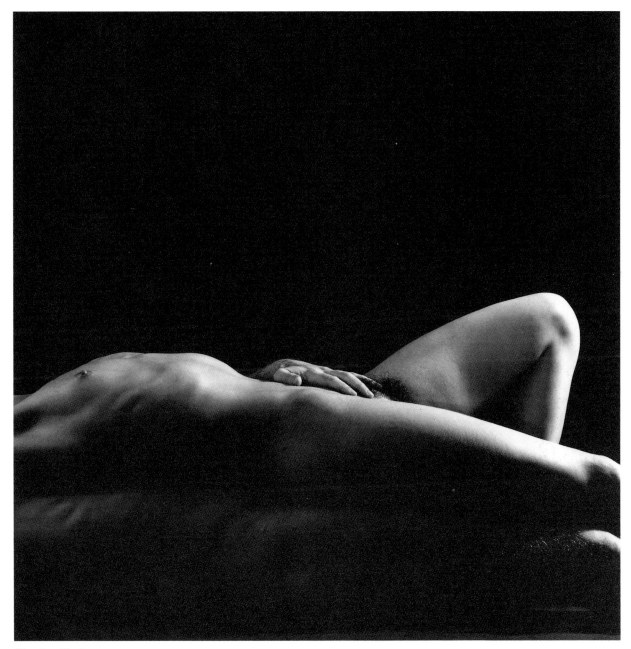

Charlie Clark

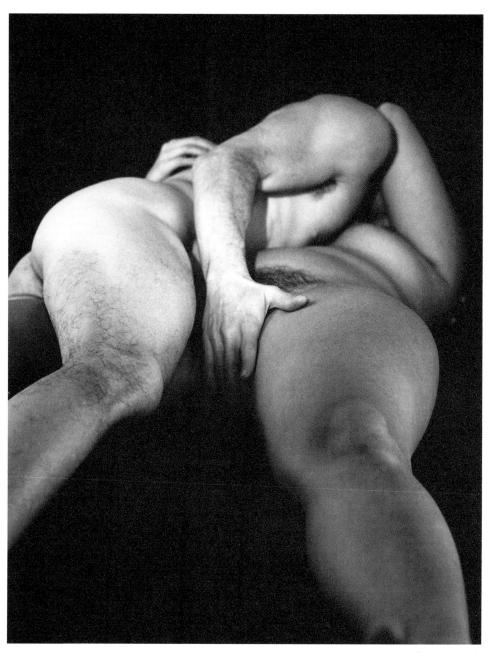

Charlie Clark

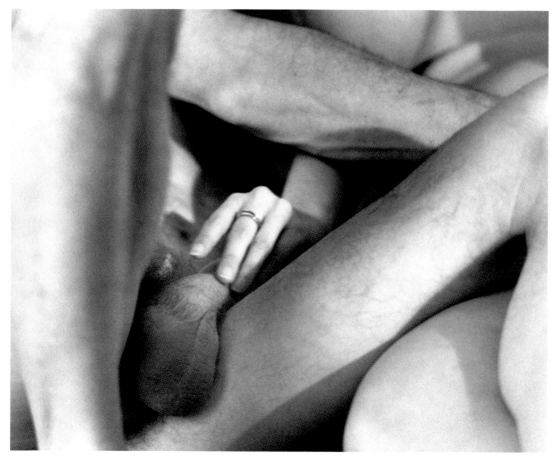

Charlie Clark

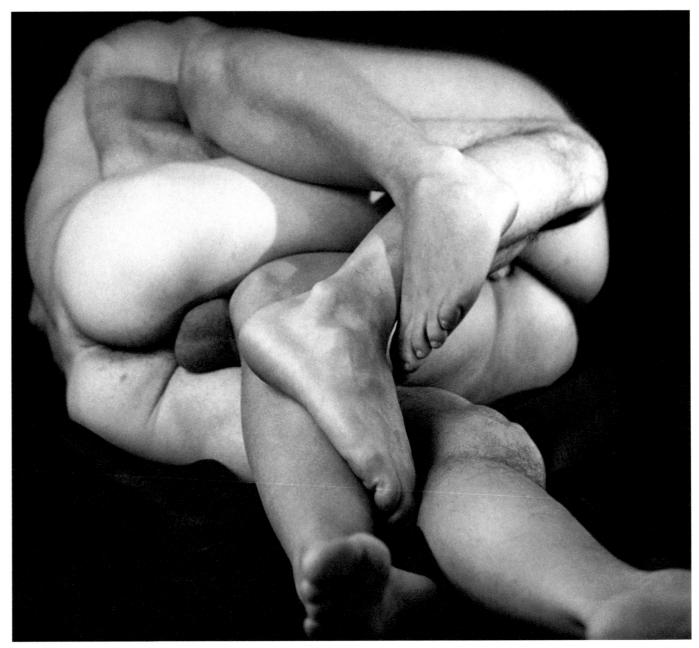

Charlie Clark

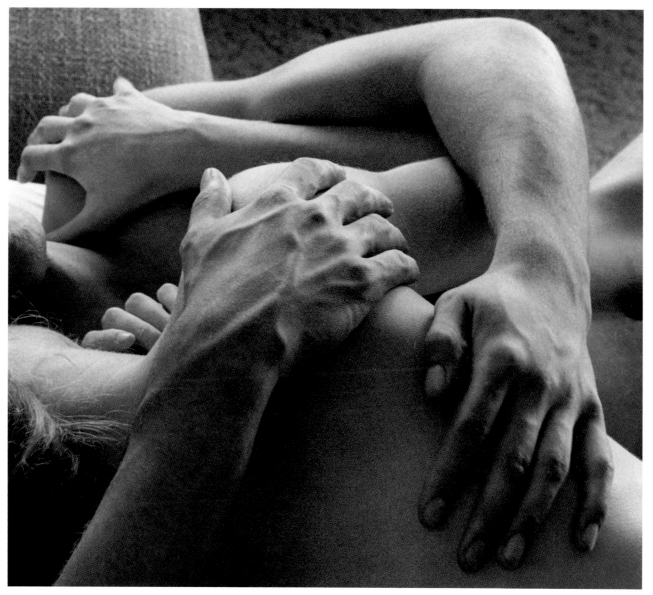

Ron Terner

# *The Girl Next Door*

He had noticed her one day in the back yard. He had noticed she had breasts.

She had always lived next door, but he had only begun to watch her when he had noticed her breasts. Before that she had not had breasts, or he had not noticed them. Now he watched the way they pushed out against her shirts, her sweaters. She was a woman. That's why they said it, that one day they were children and the next they were women. The whole body changed, rounded. Laura was a woman. He was seventeen and had never done it with a woman. Man and woman, those simple designations he had known all his life were just now assuming their full importance, their full distinction.

From his bedroom window, he was watching her sunbathe in the yard. He watched the curve of her cheeks. He could just see the top of the cleft there, the beginning of a shadowy darkness. He followed it down in his mind from pictures in books, from descriptions in pulp magazines. Laura, Laura, Woman.

He remembered noting that both sets of parents were absent. He remembered that he had casually sauntered over to where she sat on the porch steps.

"Hi, Sollie," she had said. He'd sat down next to her on the step. He had rubbed the gooseflesh on her thigh.

"Too much sun," he had said. She shuddered. He left his hand there. Her skin was hot.

"Your hand feels so cool," she had said.

He lost track of what had been said. He remembered the feel of her skin, how he had begun to move up her thigh, feeling the texture of her skin, the smooth skin of the inner thigh, and under her shorts until he felt the crease where the leg joins the body. She had not stopped him, had turned toward him and was leaning against him, her breasts on his chest, and they had somehow moved back behind the railing into the twilight shadows on the porch and she was under him, kissing him, her body arching up into his. He had opened her shirt and kissed the bare flesh of her breast and felt the nipple harden in his mouth and heard her sigh. Even now the intensity of that moment filled him with awe. That moment when he had touched the door of the unknown and entered in. His mind had slipped away into his body as he had slipped into hers. An entity had overtaken him, a thing other than his will. It pushed against the door and the door had opened for him, opened under him like the petals on a rare flower, opening and enfolding him even as the unknown power subsumed him. Oh Jesus, never a time like the first time, never a girl under him like Laura that time.

Laura under him, holding to him so tightly, her hands on his cheeks. He thought she might want him to stop but he couldn't, wouldn't, and went on and on, feeling it growing like a lightning shaft striking out into her, and he heard the surprised oh, oh, oh trailing out of her mouth, wondering and startled. They lay still on each other, wet with sweat, sticky with semen, and she had sat up and looked at him.

"Oh Sollie," she had said, "that was wonderful. Let's do it again."

And they had done it again, all that summer, whenever they could. They had done it in the back seat of her father's car parked in the garage, in the living room while her parents were upstairs sleeping, once in his bedroom when his parents were away. They had done it standing up in the toolshed in the morning, laying on the wet grass in the darkness. As the leaves fell, he raked them into a bed at the end of the yard under the arbor of grapes and they had done it there, the leaves crackling under them. They blazed with the life force, stronger than morals, stronger than disapproval. They were afire.

The pattern was set. Laura would say, "No, Sollie, I just washed my hair, I don't want to get all dirty. I always smell like

leaves." She would tease him into a kind of madness until he would grab her, hold her against him, rubbing his hands over her, kissing her, until he felt her relax, sigh into him with such totality that she seemed to become a part of him.

He thought of nothing else. He hated school where he was too smart, out of sympathy for and with his age group. He did not want to be one of them. His isolation was a matter of choice, and was now intensified by his compulsion with Laura. It was not just that he loved her: she was his life. Everything was for Laura.

When winter came, things began to change. Laura told him that they shouldn't appear to be so close or their parents would be suspicious. He agreed. It was logical, it made sense. She would say, "Oh, Sollie, no, it's too cold. I won't." He had argued, she had said no. Winter loomed ahead of him, a denial of life.

She would smile at him in school and pass by, leaving him standing in the crowded corridor with a deep ache in his bowels. Sometimes it hurt so much he couldn't walk. He would lean against the cool terazzo walls and try to control himself, mumbling mathematical equations, something inane from the last class, until he gained control over his body and over the fearful desire, the primitive stranger, that took him.

He thought about that, about how he was split into two entities, and how only Laura mediated between the two, made them come to agreement. Laura, Laura, the key to transcendence, through the body, out of the body, like a parable, a two-edged Greek prophecy.

On Christmas Eve Laura had tapped softly at the back door. His parents had just left for Midnight Mass. He'd opened the door and she had walked in wearing a long coat and high boots. She had dropped her coat and stood naked, saying "Merry Christmas, Sollie."

"Hurry up," she complained. "Come on, we don't have much time."

He'd come as he put it into her. She was angry. She put on her coat going out the door, leaving it open. He followed her outside, calling after her, "Laura, Laura." She'd gone into her house and he'd followed right behind her.

"Please Sollie, go away. Be quiet, my parents are upstairs."

He'd knelt in front of her, in the dark kitchen, opening the coat, licking his own juice. He put his tongue between her lips and she liked it and held his head, dropping her coat, arching her back, spreading her legs. Oh she had liked that, and had come for him, and he had gotten hard again and they lay on her coat and he had made her come again and again on the kitchen floor, her boots shuffling on the linoleum. She held him against her with all her strength, and when he came she groaned, "Oh Sollie, don't stop, I could do it forever, I don't want you to go, don't leave me, don't take it out, oh stay, stay, oh, oh, oh, hold it in, oh, ohhh."

In January, Laura started to date Rob. He was popular. He was a good dancer and his crowd was fun. They had their own cars and double-dated and went to the basketball games and the movies and to parties. Rob took her places and all the girls were eating their hearts out because he was captain of the football team and he liked her.

Sollie moved through the corridors like an accusing ghost. "Don't look at me like that," she had said to him once, "everyone will know."

He hated her, he did, while some other part of him loved her, conjured up her image in the darkness before he fell asleep, while he was asleep, laid him in her body and woke him, coming in his own hand.

Spring came early that year. The air got warm, trees and flowers budded, peepers called over country ponds. Laura and Rob were parked on Cemetery Road. He wanted her to go steady, he offered his class ring. He kissed her. The radio was playing that spring's favorite love song. He was kissing her, telling her he loved her, he wanted her. He had laid over her, across the front seat of the car, and come as the head of his prick got inside her lips. Laura was angry and hurt and silent and Rob had taken it for regret and said he was sorry and he loved her.

He had taken her home.

She looked up at the light in Sollie's window and went into her house and closed the door and lingered there until she heard the car drive off. Then she walked barefoot over the dewy grass and called softly, "Sollie, Sollie" under his window. And he was there and she was pulling him or he was pulling her, back into the darkness, and he was putting his prick into her, hard, into the wet of Rob's semen. Sollie was doing her, making her body feel involved and whole, molding her under him, taking her into happily-ever-after, saying her name over and over, pushing her back into the wet grass, sliding in and out, the tender pressure of him inside her. She began, "Ohh, ohh, ohhh."

Sollie knew about Rob, but put it away from him. He had her now, he didn't care. One part of him hated her, recoiling from the still warm juice that oozed over him. This part screamed whore, beat her, left her. But the other was already pumping inside her, lost in the caress of cunt, the rich reward for motion, the growing compulsion each stroke brought, until he was emptying, jerking his own cream into her, transforming her from what he hated into what he loved most.

So the spring too had its way. The date with Rob, the return, the evening's ecstasy. She asked him once, "Do you love me, Sollie?" He had told her he loved her more than his mother, his father, and himself combined, he loved her totally, he would do anything for her. He meant it. She was satisfied.

H. M. Ruggieri

# Horseman, Pass By

Never in his life had Sidney sat on the back of a horse. But his grandfather, his grandfather had been reared with them back in Rakhov. Not long before the old man died, he had told Sidney in the rasping remains of a voice of the smells of Carpathian summers that used to drive him mad. So mad that he would find himself stripping off all his clothes and, stealing his milky blue mare from the barn without his stern father's permission, he would ride out into the mountains to get drunk with her on those sweet summer smells. Sometimes they would be driven so wild as to plunge into the river together, the steep muddy bank oozing between hooves and toes until the earth gave way beneath them, the mare sinking beneath the waves, then surfacing to swim across the waters while he floated above her, his legs drifting into her seaweed tail, his hands full of the thick wet silk of her mane, until they could mount the far bank and race naked and barebacked through the hot high meadows, his flesh sweating into the flesh of his mount as they pulled together up and down and up and down so that often he came all over her flank and continued to ride and came again, at long last limping home to be led into the barn by the stableman, chiding Sidney's grandfather but full of amused understanding as he washed both the boy and his milky blue mare with hot water until they had melted apart and he could be carried to bed exhausted by bliss.

Michael Rubin

*Photographs II:*
## Connections

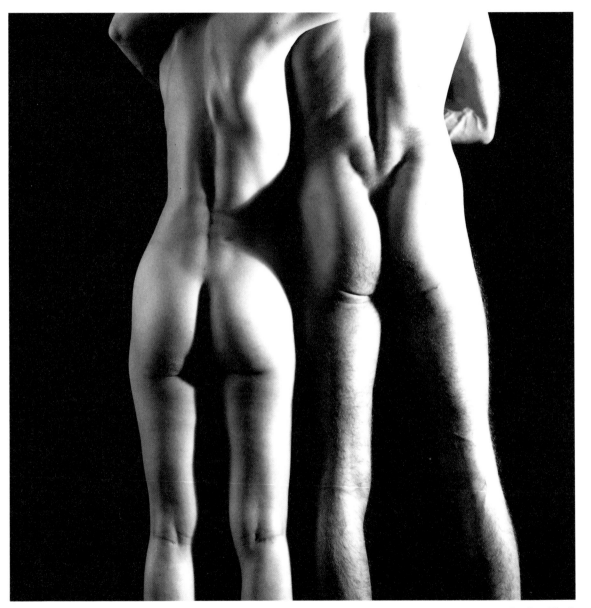

Charlie Clark

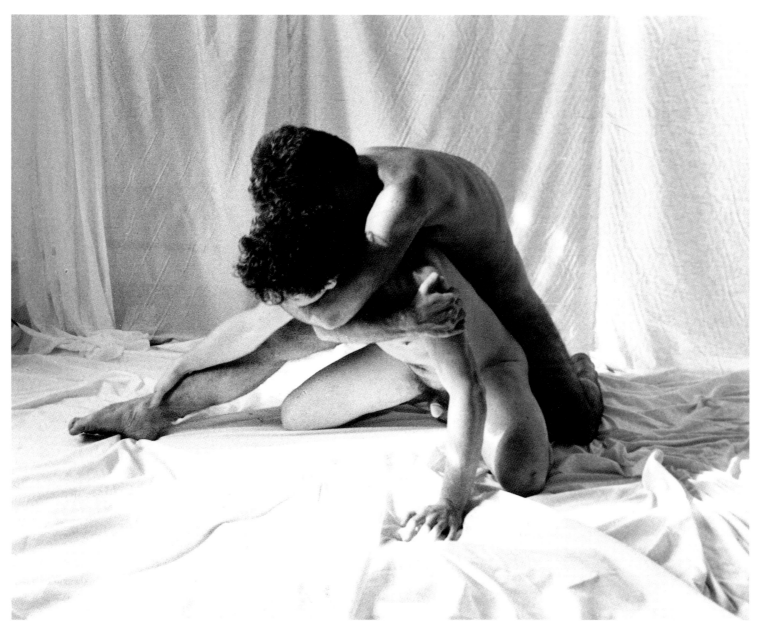

Marjorie Michael

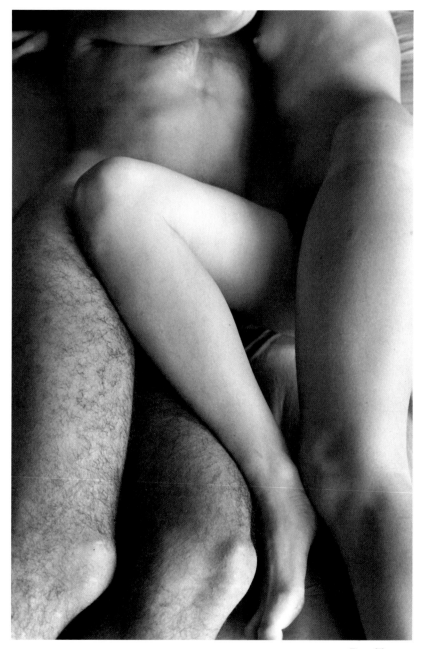

Ron Terner

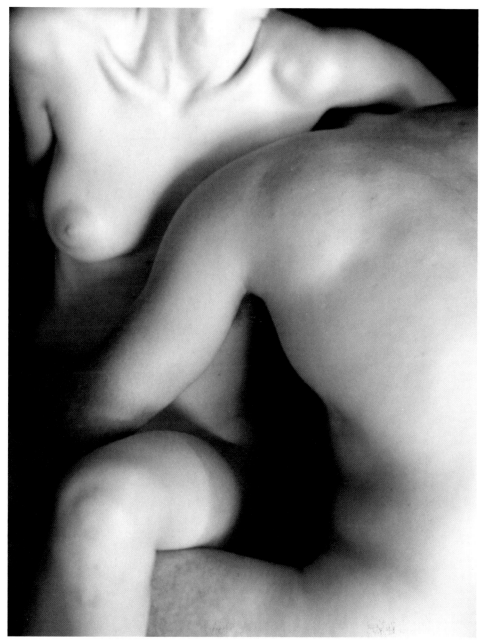

Ron Terner

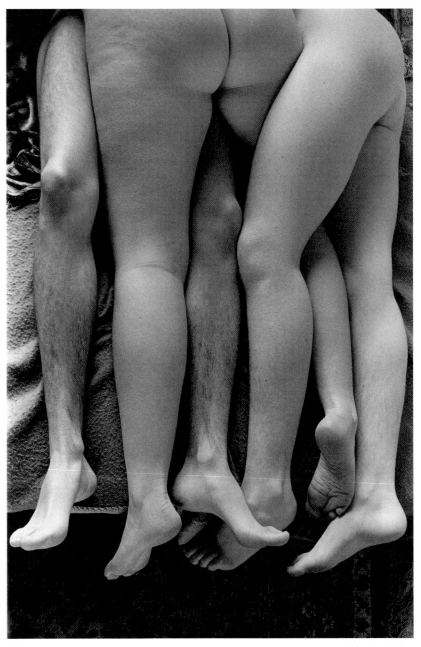

Clytia Fuller

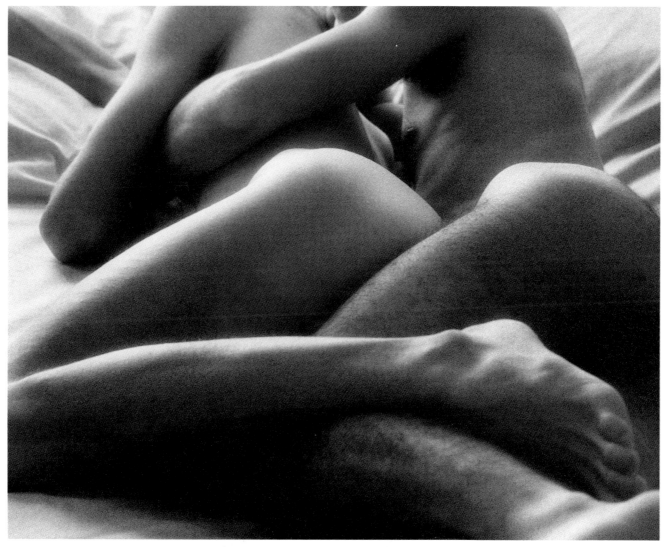

Steven Baratz

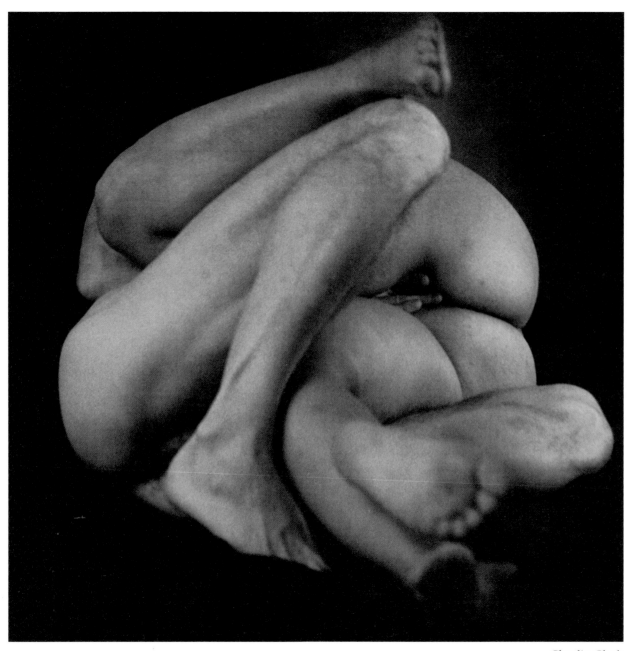

Charlie Clark

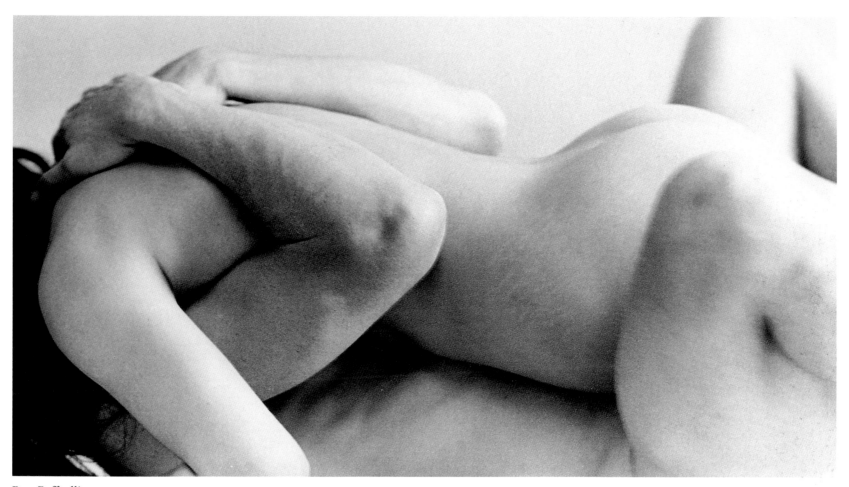

Ron Raffaelli

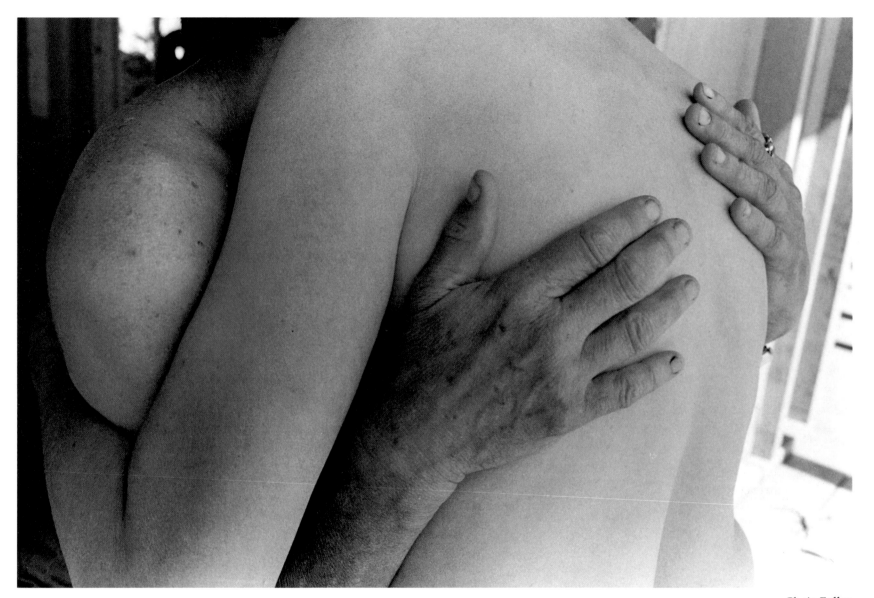

Clytia Fuller

# Other People's Houses

Irina is trying to explain herself to the woman in the mirror who looks out at her critically with slate gray eyes exactly like her mother's.

"If I told you, I don't know what you'd think of me," she says to the eyes. "You'd say I have no morals."

She can see her mother shrug the way she used to, one shoulder raised slightly above the other. People had said her mother had no morals, but they were wrong. Her mother may have left her father, but she never had a thing to do with another man.

"Irina Elena," the eyes seem to say, "you forget who you are. You call yourself Irene Jonson and sell real estate." The voice is from long ago; the words are Russian. Her mother died when Irina was fourteen, shortly after they'd come to America.

"I went to school and studied hard," Irina tells the eyes. "I speak perfect English, and I still know Russian and Korean. I've done well with my life. I married a doctor."

"You're divorced," say the eyes of her mother, who was never legally divorced. "I have no grandchildren."

The gray eyes, which are Irina's as much as they are her mother's, fill with tears. She brushes her graying hair with a rosewood brush, arranging the curls with her free hand.

"Your hair is almost white," says her mother. "Look, the blond is gone. You could have it dyed if you'd take the trouble."

"Nonsense," says Irina. She finds her clients trust her now that her hair is gray. When she shows them houses they look into her eyes; they listen and nod their heads, and eventually buy. Fifteen years ago men would stare at her breasts and women at her pale blond hair, which looked dyed though it wasn't. Fifteen years ago she would not have been given Kenwood Realty's annual award for the most houses sold.

"I'm fifty," she whispers. The eyes in the mirror look frightened. "You never had to be fifty," she tells her mother. "You died when you were forty. You have no right to ask me what I'm doing here."

A month ago, when Irina was alone in the office on a Saturday afternoon, a man had called about the house on Butternut Road, the six-bedroom place that hadn't sold in over a year. She tried to put him off; the house was too large, she told him. She wanted to go home early and have a hot bath instead of wasting her time showing a house no one would buy.

"I'd like a large house," the man persisted in an accent she thought at first might be Russian, but which soon established itself as German.

"I don't know if it would be possible for me to show it this afternoon."

"Ah." He sounded disappointed. "Perhaps tomorrow?"

Claire walked into the office, sat down at her desk, and began removing the hairpins from her dark brown hair, which fell to her shoulders. She scratched her head and sighed. Irina covered the mouthpiece of the phone and whispered, "Claire, want to show Butternut Road to some German?"

Claire rolled her eyes and said, "Did Kenwood put that turkey in the paper again? I want to quit, that's what I want. I've been running all day. You go. I'd rather stay here and answer the phones."

Irina shrugged. "Can you be there at four this afternoon?" she asked the German.

"Yes, certainly," he answered, and said his name was Max Hohenzollern, and that he'd be driving a blue Mercedes.

Other people's houses are a mystery. What lives have those walls contained? What have the windows seen, the ceilings

heard? To Irina, houses seemed to have an almost human intelligence. She took out the ring of keys she carried in her purse and tried one, then another, in the box that hung from the doorknob like an oversized padlock. Her ring held keys to realty lock boxes on houses all over the county, some furnished, some unfurnished; some excellent buys and some with rotted foundations and holes in the roof. Some were currently occupied; some hadn't been inhabited for years, and seemed haunted by former residents.

"Real estate!" Irina called as she opened the door, unnecessary in an empty house, but she did it like a magic charm, to warn away ghosts. She thought she saw a shadowy cat at the head of the stairs, but a second look revealed dust motes in a patch of yellow and blue light from a small stained glass window on the landing. It was a quarter after four, and no Mercedes. Irina stood just inside the door letting the musty house breathe while she consulted the notes on her clipboard.

At twenty after four a dark blue Mercedes with tinted windows rolled to a stop behind Irina's Volvo sedan. A tall, tanned man with wavy white hair combed back from his forehead got out, shut the door, and stood beside his car unbuttoning his suit coat while his blue eyes inspected the house and Irina in the doorway. She smoothed the skirt of her gray suit with one hand and waved with the other. He drew himself taller and, with a wave that was something like a salute, approached Irina.

"Max Hohenzollern," he said, extending his hand to her.

"Irene Jonson, from Kenwood Realty." She took the hand hesitantly and shook it. Her mother had disliked Germans, believing them all to be communists. "Karl Marx was a German," she would offer as irrefutable proof.

The stern face of the German relaxed in a smile, and his blue eyes shone. He held her hand until she withdrew it and asked, "Do you have a large family?"

"No, alas," he said. "I am alone." He followed her into the house.

"Then this is probably way too much house for your needs," she said, leading him through the living room, the formal dining room, and a library lined with empty shelves.

He paused, looking at the beamed ceiling. "What a room to write in."

"You're a writer?"

"An historian, actually; I'm working on a history of Germany, a non-military history. Interesting, no? No one thinks of Germany in non-militaristic terms." He sighed as he walked around the room. "I would buy the house for this room alone, but it's true that it's much too big for me. I have driven past many times and was curious to see the inside."

Irina crossed the room and opened the French doors to the garden, where roses choked with weeds and ivy lined a browning lawn. He stood behind her and put a hand on her shoulder. "I'd like to see the upstairs," he said.

Irina was startled at the pressure of his hand and at the pleasure it gave her. She felt she ought to move, but didn't want to. His hand was warm; his touch light yet firm as his fingers pressed into her flesh. Abruptly she shrugged the hand away, closed the doors, and led him up the stairs. She sneezed as they reached the landing.

"Gesundheit," he said, brushing cobwebs from the stained glass window, whose design depicted two blue and yellow parrots sitting on a branch entwined with yellow orchids. He traced the glass lightly with his fingertips. "Did you know that parrots are the most erotic of birds? Or perhaps it's the place, the jungle, that's so very erotic."

"I think you mean exotic," said Irina. "Upstairs there are six bedrooms, two baths," she read from the notes on her clipboard. "There's a third floor, with, I think, four rooms for servants. No bath."

"The servants can walk down a flight," he said with a half smile. "That would be quite suitable."

She laughed and continued up the stairs. He followed her into the master bedroom. When she crossed the bare floor to open a window, dust flew off the sill. She sneezed again and brushed her hand in front of her face. He came up behind her and stood with his hand on her shoulder.

"The garden looks nicer from up here," he murmured. At a distance, the weeds weren't so noticeable and the regular pattern of plants and walks could be seen. The rose bushes held a few faded blooms.

She untied the knot in the purple silk scarf around her neck and leaned into his hand as he massaged her shoulder.

"Do you find it arousing to be in a strange house?" he asked.

She stood straighter, picked up the clipboard she'd propped on the window sill, and moved away, tying her scarf again. "I could show you other houses, smaller houses," she said, clearing her throat. "Why waste our time with this white elephant?"

He moved closer again and, without touching her, said, "But this will do fine for the afternoon." He removed his jacket, laying it carefully on the floor, then loosened his tie. "It is always a bit warmer on upper floors. The servant's rooms must be unbearable."

They stood looking out the window.

"May I call you Irene?" he asked.

Irina, who had spent her life pretending not to be a refugee, wanted Max Hohenzollern to know who she really was. The warmth of his hand on her shoulder seemed to demand truth. "My name is actually Irina Elena Petrovna," she began. "I'm a Russian, born in Korea of refugees from the revolution. My grandmother escaped with most of her family and a fortune in jewels, which kept us going for years." She touched the scarf at her throat. "I think she had been some kind of lady-in-waiting to the Tsarina before the revolution. Jonson is my ex-husband. Irene is just easier for people to remember."

His hand massaged her shoulder. "And I," he answered, "am a nephew of Kaiser Wilhelm II, and a descendant of Queen Victoria." He took a small card from his shirt pocket and handed it to her; engraved in gothic script was "Prince Maximilian Wilhelm."

She smiled as she handed the card back to him. She didn't believe a word of it, but it occurred to her that her very real story was as unbelievable as his.

"Keep it," he said, kissing her gently on the lips. They embraced.

Inexplicable, she thought later, driving home alone. Never in her life had she and a man she hardly knew thrown their clothes to the floor of an empty house and rolled about on top of them. Making love seemed an inadequate description of what they'd done. Having sex, screwing, fucking: words she'd never used before were more appropriate. She felt as though he had ordered her, without words, to lie beneath him on the floor, and to move her body to his rhythm, yet it was she who had pulled him down on top of her, guiding his penis to her cunt.

After, she traced the light blue scar beneath his collarbone with her fingertips until he said, "I must go," and pushed her hand away. They dressed with their backs to each other, left the house together without a word, got into their separate cars and drove away.

More inexplicable was her enjoyment, the release that flooded through her body as though every muscle at once had been given permission to relax. She hadn't had a lover in the nearly six years since her divorce.

She'd hardly noticed the discomfort of the bare boards, though when she got home her back felt sore and, looking in the mirror after her bath that night, she could see bruises along her spine. She had always bruised easily.

All the next week her emotions were divided between fear that he would try to contact her at the office and despair that she would never see him again. What would she say if he called? Just the thought of that afternoon made her go damp between the legs as she sat at her desk in her gray suit and white silk blouse, calling clients to inform them of new listings.

She thought of telling Claire about Max, but was afraid she might be shocked. Claire once said she couldn't imagine her mother making love, and had looked at Irina in a way that included her in this category of sexless older women.

"She must have done it at least once," Irina had told Claire sharply, and was glad she had no disbelieving offspring of her marriage to Dr. Jonson to sit before her open-mouthed saying,

like Claire, "I just can't imagine it." Young people have no imagination at all, thought Irina. When she was twenty she would never have been able to imagine a man like Max, and wouldn't have known what to do with him if she'd met him.

Sunday Irina was in charge of an open house on Bothin Road, where the owners were gone for the weekend. She brought with her a bouquet of red and white gladiolas which she arranged in a vase on the mantlepiece, and a basket of oranges for the dining room table. The fruit and the flowers were a gesture to make prospective buyers feel at home in a house cleaned to a motel sterility, with all valuables locked away. Irina understood the psychological value of personal items in the sale of a house. She opened a window in each room, knowing people wouldn't buy a house that didn't look as though someone lived there.

When the doorbell rang, she answered like a hostess, showing the house with the warmth necessary to a sale.

"The children's rooms," she said, "are well placed at the back of the house, don't you think? Yes, the shutters are included. The owner made them himself, as well as the buffet in the dining area, which of course is also included. Yes, he does beautiful work."

The faucet in the bathroom dripped. Irina considered shutting off the water to disguise this, but people sometimes liked to test faucets. "It just needs a new washer," Irina said, hoping this was true. Why hadn't the owner fixed it before the open house?

Irina's jaw ached from smiling; the skin on her palms recoiled from shaking another hand. Two people seemed serious about making a bid on the house, and from noon on there were never less than ten people roaming the comfortably furnished rooms and sniffing the odorless gladiolas. She saw a child steal one of the oranges.

It was nearly four when Irina thought she saw Max across the room while she was explaining the heating system to a man and his teenaged son. She smiled at him, but his face remained expressionless though his eyes held hers and he nodded his head once, abruptly, a gesture that could be mistaken for a ner-

vous twitch. His hair seemed to be darker. She remembered it as pure white, but now it was brown streaked with white. Hadn't he had a moustache?

The father and son left. Irina paced the hallway looking at her watch. The open house was due to end at five. It seemed to Irina that people who were just looking spent longer in a house than those who were serious about buying. One man sat on a bed and bounced slightly as though testing its spring, while his wife fingered the material of the curtains.

"The house doesn't come furnished," Irina reminded them.

"Of course," said the man, standing up.

It wasn't the house they wanted so much as the life within it. They wanted the beds, the curtains, perhaps even the jobs and hobbies of the owners. Irina stood in the bedroom door until they left, all the time imagining what the bed would feel like with Max on top of her. In the living room they lingered, looking at the titles of the books on the bookshelf by the front door, until she told them it was time to go.

When the house was empty at last, Max was still in the living room. She approached him smiling; he shook her hand.

"Good afternoon," he said. "I am Raymond de Leon. My card."

Confused, Irina took the card and looked from the Paris address listed beneath the name to Max's face. "Didn't I meet you at a house..." Her voice faltered.

He smiled then, and looked into her eyes. "It's possible," he said. "I have been looking at houses for a long time."

His accent was definitely French. Her heart thumped.

"Someone who looked almost exactly like you," she murmured.

But she was convinced it was the same man. The hand that took hers now was Max's hand; the touch and pressure were his. Perhaps she was wrong about the hair, and he could have shaved the moustache.

"It seems a bit small, the house," he said, "but I would like you to show it to me. It does have possibilities."

He picked up one of the business cards she'd left on the coffee table in the living room. "You are Irene Jonson?" he

asked.

She wanted to say, "Of course. You know who I am," but if Max were playing a game, why not play along?

"Yes," she said, "though that's a name I only use for business purposes. I am really . . . I am really an Italian countess, Contessa Silvana Di Megliore." She made up the name rapidly. "I'm forced, alas, to earn my living selling real estate. We all have false names at the company, you know. It wouldn't do to give out our real names, we meet so many people each day."

This wasn't in fact far from the truth. Irina wasn't the only one who had found her real name inconvenient. John Kamadulski, the head of the company, changed his name to John Kenwood before going into business. Claire's name was really Clara, but she felt Claire sounded more like a woman who would know about houses.

Irina led Max to the kitchen. She had forgotten the name on the card she still had in her hand, and consulted it briefly. "Monseiur de Leon, do you do much cooking?"

"Ah, yes," he answered. "No one in America believes men cook, but it is in fact one of my greatest pleasures. This is a rather small kitchen." He sniffed at the efficient countertops and cupboards, and the narrow stove and refrigerator fitted beside the sink.

"In America, it is all convenience," said Irina in her best Italian accent. It was like learning a language backwards, she thought, to try to have an accent; for most of her life, she had struggled to shed her accent.

"Ah, yes," he said. "In America, the wife always works. Dinner must be made in the microwave, zap!" He snapped his fingers. "Even the stove will soon be obsolete."

Irina laughed. Leading him to the bedrooms, she said, "I wouldn't be surprised if they invented a kind of microwave for making love, you know? Step inside and immediately you're finished. You wouldn't know what hit you, but you'd feel so very satisfied."

"No, no, that wouldn't catch on." He paused beside a king-sized bed. "You see? While the size of the stove and refrigerator might shrink, the bed grows. There's the proof: America is safe from instant sex. That's one thing they still have time for, thank God."

They stood looking across the bed as though it were a swimming pool. "Would you like to try it?" he asked.

She answered, "That isn't part of the tour," with a coyness she didn't feel. She remembered his hands on her body.

"But I'm not just any prospective client, Contessa." He moved closer, and began to unfasten the buttons of her blouse.

As they lay down on the bed she felt a moment of panic. What if the owners came back early? What if the bedspread were stained? What if someone found out what she'd done? He kissed her eyelids, he kissed her neck and her breasts, then moved his hand between her legs. She gasped as he kissed his way down her belly. She forgot who she was. The contessa moaned and cried out like Irina never had.

Afterwards it was a pleasure to lie on a strange bed in a strange room and feel his familiar body. Yet where Max had made love swiftly, almost as though he commanded her body to obey him, Raymond had been slow, taking time to gratify every inch of her.

"Max," she whispered in his ear, hoping to catch him off guard.

"My dear," he answered, "you must be more careful. You're lucky I'm not a jealous man."

She felt along his collarbone until her fingers touched the familiar scar. Sensing he was falling asleep, she turned on the light and said, "We'd better go."

Raymond sat up, blinking.

"They'll be back tonight," she said. "Get dressed."

All trace of the contessa had vanished as Irina hurried into her beige silk dress. Raymond de Leon sighed as he stood up.

Irina straightened the bed as he dressed, leaving it, if anything, neater than it had been, and rushed him out the front door.

"Will we meet again?" she asked as she locked the house, but he wasn't standing behind her as she thought; he was get-

ting into a low green sports car. He honked and waved as he sped away.

They did meet again, at different houses, using different names. Sometimes he would turn up at an open house, sometimes he would call the office and arrange for her to show him a house. He was Max Hohenzollern, with his white hair and moustache, or he was Raymond de Leon, French businessman searching for an American pied-a-terre. He was also Hank Jonas, an ex-basketball player from Kansas, Hugo Garcia, an Argentinian cattle rancher, or Hermann van Damme, Dutch art dealer. Irina was amazed by this cast of characters, who all spoke with Max's voice, though in different accents. All were exact replicas of Max with only superficial differences: blond hair or brown, a moustache or no moustache.

It was Mr. van Damme who explained the scar beneath his collarbone one evening as they lay nude on a double chaise longue beside a swimming pool surrounded by a high hedge of junipers. He said he was stabbed in a confrontation with a counterfeiter who did perfect imitation van Goghs; stabbed with a palette knife, he added. She stifled a laugh as she traced the scar with her fingertips. I know his body like the blind know braille, she thought. I know him, no matter who he thinks he is.

She kissed the scar, then kissed her way slowly down his chest and belly until she reached his soft penis, which she took in her mouth and sucked until it hardened and he began to breathe heavily. She sat up abruptly when she heard a thrashing in the bushes beside them. A young man's head poked through.

"Oh," he said, "I'm sorry." His brown beard trembled. "I thought it might be Mr. Mitchell again. He has a heart condition, you know." The bearded head quickly withdrew.

"Hurry, get dressed!" Irina insisted, pulling on her white slacks.

Mr. van Damme was reluctant. "Why run when we've already been seen?" he asked. "He probably just thinks we're guests of the Mitchells. He doesn't even seem well enough acquainted

with them to know they're in Hawaii for a month."

The close call seemed to have excited him. Still lying nude on the chaise, he pulled her back down on top of him.

One day in the office she asked Claire, "Have you ever met a man who turns out to be many different men?"

Claire raised her eyebrows.

"I mean, he likes to pretend he's different people," Irina explained. "But sometimes I'm not so sure he's pretending. He really seems to believe he is these people."

"That's not the way it happens to me," said Claire. "I meet lots of different men, but they all turn out to be my father."

Irina laughed.

"Does this guy want to buy a house?" asked Claire. "Maybe you could sell each of his personalities a house."

"I don't think he wants a house." Irina leaned on her desk. "He seems to want to meet me, over and over again, so I show him houses."

"Are you always the same?" Claire asked.

"I'm always Irene Jonson, the real estate agent," she answered, "but then I'm also—well, you know I'm Russian and my real name is Irina."

Claire nodded.

"So I told him that once, and then I invented an Italian countess, and sometimes I'm just straight Irene Jonson, American businesswoman, and that's as far as I've gone with it. But it doesn't seem to matter; he always pretends it's the first time he's met me."

Claire frowned. "Are you sure you should be alone with this guy? He sounds weird."

Irina wanted to be alone with him as much as possible. She volunteered for open houses, and promptly answered every phone message she got, never knowing for sure if a man called Albert La Tour or James Ross would really be Max.

"Tell me what you want more than anything in the world," Hugo the cattle rancher asked her one afternoon as they sat on

a leather couch before a fireplace in a house on a hill with a view of the bay.

Irina the displaced Russian noblewoman, with an accent much thicker than her mother's had ever been, said, "Once when I was very small I was taken to Harbin, China, by my father to visit his mother, who had settled there. I remember being bundled in furs on a sleigh; it was mid-winter. I was three, and I remember the hat I wore, an ermine bonnet that almost covered my face. A servant came out, a very tall man with blond hair and a long blond beard, and lifted me from the sleigh in his strong arms. My father spoke to him in Russian. I was amazed; I had never seen a Russian servant. All our servants were Asian. I remember thinking then, I want one of those—I want a tall blond Russian to carry me indoors and take off my coat and leggings.

Hugo ran a hand through his salt and pepper hair. Irina smoothed his brown moustache. Sometimes it was hard for her to control the urge to pull it off, exposing him as a fraud. If she did, would she end up with one lover, or would she lose Max and his alter egos forever?

As she reached to caress his scar she said, as though discovering it for the first time, "How did this happen?" and waited for his story. She was beginning to enjoy their game.

He was nicked by a young bull, he said, while branding him.

"A young bull," she repeated, her hand sliding to his cock. "I prefer the older ones myself." The sparse hair on his chest was white, and the hair on his balls was light brown and white; this and the scar never changed, nor did the light tracing of his hands over her body, or his instinctive sense of where to touch her and when, though this sense might be used differently when he was Max, fast and commanding, than when he was the slow and sensuous Raymond. Hugo the old bull was like a young bull forever tantalizing her by just missing the most sensitive spots of her cunt and clitoris until she thought she'd scream, at which point he instantly touched the exact place that sent her sailing over the waterfall of her orgasm.

One morning in the office she answered the phone and the now familiar voice said, in a Russian accent, "Could this be Irina Elena Petrovna?"

She said it could, and smiled at how well he imitated her accent.

He paused. "Possibly you don't remember me."

"The voice is familiar," said Irina. "Haven't I met you recently?"

"Oh, not in forty-seven years," he replied. "You were a child of three. I worked for your father's family in Harbin. You had the most exquisite gray eyes and long blond curls." His voice

Gary Epting

trailed off in a sigh. "So many times I wanted to stroke that hair, and your satin poreless skin, but one cannot do that with a child. Your father would have had me shot. A servant is worth nothing."

Irina's breath caught and she felt herself flush. "You had a sort of peach fur on your arms and legs. I wanted to lick it with my tongue, little Irina; I wanted to sniff it, to rub my nose along your white fuzzed knees. But I restrained myself."

Irina's heart beat faster. "Perhaps we could talk," she said. "I should warn you I'm a bit older."

"All the better," he whispered. "A child can be, at best, a mere shadow of the woman she will become. The woman you are now interests me far more than the child you were."

He breathed in her ear for a few seconds, then said that he was looking for a house. "I found you by chance through several calls to this agency and others. People told me about you, and I realized who you were. I would like a large house."

Irina flipped through the notebooks on her desk, finding at last the address of a four-bedroom house whose occupants were away for two weeks. "Do you have a family?" she asked. "Children?"

"A wife," he answered. "One son who lives with us. Grandchildren who visit frequently."

She gave him the address and told him to meet her there in an hour, which would give her time to run home, shower, and change.

Who would she be this time? She chose a Mexican blouse and full skirt, but peasant hadn't been her role in Harbin. She finally put on a dress of a goldish yellow with a gilded leather belt. Her hair still had some gold in it. She added gold earrings, a gold bracelet from Russia that had been in her mother's family and had engraved on it a design of birds sitting on vines, and put lipstick on a mouth she formed to the haughtiest expression she could imagine. Her gray eyes stared proudly straight ahead. She wished she had time to rent a golden car.

When she arrived he was sitting on the front porch. His white hair and beard were streaked with gold; he wore a white linen suit and held a panama hat on his lap. He stood up, clutching the hat, as she got out of the car.

"Irina Elena, I would have known you still." He held out a hand with gold rings on every finger. "Those eyes, that hair, golden even now."

Irina couldn't remember the servant's name, if she'd ever known it. "Is it Ivan?" she guessed. "Is it really Ivan?"

He smiled and nodded, clasping her hand. His eyes floated in tears. He breathed heavily. "I am speechless after all these years."

She said in Russian, to see what his reaction would be, "It's been a long time."

He shook his head. "I've been in this country so many years I no longer understand."

She continued in Russian, "Oh, it will come back to you. A language never leaves you. Doesn't your wife speak it? Your family?"

As if he understood her, he answered in English, "I came here alone. I was an orphan who never knew his family, though I believe I may have been an illegitimate son of your grandfather's. I came here after the Korean War, married an American and went into business in Los Angeles selling cars."

She laughed. "So that's where you get your different cars." He looked puzzled.

"We're here to see a house, aren't we?" She took out her key ring and opened the door.

"Real estate," she called. "Hello?"

His familiar hand landed on her shoulder as he followed her into the living room, which had high beamed ceilings and oriental carpets on the floor. He dropped to his knees and caressed the carpets with his hands.

"Fine, fine work," he said. "I haven't seen such rugs since I left the orient."

She stooped and brushed a hand across the rug. "You know, of course, the rugs don't come with the place."

She stood again. Still on his knees, he reached up and took

her hand.

"It's been years since I've been anyone's servant," he said, "but I could be your servant forever."

He dropped his hat on the coffee table and inched closer until his nose was level with her crotch, then put both hands under her dress and slid them up her smooth brown legs. She hadn't worn stockings, and watched his surprise when his hands arrived at the top of her legs to discover she hadn't worn underpants, either. Slowly he caressed her buttocks, then lifted the golden dress and sniffed into her hair until his tongue found the spot he was looking for. As he licked she grasped his hair, trying not to pull, though the urge to do so was irresistible as she came and fell back on the chair behind her.

They heard a key in the lock. He pulled her dress down over her knees and stood beside the chair. Her hands clutched at the air around her, but her briefcase was on the coffee table beside his hat.

"Real estate!" a woman's voice shouted. "Anybody here?"

It was Claire. Irina's mouth felt dry. She cleared her throat and stood up. "Hello, Claire, it's Irene Jonson here," she called.

Claire paused at the door to the living room. With her was a woman carrying a large white plastic purse that looked like a picnic basket. "I'm sorry," Claire said. "I didn't know you'd be here. Is it all right if I show Mrs. Melrose the house? Mrs. Melrose, this is Irene Jonson, another one of our agents."

The woman with the white purse held out one hand. It took Irina a moment to realize she ought to shake it. "Mr. . . . Mr. Serebrenov here is very interested in buying the house," she said as she clasped Mrs. Melrose's hand. "As a matter of fact we were just discussing terms, but of course you're welcome to have a look around."

Mrs. Melrose glanced out the living room window and sniffed. "I don't know if this would suit us, anyway," she said dubiously. "There's not much of a yard."

"Would you like a quick look upstairs?" asked Claire.

Irina noticed that Ivan was smiling directly at Claire's small breasts, and felt a sudden desire to hustle Claire and Mrs.

Gary Epting

Melrose out of the house.

"If she doesn't like the house, why bother?" Irina opened her briefcase and took out her clipboard. "Now, Mr. Serebrenov, where were we?"

"I'd like to see it as long as we're here." Mrs. Melrose whined like a child about to be deprived of a treat. A looker, thought Irina. Claire doesn't know the difference between a serious buyer and a looker.

Mrs. Melrose started up the stairs. "I just want a glance at the bedrooms," she said.

Claire followed her.

"A moment," said Ivan in his charming Russian accent. "I don't believe I caught your name." He held out his hand.

Claire took it and said, "Claire Pope. How do you do?"

"A pleasure," said Ivan and, still holding her hand, he added, "Mrs. Jonson and I were going to have lunch together. It turns out we knew each other years ago. Would you care to join us?"

Claire looked over her shoulder at Irina and raised her eyebrows.

Irina shrugged and looked out the window. "That woman's right," she said. "The yard is practically non-existent."

Claire backed away, but Ivan still clasped her hand. "Such a beautiful young woman. It would be a pleasure if you could join us. Don't you agree, Irina?"

"I'm afraid I can't," Claire responded. "I have a luncheon engagement, and I'm terribly busy all afternoon."

"A pity," he sighed as he let go of her hand.

"Mrs. Melrose?" The bun at the back of Claire's head slipped sideways as she started up the stairs.

Ivan stroked Irina's shoulder. "I would have loved to spend the afternoon with the two of you."

Irina tensed. This was beyond what she was ready to accept. "I'm afraid Claire's a bit more of a prude than she'd like to admit."

"Young people so often are." He smiled and embraced her as he began to unzip the back of her dress. "You'd think they'd want to try what they've never done before, but no, all they want

is to find the perfect one-and-only to marry. I was the same at her age. Older people have so much more imagination, don't you think?"

Irina pulled away. "Not while they're in the house."

The women's footsteps and muffled voices could be heard overhead.

"It adds to the danger," he said.

She backed away, trying to zip her dress.

The women descended the stairs.

"It was a pleasure to meet you, Mr. Serekov," Claire called as she and Mrs. Melrose walked toward the front door.

"Pleasure," Ivan murmured as they left. "What does she know of pleasure, a girl like that, eh?"

Irina breathed deeply and buried her head beneath his collarbone, kissing his chest and smelling his familiar odor. "I'm just glad she's gone," she whispered. "Aren't I enough for you?"

He laughed. "Oh, yes, though I wouldn't say no to more. Shall we look at the bedrooms?"

They climbed the stairs and surveyed the four rooms, choosing one with a large canopied bed.

At sunset they still lay nude on this bed.

"Tell me about your life since I saw you last," he asked.

She laughed. "We moved," she said in her phony Russian accent, "and moved and moved. To Korea. To China. Korea again. Japan. And then to Los Angeles, and then San Francisco, where I graduated from high school. And then I was a secretary," she continued in a sing-song voice, "and then I married Dr. Jonson, the neurologist."

"Tell me about when you were married to Dr. Jonson," he said.

"There's nothing to tell," she answered. "Almost twenty years of nothing to tell. He wanted children and I didn't, though I didn't know it. But my body knew. I must have seen every specialist in the country and still I didn't conceive. I studied real estate. He hated me as a businesswoman and left me for a young woman who was soon pregnant. I think they have three children now. He must be almost sixty, more like their grandfather. Now

everyone's happy." She threw her arms around his chest. "Most of all me."

She felt like she was twenty again, except for the ache in her back from lying all afternoon on a hard and unfamiliar bed. She stroked his beard and playfully tugged at it. "Is this real?" she asked. "Is this the same beard you had forty-seven years ago, gone a little gray?"

The beard was strangely resistant. She pulled harder.

"Ow!" he protested, but she felt it give a little on the right side.

"Imposter!" she cried. "Now that you know all about me, I should unmask you!"

"No! Please. This glue would remove a layer of skin along with the beard."

"Who are you?"

"What do you mean?" he asked. "I am Ivan."

"And yesterday you were Max Hohenzollern and tomorrow you might be Hugo or Monsieur de Leon, or who knows?"

"But isn't that my attraction for you? That you never know who I really am or who I might be next? Would it make you any happier to know I was Ray Maxwell, insurance agent, and always would be? What would you think then?" His Russian accent was gone.

She sat up. "Ray Maxwell might be a very nice guy."

"But just about as exciting as your Dr. Jonson. Perhaps a good deal less so." He slipped back into his Russian accent again.

"How did you really get your scar?" she asked, touching the spot beneath his collarbone with her fingers.

"I had a tumor removed," he answered. "Non-malignant. See? Dull and boring."

They sat silently as the room darkened.

"And what about all that nonsense about Irina Elena?" he asked. "Do you expect me to believe that stuff?"

"But it's true!" she protested.

"You're no Russian," he said. "You have no accent except when you put it on. You don't even look Russian."

Her mouth dropped open.

"A real Russian would have much more of an oriental look." He pushed the skin beneath her eyes gently with his forefinger. "The Mongol invasions, you know. That left its mark on every true Russian."

"But I . . . "

"Irene Jonson, you are as much an amateur dramatist as I am, so relax and play with me." He lay back down on the bed.

She felt her past slip away from her. "But it's true. I was born Irina, in Korea. The part about the Italian contessa is nonsense, but I am a Russian, a Russian who happens to speak perfect English."

He chuckled and patted the pillow next to him. "Enough of your story," he said. "We've got better things to do."

She opened her mouth, and shut it. Relieved of her past, she felt faceless and ageless. She could be anyone at all, or no one. It didn't matter.

She held his hard penis in her hand. "Aren't we rather old for this?" she asked.

"So we're breaking the age barrier. Hang on." He pulled her down on top of him.

She made love again in a strange house to this man she didn't know. Perhaps he was right—it was the game that created the excitement; without it they were no more than two aging bodies, their real identities folded around them like shrouds.

She fell asleep and dreamed she was in an empty house she'd never seen before, though she knew there were three bedrooms upstairs. She inspected this house from top to bottom, taking notes on her clipboard. In the kitchen she found a door she hadn't known was there, and opened it, descending a staircase that seemed to be miles long. Finally she reached a large room, a room she had been unaware of, furnished in red and purple pillows of various sizes, some large as mattresses and some small as a child's bean bag. On the walls of the room were heavy red drapes which she pulled back to find large windows looking out over a city she had never seen in her life, in which all the buildings were round. "It's not a basement after all, it's an attic," she told herself, and, opening one of the windows, she leaned

out to see more, until she found herself falling into the bed in the room where she had gone to sleep.

It's morning, and he's gone. The clock on the bedside table says eight. Irina sits up, dazed, then finds her clothes, quickly dresses, and makes the bed. She thinks she hears a key in the lock. She finds her purse and briefcase, then starts down the stairs.

"Max?" she calls, "Hugo? Raymond? Ivan?"

The house is silent. Upstairs again, she combs her hair. She says to her image in the mirror, who looks so much like her mother, "The next time I see him I should tell him to get lost." But the woman in the mirror, who is not her mother, knows she won't.

Irina consults the calendar in her purse and finds she is scheduled to show another house to Hugo at eleven. She wants to be a French painter. She wants the two of them to make love outside by a pool. She checks her clipboard. Yes, the house has a pool. She hopes it's secluded. She'll have time to go home and change. This time the peasant blouse, and a full skirt, or perhaps jeans. If she hurries, she won't be late. Hugo is impatient, and so is she.

Susan St. Aubin

# Photographs III:
## Women and Men

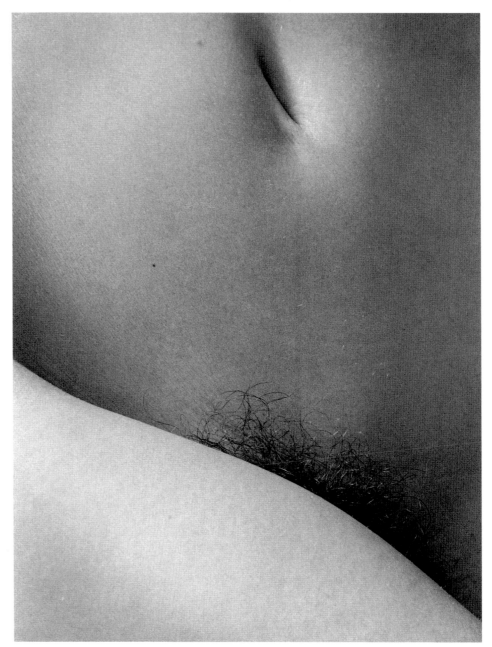

Morgan Cowin

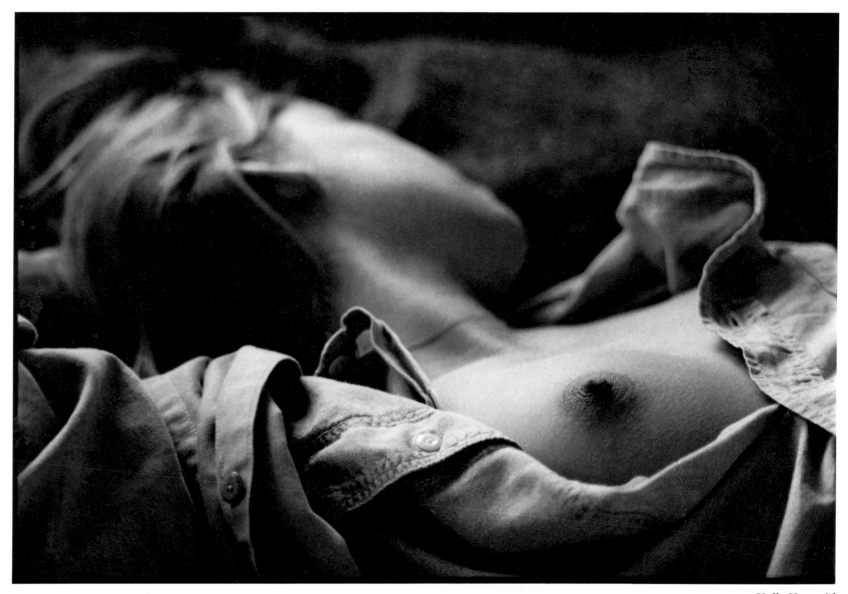

Hella Hammid

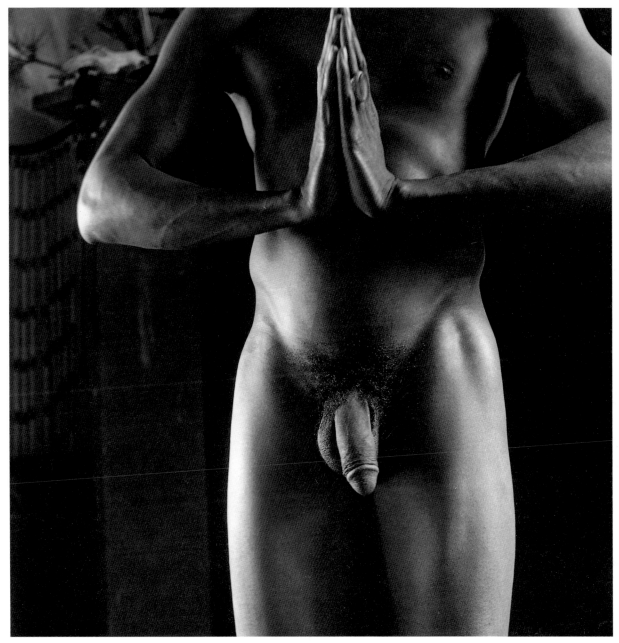

Greg Day

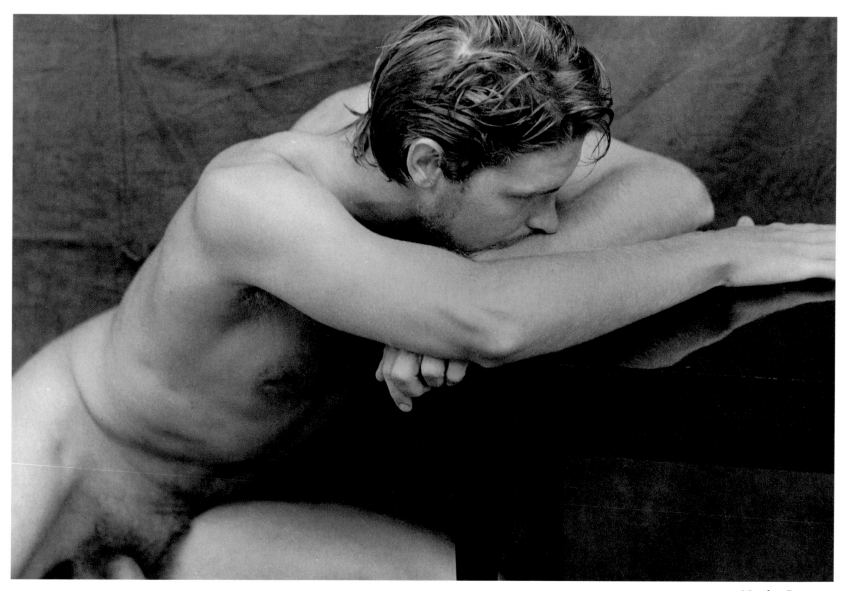

Martha Casanave

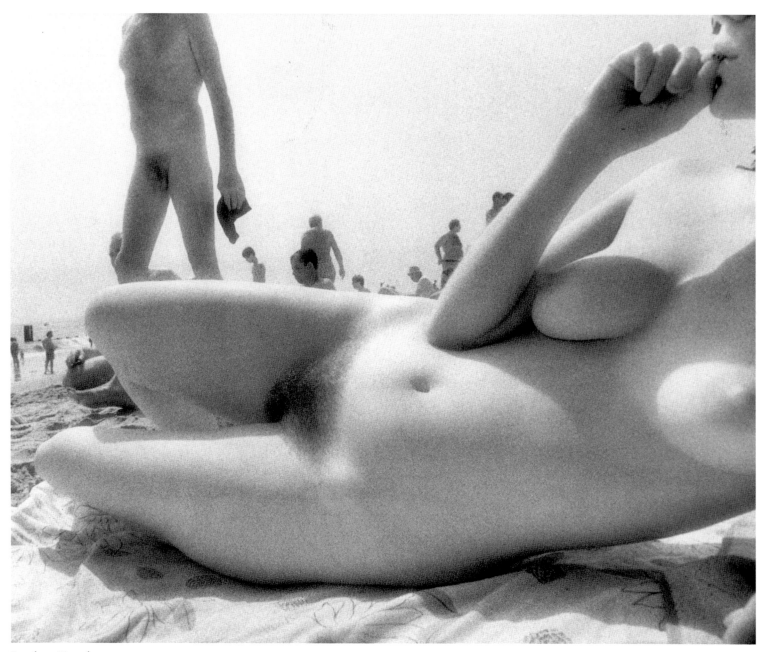

Stephen Siegel

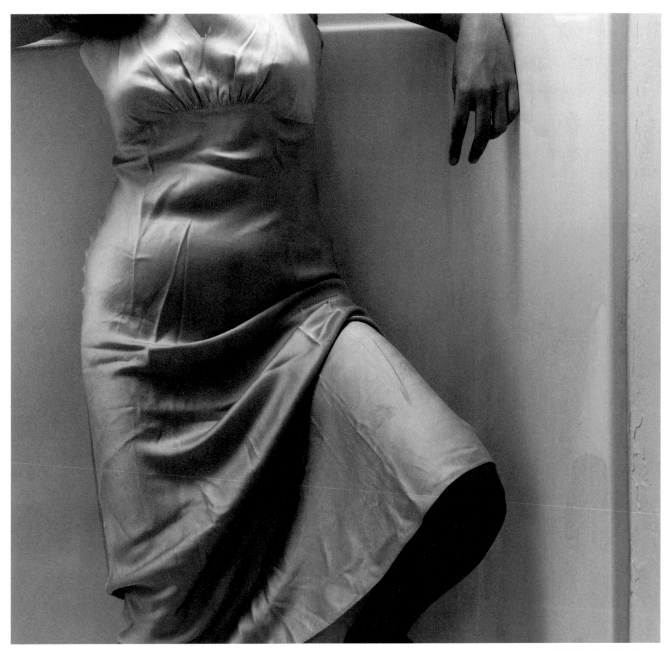

Catharina Marlowe

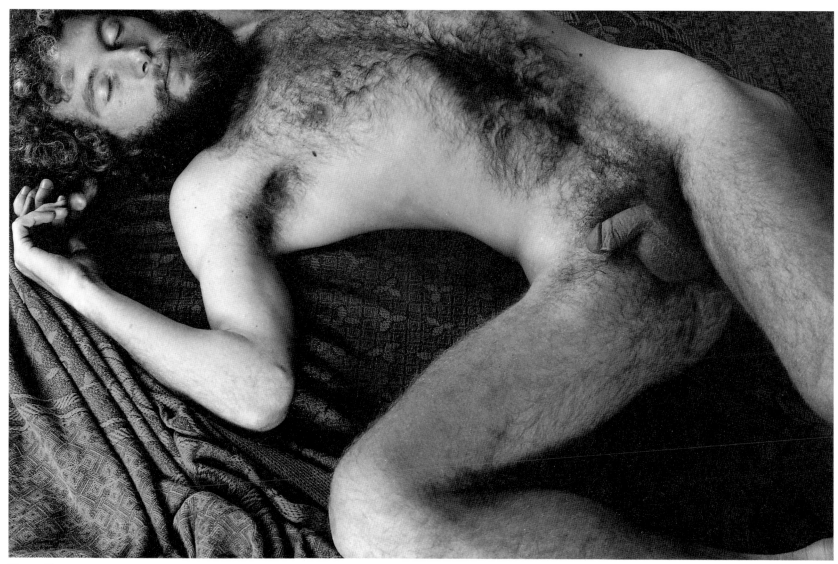

Gypsy Ray

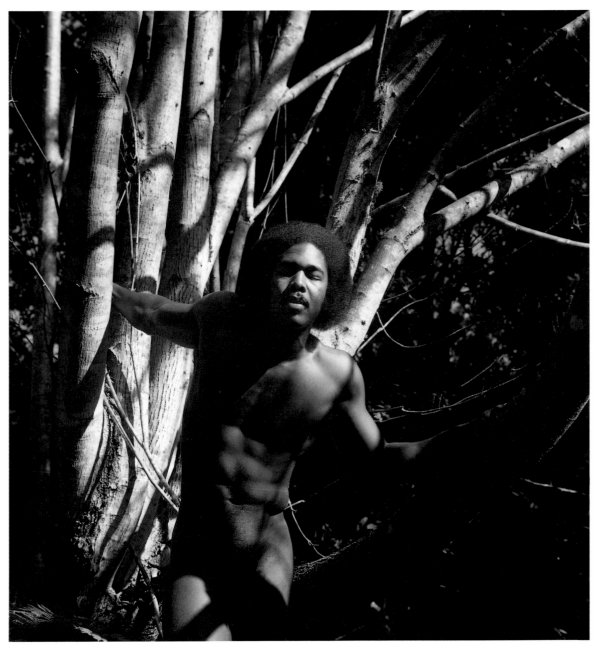

Gypsy Ray

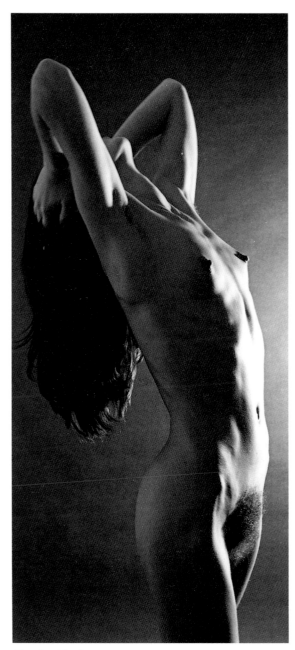

Charlie Clark

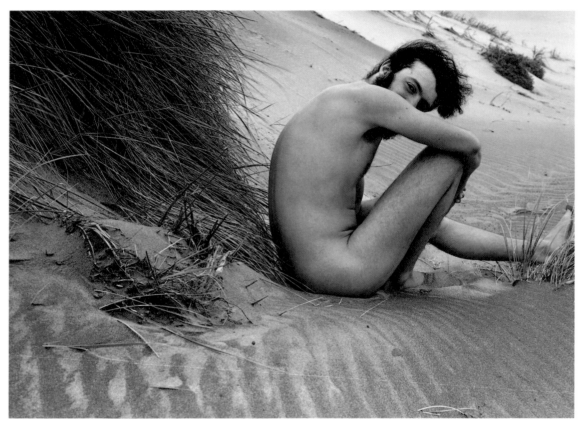

Gypsy Ray

# The Dozen Kisses

She passes him where he's leaning against a wall on Polk Street with three other boys. Pretty soon she walks back and leans against the wall next to him.

—Hi.

He nods. He looks into her eyes very steadily.

—Nice day, she adds.

—Yeah.

—What's your name?

—Ken.

—How old are you?

—Sixteen.

—Sure.

He shrugs.

—You want to go for a walk?

—Where?

—I thought you might know a good place.

He looks a little uncertain.

—It depends . . .

—How much to go indoors somewhere?

—Well, forty dollars plus—you mean like a room?—plus the room then.

She takes money out of her jeans.

—Hm. Haven't got it.

She smiles.

—How much for a kiss?

She notices him glancing up and down the street quickly.

—Can they bust you for a kiss? Jesus. Well, live dangerously.

They are both aware of the other three boys, who are watching the passers-by relentlessly.

—So how much for a kiss?

He grins a little and cocks his head back.

—First one's free.

She laughs. She leans toward him and he backs off, then stops. She kisses his lips very gently.

—And the second?

—Oh now that'll cost you.

—Yes?

She sees a flicker of embarrassment in his eyes.

—How about a dollar? That's probably standard church bazaar price.

She peels one off the stack and gives it to him. He puts it in his front jeans pocket. She kisses him again, more lingeringly.

She gives him another dollar and this time puts her hand on his shoulder while she kisses him, and just touches the lowest curls of his hair against his neck. He looks again up and down the street. Two men passing look away. She checks out the street too. Then she steps out to face him, plants a boot on each side of his sneakers, and slowly pulls another dollar loose. She folds it, and tucks it with two fingers deep into his jeans pocket. Leaning in, she finds his mouth again. Her tongue rolls slowly over his lips. The tip flutters between and he opens to her. She pulls back slowly.

—God damn, she says softly.

She puts another bill in his pocket.

One hand on the wall at either side of him, she lets her thighs touch his, her pelvis press what's in his jeans, her belly lean in against him while she kisses with her tongue slowly thrusting deep in and out of his warm, wet mouth.

—Hey, he says.

—I didn't do anything but kiss you.

—The hell you didn't.

But he keeps his half-closed eyes on hers. She takes the five from her dwindling stack.

—I won't lay a hand on you.

With a steady smile she puts the end of the rolled bill under

the edge of his pocket and delicately taps it down in with the end of one finger. His shoulders are against the wall, his curly hair spread on the brick. This time when her mound nudges his crotch, there's more there. She pulls back slightly and with a soft intake of breath he pushes close against her. Her return weight moves his buttocks back onto the wall, but then she removes herself subtly from the proper contact—he finds it again, and rubs. This kiss falls on his neck near the shoulder. It strays by millimeters till he sinks down slightly along the wall, pressing out harder at the hips. Then it takes on an edge of teeth. His breath comes out in pieces.

She pushes the delicious numbness in her crotch up against his ridge a moment, then backs away. He opens his eyes. She looks into them, breathing raggedly.

—How many is that?

—How many what?

She smiles delightedly.

—One, she tells him.

—One, he repeats. She kisses his panting mouth and he struggles for breath around her tongue. She shoves up and down on his bulge, keeping her mouth open and breathing through it, but with her tongue lying on his. The rhythm of their breaths in each others' mouths heats her. Then she feels his tongue move—around, up over hers, into her mouth. It's very soft. She closes her lips gently as she lets her breasts touch the buttons of his shirt pockets. She feels she is surrounding his whole body, small and strong and pushing against the trap her thighs and arms make, without wanting to get free, but only be more securely prisoned. Wet runs out of her. When she notices that the three boys have moved between them and the sidewalk, she pumps harder at him. Her legs are spread too far around his, she realizes. Just then she feels his hand working between them. She shrinks back to let it pass, clamps it tight, gives way again. Finally she feels small fingers paddling in her crotch. They don't hit critical spots but the fact that they are there makes her hump harder. His hand twists and cups his own genitals, perhaps protectively. The added bulk between them gives her the

excrescence she needs. She feels the change in her cunt that is like the difference between warm sun and heat lightning. She abandons his mouth, gasps air, and wriggles herself urgently on the hard bumps of his knuckles. She builds quickly—she comes: globular lightning in her groin implodes, rebounds, sheets out over her whole body and jerks it like a puppet. She presses home and milks long surges of pleasure from her cunt. Finally she makes herself lean back.

She laughs. The whole episode has been carried off silently, without much obvious movement, the way she learned to do it in the dorm. Often men—and women—don't even know when she's come. But the boy is looking at her: he knows.

—Now how many?

—Two? he mumbles incredulously.

She pushes herself against his hand again.

—No, don't move, she says. It's good that way.

He moves his fingertips under his balls, and pushes out against her. Her mouth drops onto his collarbone while she applies herself again to his fist. She lets her tonguetip slide slowly down toward his tit, and he arches a little sideways, giving the lightest moan. At that, all her hip muscles tighten. She prods at him rapidly and in fifteen seconds the heat of her cunt coalesces again, makes her stop her breath and squeeze onto him, orgasm bringing a ferocious tenderness. She wants to run hands hard down his back, capture his ass and hug him into her, clasp him, carry him to the ground. She staggers a step back and,

—Three, he says, reaching for her, with a hand that turns timid at the touch of her flannel shirt. But she can feel the light pressure on her flank and leans upon him. She buries her lips in his curls, licks into the roots of his hair as she rubs off. There is a faint smoky smell to his hair; she wonders where he spent the night, and at the quick images, comes. She wonders if men fuck into him, and if he comes then, or not. She presses him hard into the brick. She is breathing heavily when she throws her head back.

—Four, he gasps, and his hand drops to her ass and presses

her still in. She continues rubbing, and feels his other hand under her, faster. The alien rhythm excites her; she sets up a sideways counterpoint. With a faint cry covered by the traffic noise, he arches hard between her thighs, again and again, and she closes her teeth on his lower lip. Another cry lifts her to the finality of his intervals. All her muscles stiffen, she tremors, and as he comes, breath cracking in his throat, she feels herself against a field of stars, of sparklers, of firework fountains. She grinds her teeth back and forth on his lip and he spasms help-lessly; she lets his mouth go, fucks on him while he rises to her. He gasps shallowly, with closed eyes.

—Yes! she hisses. Yes—

And comes. He sags and she catches him to her a moment, scraping a knuckle on the wall, still pulsing. There is a smell of come between them. As he gets his feet again she divides her last two dollars, putting one in her own pocket and holding one to him.

—How about special rates for a steady customer: two for the

Gary Epting

price of one?

He gives a breathy laugh, part disbelief, and takes the green paper.

A small patch on his jeans, surprisingly off to one side, shows wet.

They both look carefully up and down the street. But something of their own private universe still clings, behind the screen of the other three hustlers. She feels the spot on the wall, warm from his body. One arm around him she leans there, and kisses his cheek.

—How old are you really?

—Fourteen. She gazes at him. —Practically.

She sighs.

—*Certified* jailbait.

—They wouldn't do anything to a woman.

He is still panting a little.

—Like hell they wouldn't.

—Serve you right for ripping off an innocent little kid.

—Ripping off? You were paid handsomely for those kisses.

—"Kisses."

—I've still got one more coming.

The three other boys suddenly drift apart and walk toward the ice cream parlor two doors up. He pulls away from her and starts walking. She walks beside him, hoping that to the two cops across and down the street she will look like a mother or maiden aunt, girlfriend.

—So I'll take a rain check.

Looking over, she memorizes his eyes, of the lightest green, and the wildly curly hair that is a dark powdery spade-blond, his complexion almost the same shade.

The two cops walk by.

—This must be a scary way to live.

—*Sometimes*, he says pointedly, more than others.

—Next time I'll bring enough for a room. Are you here a lot?

—Only when I need money.

Irony.

She steers him around the corner onto Sutter, looks both ways, puts her arms around him.

—The hell with rain checks. They hug gently and it is he who turns his mouth to hers.

—You're terrific, she murmurs. Don't let anybody tell you different. She walks away, looking back once and waving.

C. M. Decarnin

*Photographs IV:*

# *Awakening*

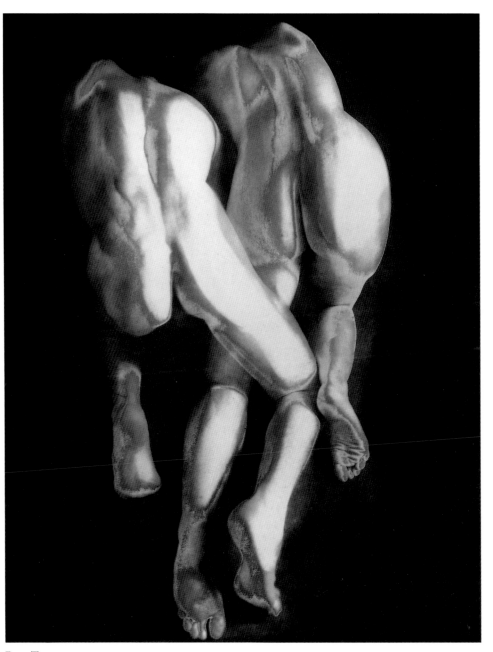

Ron Terner

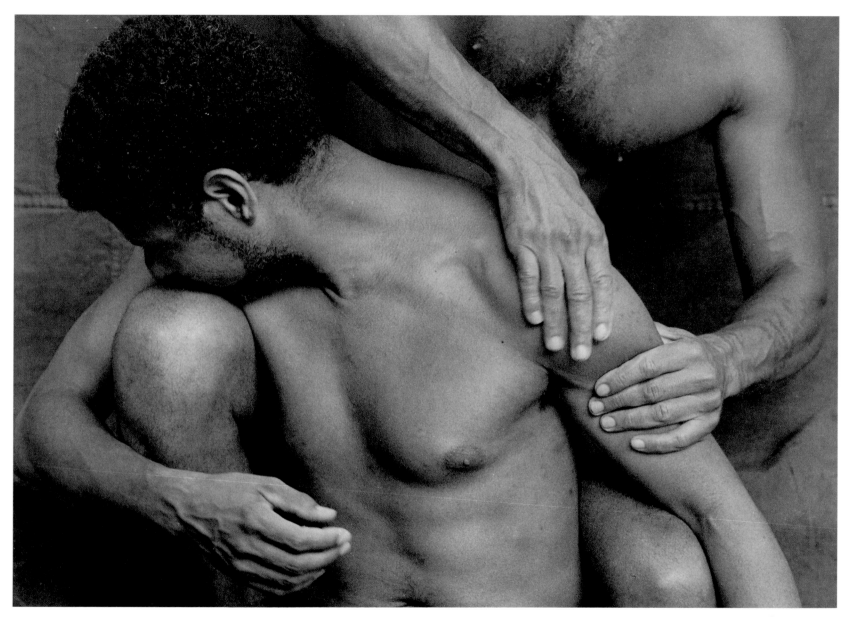

Martha Casanave

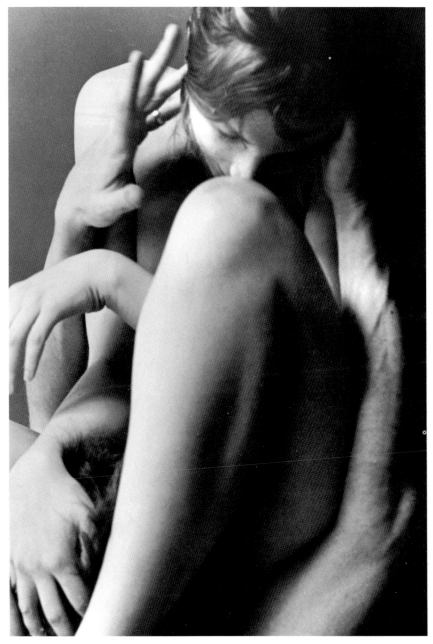

Ron Raffaelli

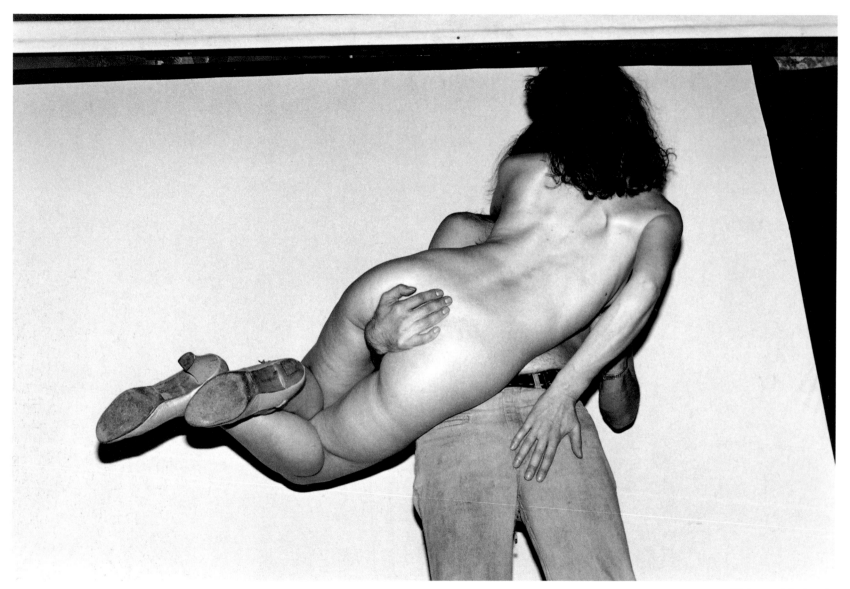

Vivienne Maricevic

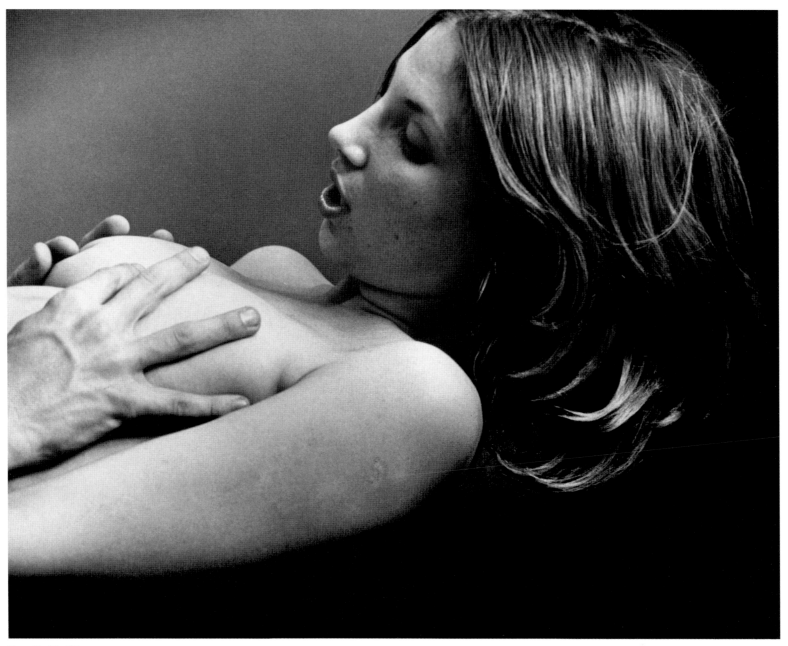

Ron Raffaelli

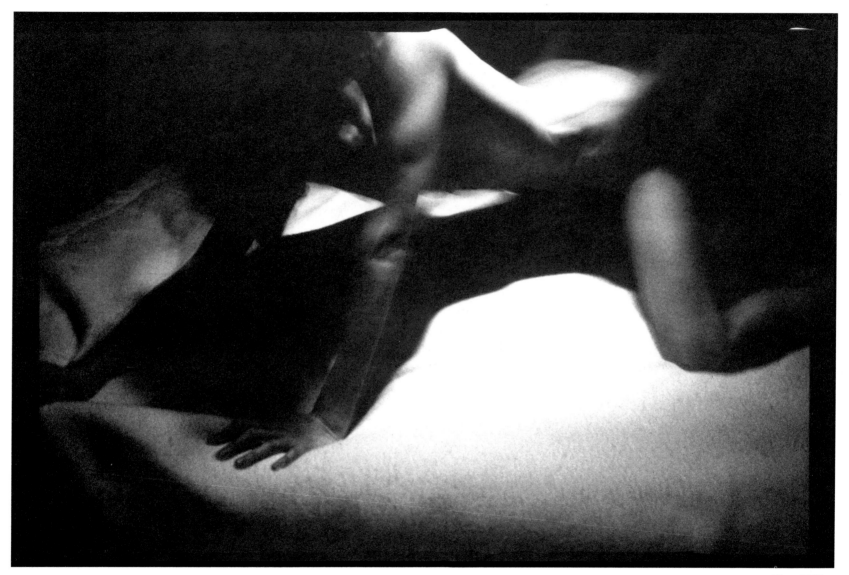

Tom Millea

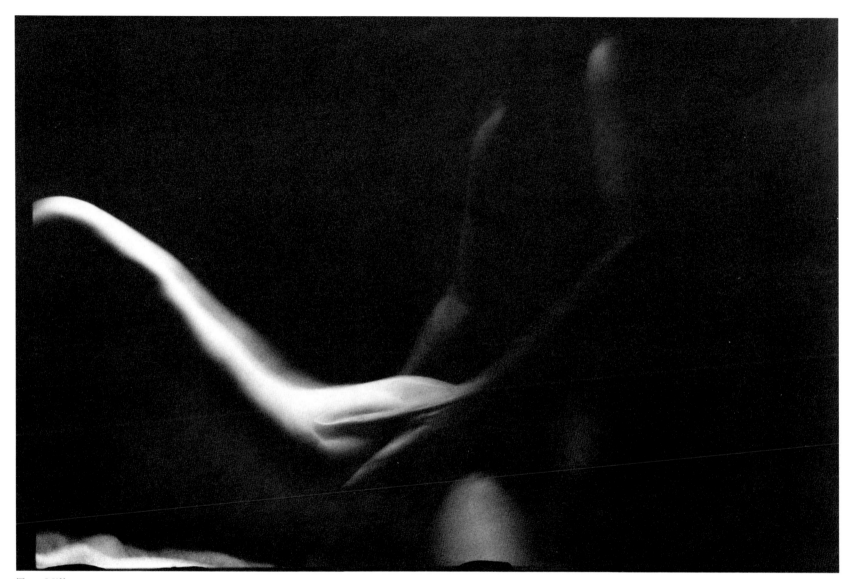

Tom Millea

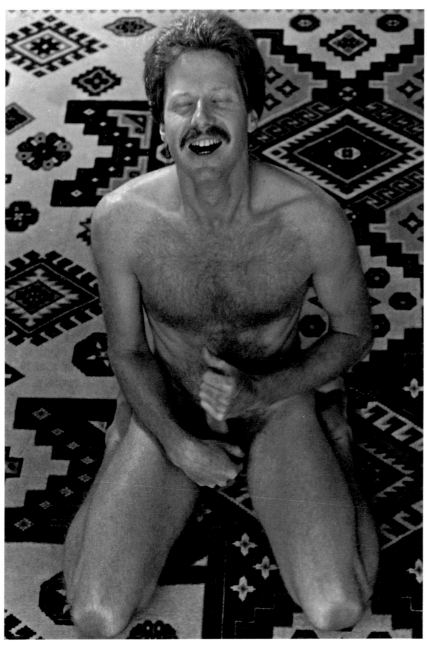

Jack Morin

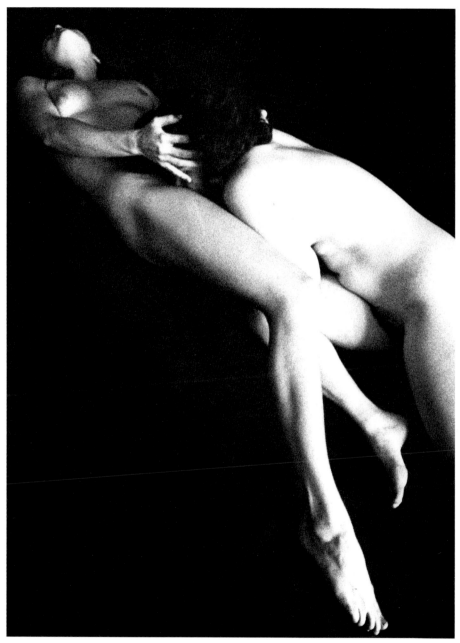

Ron Raffaelli

# *Why Do You Love Me?*

She asked me, "Why do you love me?" When I answered truthfully, saying I did not know, any more than I know why the earth turns and carries me on her belly, she was disappointed. So I said I love you because of this and because of that. All true, but not the Truth, and she was satisfied.

Sometimes I lie with her and feel her turn, and like the earth she seems vast, alive, and I surrender to her movement. When we love with our bodies it is a meditation, an immersion. We are two women exploring one another's homes—the surfaces, the interiors. There are turnings, tuggings, nippings, and strokings. There is passion rising.

I move over her, seeking the soft mountains of her breasts, the valley of clavicle. Trace the curve of her throat, slide along her cheek. *I love you.* I search the shapes of her ear, stroke her temple, tease her mouth. *I love you.* We roll and twist. She hovers, drops deeply into me. *I love you.* Now her back lies against my belly. My hands slide over the cushions of her breasts, over her belly, once so flat and tight, now rounder, fuller. My breasts press into her shoulders as I reach further down, down, caress the inside of her thighs, stroking gently, carefully, as I slide over her second mouth. Reaching under, around, I caress her buttocks. If only my arms were longer I could reach all the way to her toes, telling her with each movement, *I love you.*

I move from beneath her, encircle and slide down. My mouth finds her center; tongue slides, circles, my fingers reach inside. We sway and rock, sensing, dancing. I slow to prolong the moment, for she loves to hover on the edge of pleasure and then rise and swell, an ocean wave, cresting, powerful. She hesitates, suspended, then surges, succumbing. There is no turning back. I cling, tossing and tumbled.

At last I move over her. Let my body down slowly, sinking into her softness. She is crying. I feel our strength and delicacy mingle and I am filled, streaming with love. My juices run down her legs. Hugging me, she laughs at my incontinence.

I turn to her, my head drawn back just enough so that I can see her eyes, and ask, "Why do you love me?" She smiles and answers hesitantly, "I don't know."

Lauren Crux

## Poems I:

# The First Soft Touch of You

## *Tell Me an Erotic Story*

"Tell me an erotic story,"
she says as she puts
my penis into her mouth.
I can't think of a thing
as she tongues the tip,
moving my shaft
with one hand.
When I go into her
she palpitates
and we simultaneously
quiver when I come.
A single drop
hangs from the tip
like a pearl.
Next time she asks
for an erotic story,
I will give her this.

Arthur Knight

## Exclamation Points

I watch you washing dishes,
the top half
of your pink nightgown
folded around your waist.
As you bend over
your breasts sway
above the soapy water,
nipples like stars.
Outside it's night.
I remember the first
soft touch of you.
Yesterday afternoon
you pretended you were
a student of mine
while we made love.
You called me professor
and said you were
having trouble
with exclamation points
just as I went into you.
"Here's an exclamation point!"
I said, and you told me
you hadn't seen me
smile in a week.

Now you plunge your arms
into the warm water, silk
rustling around your hips.
I never thought
someone doing dishes
could be so interesting.

Arthur Knight

Greg Stirling Gervais

## Twenty-Six

The phone rings,
and you tell me
it's your mother
as your fingers
move my penis.
The light comes thru
the large bay windows,
and your mother's voice
evanesces.
You tell her, "Being 26
agrees with me,"
as my penis
slides into you.
"It's a good age."
I think so too,
moving slowly, gently,
feeling your fingers
tighten on my back;
you keep me
inside of you.

Arthur Knight

## I'm writing poems on you

I'm writing poems on you
all these kisses small bites my hands on you
my tongue tracing starfish on your skin
that's what I'm doing
I've hardly begun
there's a history of springtime I want to lick across your groin
a sparrow song behind your left ear
dawn on a mountain across your toes
my cunt is lined with love songs
and I'm scrawling valentines along your cock
it feels so good right now to be a woman, to be a poet
wait! I'll tell you about it all the way up your spine

Lenore Kandel

## My Lover's Cunt

My lover's cunt
Is 'bout four miles deep!
I can reach in there
With my whole hand.
I can play in there
For half-an-hour
At least!
And she
Comes
And she Comes

And she Comes some more!
She floods my hand, my arm
My bed
With her come—
And then—
She comes again!

Then she pushes up
From four miles down—
She almost shoves my hand
Right out—
With just her cunt,
Yeah, just her Cunt!

But I hang on,
I play some more—
And then—
She comes Again!

Dreaminhawk

## Nipples and cocks

Nipples and cocks
nipples and cocks
Nothing tickles the palate like
nipples and cocks

Lose your appetite for
clippers and clocks
by trying a tipple of
nipples and cocks

Up with your T shirts
Down with your jocks
Tempt your taste buds with
nipples and cocks

Don't riddle your brow
or rot in your box
It's nicer to nibble on
nipples and cocks

No need to be fancy
or unorthodox
Just try a plain diet of
nipples and cocks

Nipples and cocks
nipples and cocks
Nothing tickles the palate like
nipples and cocks

James Broughton

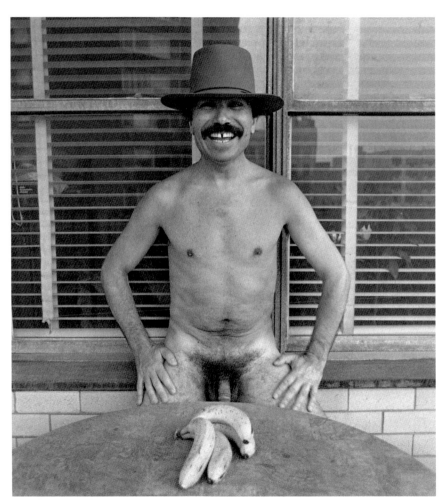

Vivienne Maricevic

## Like Nothing Else

Almost twelve o'clock
your parents asleep upstairs
your new lovely dress
around your waist your thighs
pressing & pressing against me
ears your back
a cathedral your neck
white your cheeks red mouth
open lips wet nipples majestic
sighs quicker & quicker
then nice

            Jerry Hagins

## When you're gone

When you're gone
pulsating shower spray
and water bills too high

            Cheryl Townsend

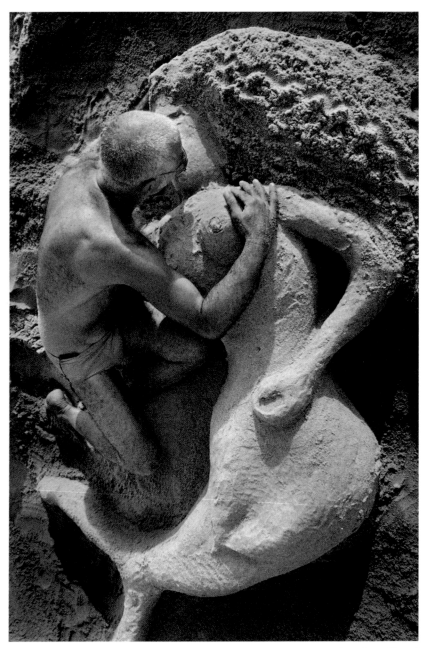

Stephen Siegel

# *This is for every man who licks*

This is for every man who licks
his shoulder during solitary sex,
rubs his beard against the stripey
deltoid muscle or bites himself hard.

This is for the woman who at the body's
buffet touches her breasts one at a
time then reaches for the place
she has made clean as Mother's kitchen.

Masturbation should be as exciting as any
heavy date: have a drink first, lay out
some poppers, open that favorite book
to the most shameful passage because
without blessed shame nothing is
as much fun.

And please don't jump up afterwards
and rush for the washcloth like all
the relatives were on the porch
knocking, their hands hot from
casseroles and a cake with God's
name on it.

Rather lie there, catch your breath,
turn to yourself and kiss all the nimble
fingers, especially the one that has
been you-know-where, kiss the palms
with their mortal etchings and finally
kiss the backs of each hand as if
the Pope had just said that you are
particularly blessed.

Ron Koertge

*Photographs V:*
# Sex Play

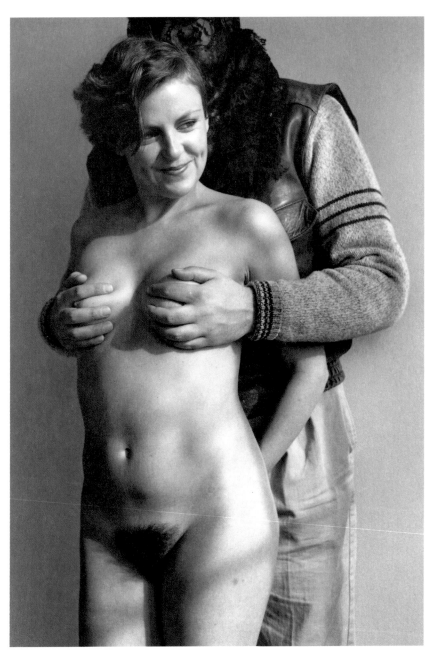

Vivienne Maricevic

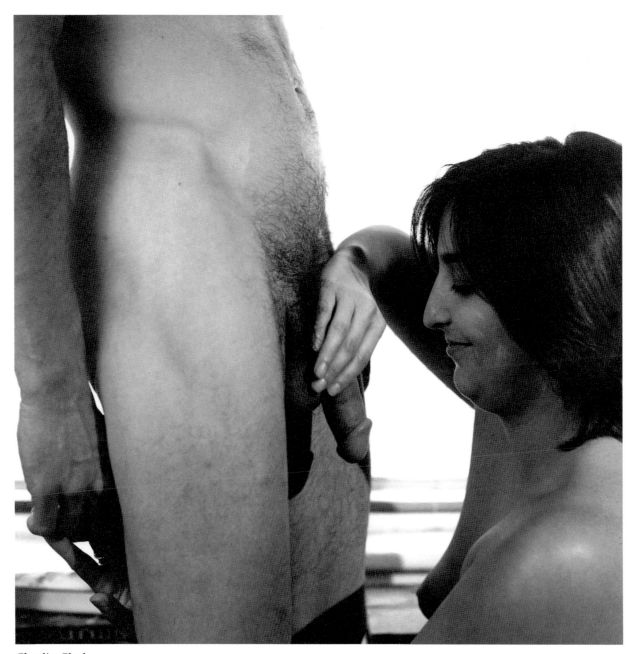

Charlie Clark

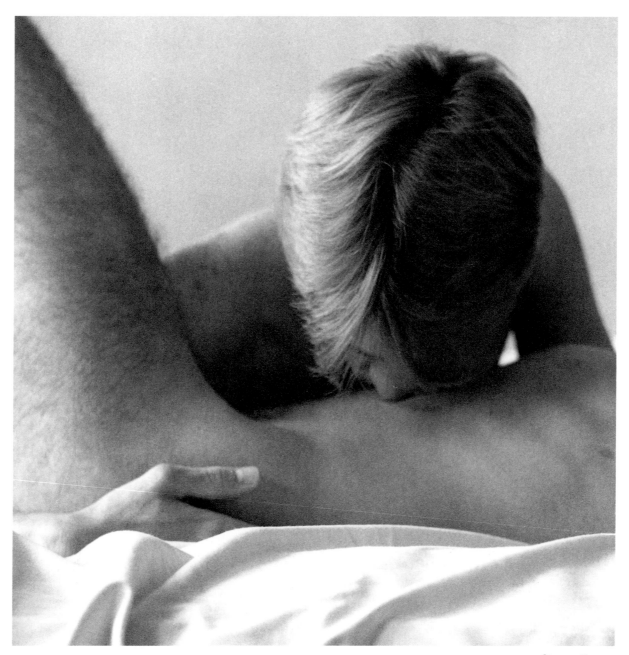

Steven Baratz

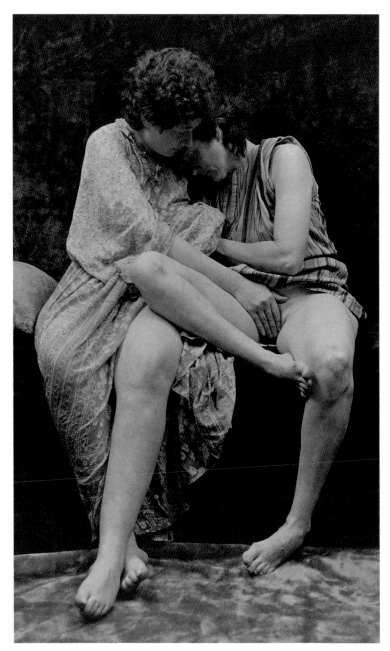

Tee Corinne

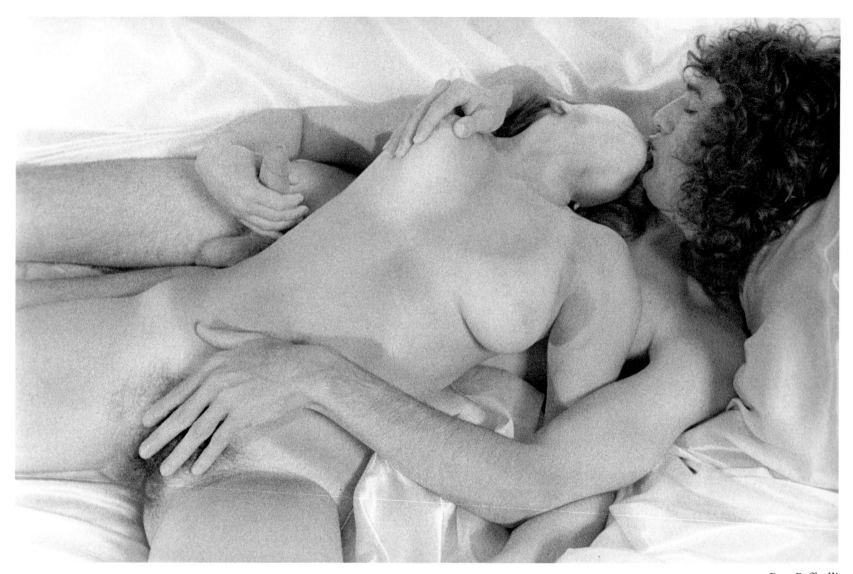

Ron Raffaelli

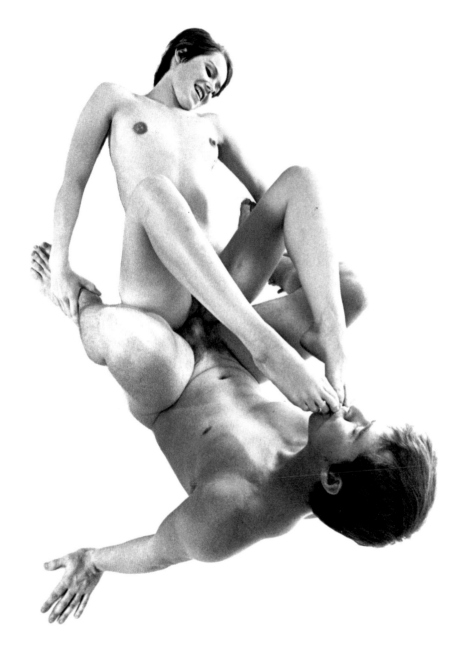

Ron Raffaelli

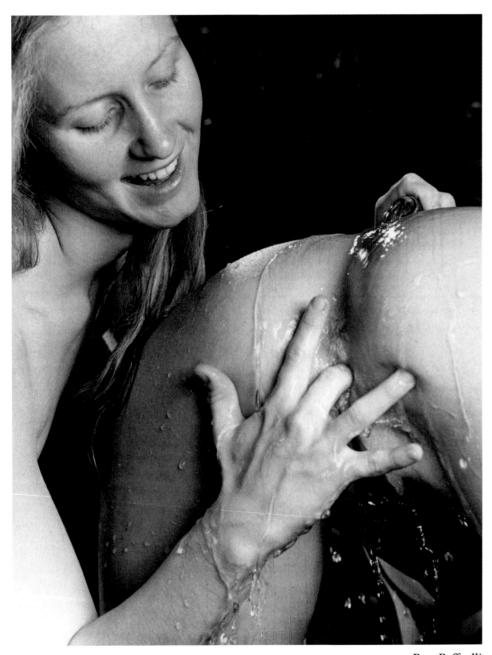

Ron Raffaelli

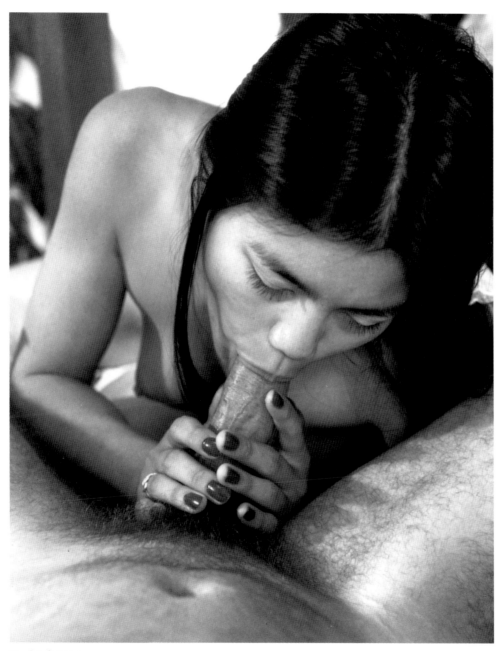

Paul Johnson

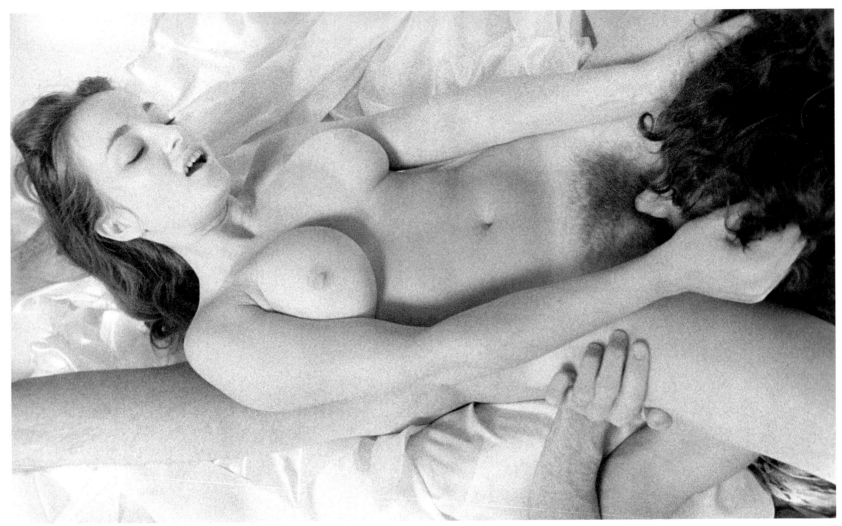

Ron Raffaelli

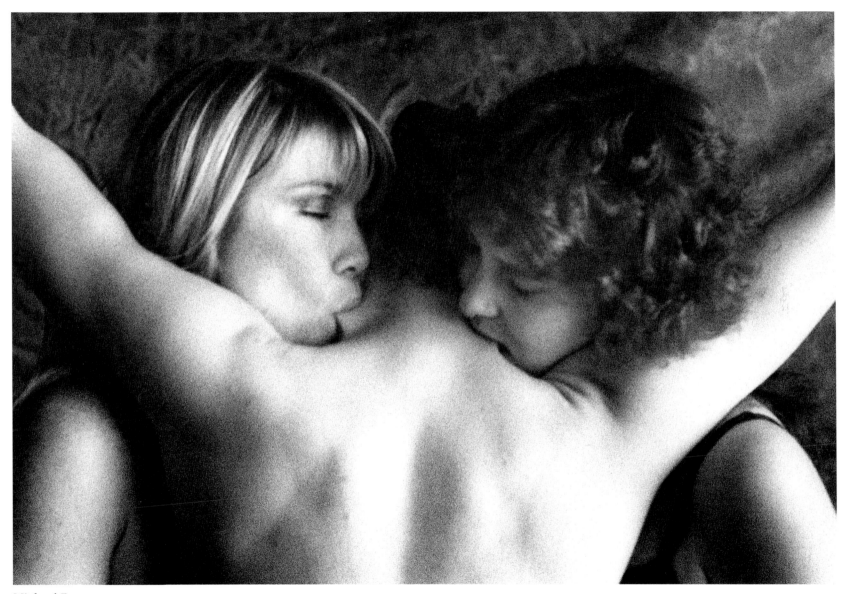

Michael Rosen

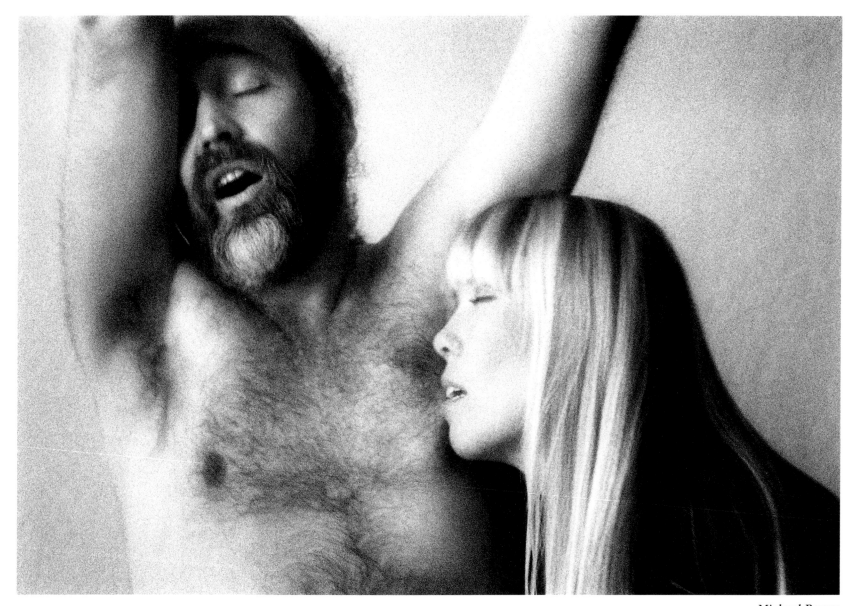

Michael Rosen

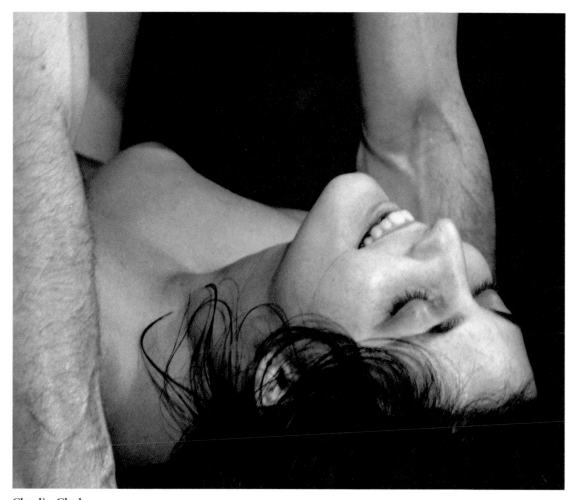

Charlie Clark

# Walkin' My Baby Back Home

Saturday morning and I woke at the usual time, just before light, even though the radio wasn't set. The little boy had gone to stay overnight with his school chum. We'd had some wine and a nice dinner, gone to a movie, and being a staid old couple, tired from the long week, came home and went right to sleep.

J was beside me on her back, breathing easily. But she must have sensed me awake, because she partially awoke, and we began our morning ritual. She turned her back to me and stuck her bum out against me, and I rolled over on my side, facing her back. She lifted her head and held her long hair out of the way so I could slip my lower arm under her neck. I put my upper arm loosely over her, and she snugged her bum up against my groin. (She's British, which is where I get that very useful and satisfying term, bum.)

She was instantly back asleep. I was wide awake and in the dark began to have my favorite fantasy: that storms of fortune had cast me together, the night before, with a young woman I scarcely knew, and we had had no choice but to sleep in the same bed that night. I would of course have made no advances, not wanting to take advantage of the situation, but now as I awoke, I could see that in her sleep she had moved her body against me. Did she mean it as an advance? Or was it an involuntary action on her part, part of her unconscious ritual with her own man in some distant place? I froze in position, afraid to move, afraid that at any moment she would awaken and jerk apart from me, angrily. But she continued to sleep, and I began thinking about her bosoms almost within touch of my fingers.

Finally I could no longer resist, and very gingerly I felt with my hand, and found one of her bosoms had come out from her loose top. I touched it gently, felt its weight and curvature, and the particularly smooth texture of the skin. Very carefully, so she would not awaken, I reached around with my other hand and found her other breast through the material of her nightie, and I stroked the two gently, in opposite directions, and felt the nipples rise up, and I stroked both breasts so that the palm of my hand rubbed along the nipples throughout the length of the stroke.

She stirred then, and I felt a moment of anxiety, but instead of spurning me she stretched and arched her back against me like a cat. I took that as permission, and now stroked her breasts openly up and down, and opened the few buttons of her nightie and stroked her torso up and down, feeling the strong boyish curves of her muscular chest, tracing the individual breasts up to their origins in the armpit.

It was slightly light outside, still sometime before sunrise. A dog was barking, but not even the first birds were moving. I continued enjoying the way her breasts felt. Why is that so satisfying? It must go back to memories of nursing, but also the smoothness of the skin must be designed to give pleasure to the touch, that being a first bond with the infant. Women enjoy being felt there. Odd to think of that difference between the sexes, that difference in the way the senses are arranged. I don't myself have any particular erotic sensation when my breasts are touched.

She adjusted the position of her bum slightly, so that my erection was framed between her cheeks. Could I (reverting to my fantasy) take that as an invitation to go the next step? Timidly and tentatively, as I stroked down her body, I continued the movement of my fingertips, so that they brushed lightly over the hair of her pubis. Sparrows began rustling around in their nest in the eaves right outside the window.

Now I began frankly stroking the hair, feeling for the cleft, and she moved her legs apart to accommodate my hand. I moved my fingers to sudden wetness, lubricated them, and then

brought two moistened fingers back along either side of the ridge of her clitoris. I continued this very gently and meditatively, rewetting my fingers when necessary, because there was no urgency of time, no radio about to come on, no Oedipally jealous son to wake up at the strategic moment and come to join us in bed. I wanted to stretch out each step as long as possible.

It was lighter outside, and the sparrows were chirping and peeping—what is the line from Eliot, the sparrows something in the gutters—and she grew impatient and began pushing back against me. But I enjoyed the leisureliness, the holding back, the teasing her for a change, instead of the other way round, and going back into my fantasy I began to dare hope she was going to let me in, she was not going to spurn me— though I still mustn't go too fast, mustn't pressure anything.

Suddenly she turned around toward me and pushed me on my back and got up on me. I like that too, and put my arms up over my head and abandoned myself to her. I sometimes think I ought to work on a fantasy of being the woman, but I've never quite got that one going, never felt myself invaded by the other.

Quiet squawking and peeping now from a family party of blue-jays in the yard, moving through the trees for acorns. I heard twigs that they knocked loose dropping to the ground. We were not making a very good connection, so I rose up, pushed her over, and got on top. She likes that—my impatiently pushing her off from her male role, forcing her down. But I was still teasing her, feeling the luxury of our freedom from hurry. I just touched her clitoris with the tip of my penis, my penis against her penis, and didn't go any farther. Is this like homosexual love, a form of it, dick to dick? Gide wrote that he always took his loving face to face. Then I moved down farther and just entered the mouth of her vagina, the fullest part of the head of my penis against the opening.

Back to my fantasy: Do I dare try to enter her? Will she suddenly recall herself and stop me? I heard a pickup truck start, the engine gunned a couple of times—my neighbor who goes to work on Saturdays at 6:30. I entered all the way, up to the

hilt, and heard her suck in her breath in a little gasp. I wonder what her fantasy is, or if she has one. I know she does sometimes, because she has told them to me.

We lay perfectly still, as close, I thought, as it was possible to lie. It was very pleasant—time, so much time, no hurry. The sun was beginning to rise outside. A flock of grackles were in the yard, moving through it like locusts, making their peculiar grackle sounds, their gabbling contact notes. Though I could not see them, I knew they were seizing dead leaves and bits of bark in their strong bills and throwing them up in the air, looking for the insects hiding beneath.

Again she was the first one to be impatient, and began pumping her hips against me. We moved together in rhythm for a while, slowly however—I continued to insist on the slowness—and sometimes I withdrew my well-lubricated penis and moved it back and forth on the outside, against her clitoris. I pressed my chest against her breasts, and then I did feel something, an erotic feeling, from my chest pressed against her like that, and even the first stirrings of my come somewhere down deep inside my body, wherever it starts rising from. (Kids now are spelling it "cum." Then would you say someone was "cumming?")

She opened her nightie to expose her breasts to me, and I bent my head down to take first one, then the other, in my mouth and hold the nipple with my lips and pull on it, then opened my mouth very wide, trying to keep my teeth from making contact, and tried to suck her entire breast into my mouth. I was feeling very oral. I disengaged the lower part of my body from hers and moved on down in the bed and put my hand over her mound. It was what she wanted and she spread her legs wide apart to give me access.

It was completely light in the room as I sucked her clitoris into my mouth, which must be something like sucking a cock, I speculated, come out of the same sensorium. I looked up, seeing the hair of her crotch, out of focus for being so close, then her white stomach, her chest, the underparts of her breasts, the underside of her chin. Her face was turned away from me, her

eyes closed so she could concentrate, but also I think because she feels silly watching me, or being watched by me, not knowing what expression to have on her face. I like to watch her when she is eating me—she is so pretty—to see her pretty face performing that intimate act for me. I felt my come rise up in me, and I worried that I would come prematurely against the sheets at the bottom of the bed, but it subsided again.

Someone was shooting in the woods across the field, behind the house. Squirrel season now? Rabbits? I stretched my tongue out and reached down and tried to put it into her vagina. Once, on a long slow morning like this, I blew into her vagina, and to my surprise my breath instantly came snorting and farting back out again, and she was so embarrassed she got furious with me, and it ruined the whole morning. I wouldn't try that again.

I began working steadily, licking against the top of her clitoris. This was the way, to keep doing this in exactly the same way, slowly, not rushing, but dependably, tirelessly, so that she could concentrate on working towards her climax with complete confidence that I would do my part. Many women don't come from screwing, but almost all come this way. In my experience, and I thought back, maybe half came by screwing and the other half this way. No one had ever written this, but I had a theory it was the shape of the cunt. Cunts are very different from one another, and some have the whole apparatus very small and close together, so that vagina and clitoris are nearly touching, so the clitoris is rubbed during screwing. Others are more spread out, and so the clitoris needs its own rubbing, and can't be reached from the vagina.

"Don't take me half the way" J was singing the other day. I worked steadily. Sparrows, grackles, and bluejays. Certainly not a very impressive list of species at this time of year. I heard a crow cawing. Four species. I liked it that she let me go on and on. It meant that she was really enjoying it. Otherwise, after a while she would get embarrassed at the time it was taking, and stop me. But I liked doing it. I liked my absolute control, my dependability and tirelessness.

Sometimes we would do it a different way. I would have my dick in her and rub her clitoris with my hand, or have her rub it herself, so she could come while I was in her. It was nice when we could do it, but it seldom worked—me coming or losing my erection long before she was ready. Still I liked it this way. I liked being close to her cunt, feeling her absolutely still at first—then, towards the end, beginning to pump slowly against me.

The hairs of my beard pushed back against my nostrils, and I had to work hard to suppress a sneeze. There was a *splik splik* in the back yard that at first I thought was a downy woodpecker, but it was slightly harder, sharper—a hairy woodpecker, I'm quite sure. It was working on the dying red oak tree. Has anyone noticed that here in the mid-South all the red oaks are dying, a black mould under the bark? Will they all go, like the elms did farther north?

My right arm was going to sleep, but I hesitated to shift my position because I didn't want her to begin feeling guilty, thinking I was uncomfortable. I felt it go from pins and needles to numbness. What happens if you leave it? How long can your arm live without blood before gangrene sets in? Thirty minutes? An hour? Could you voluntarily leave it, or would your body send signals making it intolerable to you, find some way of saving you in spite of yourself? I have often awakened to find my arm in a position where it had gone to sleep. Some signal in the body woke me to warn me to move my arm.

Then I did move, changing my position, flexing, making a muscle of my arm to pump blood back into it. She took the opportunity to change her position too, moving her bum and putting one leg up over my back, which opened her legs farther apart, showing me what she wanted me to do. I liked that, when she made signals to show me what she wanted.

I brought my left hand down and rested it casually on her buttocks, inside the crack of her bum. After a moment, I moved it and put two fingers deep inside her cunt, and she sighed. When my fingers were good and wet, I withdrew my hand and put one finger gently on the crinkled skin at the opening of her bum. My tongue was not stopping all this time, but continued

its steady rhythm in exactly the same place.

She began breathing faster. I left the finger there, and let her imagine what I was going to do, and how it would feel, because I know the inflaming power of the imagination—on me, at any rate. Then I rubbed the opening of her bum gently, and she almost seemed to take my finger in, it went so easily, and I pushed my finger, my middle finger, all the way up her bum, and then I put my index finger up her vagina as far as it would reach. She was pumping against me and moving her head back and forth. I moved the two fingers like a scissors, and I could feel the tips of the two fingers touching together through the thinnest membrane of skin, and it was clear to me once again that the reptilian cloaca is still there—that mammals have grown this thin membrane of skin to separate the vagina from the anus, but that these are merely the two modern chambers of the primitive cloaca, from which egg and excrement both came.

Ooo, she moaned in anticipation, and then she was coming, the vagina flexing tight on my finger, and her clitoris so sensitive she couldn't stand to have me touch it any more and tried to pull away from me. But I pursued her with my tongue, touching her, making her cry out finally, and then she pulled me, my whole body, up on top of her, and I went into her quickly so I could be in her when she still had sensitivity from coming, and it was my time now, to put myself at whatever angle felt best, to take as much or little time as my body wanted, and before I could wipe my mouth off against the pillow she was kissing me deeply and giving me the whole of her tongue with all its slime and smell upon it, and then I was no longer thinking at all.

We had not exchanged a word, and afterwards we would not say a single word about it, rather get up and have breakfast and go on about the day. But perhaps sometime after dinner tonight, when I have forgotten all about it, she will look at me for a moment in a special way, and come over and put her arms around me.

Norman Lavers

# Photographs VI:
## *Male Nudes*

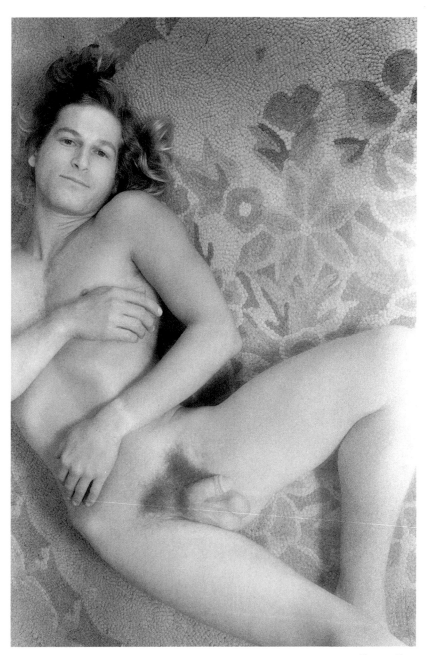

Gypsy Ray

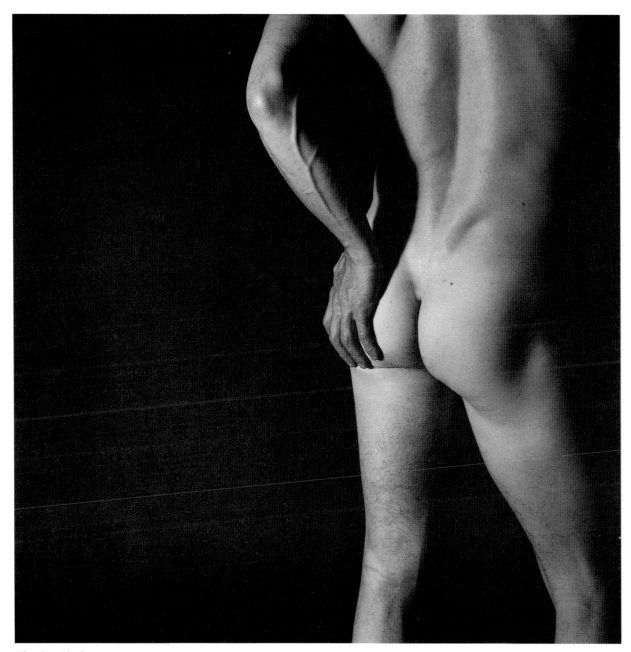

Charlie Clark

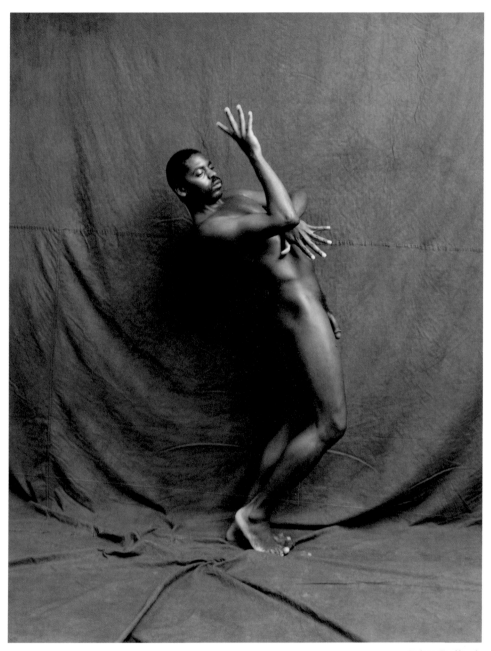

Edna Bullock

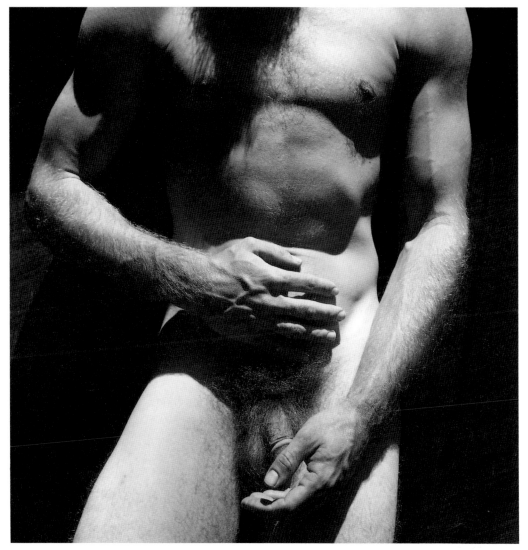

Gypsy Ray

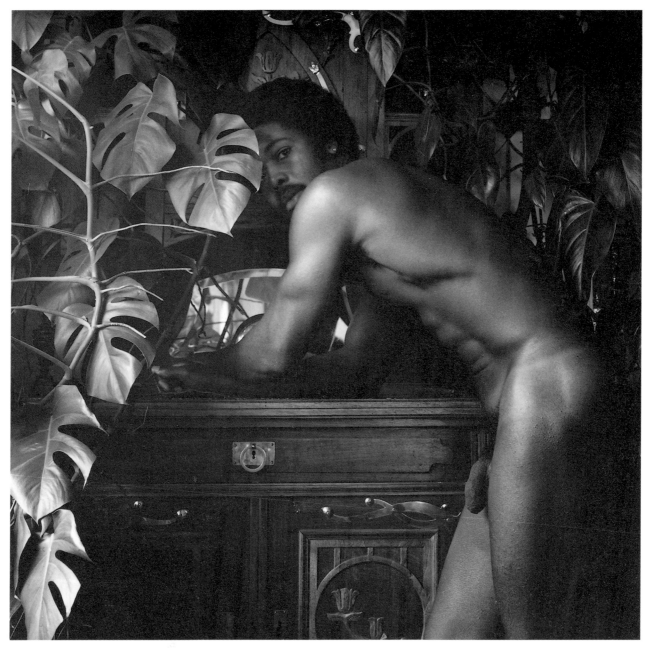

Gypsy Ray

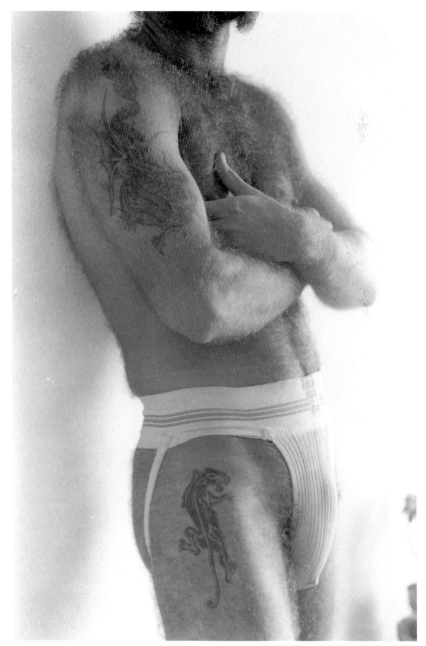

Greg Day

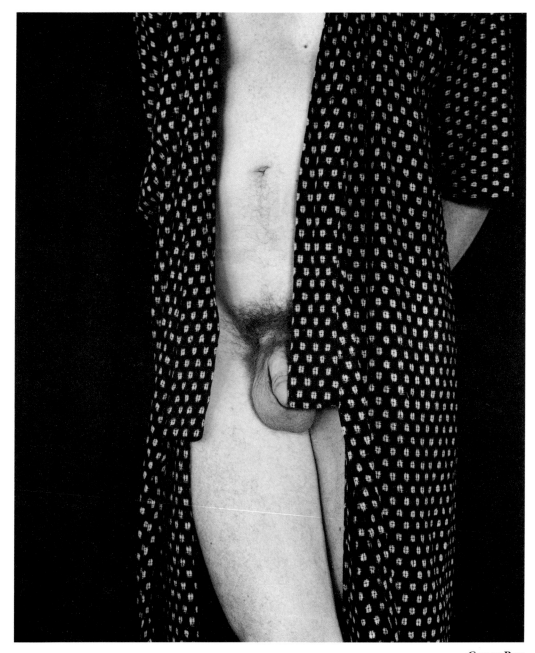

Gypsy Ray

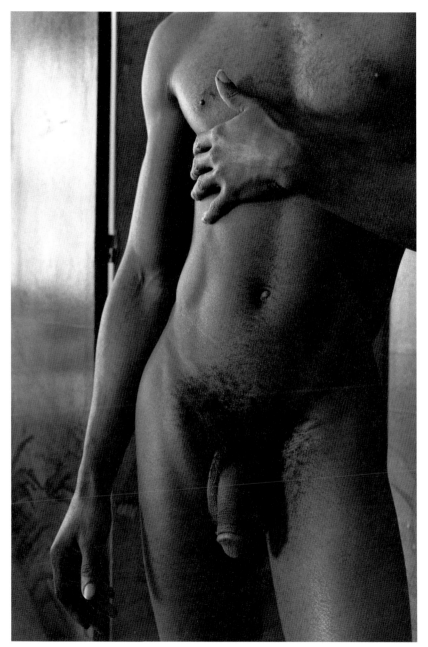

Morgan Cowin

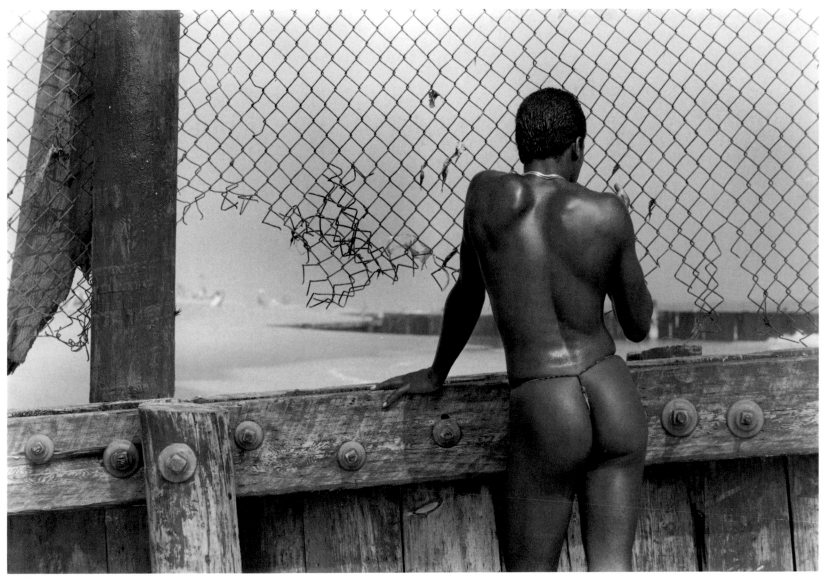

Terry Rozo

# The Work to Know What Life Is

At night, when you were in my body, when you were the tree giving breath to the night, I took it in. We lay there, your mouth open against mine with the breath going back and forth. I said, "This is the Amazon. I want to grow dark as a jungle with you, to feed all the myriad birds, to give off air to breathe." We lay together, dark woods feeding the universe, you breathing into me; I, taking your breath, holding it in my body, saying, "Life, Life, Life."

I wanted to be a plant form. I wanted to laugh under you like grass, to bend and ripple, to be the crisp smell, to be so common about you, to be everywhere about you, to house the small and be there under your body when you rolled there, where I was.

I wanted to be the animal form. I wanted to howl, to speak the moon language, to rut with you as the August moon tipped toward roundness and the blood poured out of my body. I held your penis that had plunged into me, and afterwards my hands were red with my own blood. I wanted to paint our faces, to darken our mouths, to make the mark of blood across our bodies, to write "Life, Life, Life" in the goat smell of your hands. You carried it all day on your fingers, as I carried your pulse in my swollen cunt, the beat repeating itself like a heart. My body had shaped itself to yours, was opening and closing.

I wanted to be the forms of light, to be the wind, the vision, to burn you like a star, to wrap you in storm, to make the tree yield. I wanted to drown in your white water, and where your fingers probed I wanted to hear each pore cry out, "Open, Open. Break Open! Let nothing be hidden or closed."

I wanted to be all the violences opening, all earthquake and avalanche, and the quiet, all the dawns and dusks, all the deep blues of my body, the closing and opening of light. I wanted to be the breath from the lungs of the universe, and to open your mouth with a tongue of rain, to touch all the corners and joinings. And when you entered me, when I heard you cry, "Love me, love me, love me with your mouth," I wanted to enter you with everything wet and fiery, to enter you with breath until you also called out and called out and called out, "Life, Life, Life."

Deena Metzger

# Song of Joy

spilling my cunt, spotting small brilliant flowers. I am ripe, dripping, and my blood sings, the song slapping between us.

Donna Ippolito

Fearful, wanting to hide my blood, I lie tight. Your tongue to me, licking at my cunt, everywhere tasting. Fearful, I lie tight, whispering stop, won't you stop. I lie tight, wanting to close my legs, hide the shame, the feeling I am an odor and a stain. I lie tight, fight the blood, squeeze shut my pleasure, hating the blood. I try to push your head away and it lifts to look at me. All smudged, it lifts. My blood is all over your face, I say, touching it.

This blood, this blood, it must be me. Woman bound, breasts swollen, hips more round. I fight this blood, squeeze away my pleasure, then drown in waterfalls spattering red. Blood rapids carry me away, their force more than the fear, and I begin to meet the blood, unlock my fingers, unlock the terror in my spine, my cunt. Finally, I stand on the blood as though it were earth.

Blood soaks the sheets and I don't care. *It's only blood.* It's only my brightness. It's only the thin wires which feed and heal. It's only ourselves making ourselves, thumping through the body. The pump of blood, of hips, of air. Eat blood, know blood, see blood, taste blood. I lie in it, lie against it on you, feel it damp, feel it crusting, and I know it's only blood.

You wear my stain exultantly. I could bloody your pale hair with my cunt, the blood covering everything like some kind of joy dust. I open my legs, offering you not my cunt but my blood. And you take all of me with pleasure.

You are so smooth this way, slippery and deep. The glossy blood lifts us as you pierce me, light through a pane. I am

*Photographs VII:*

## Women in Nature

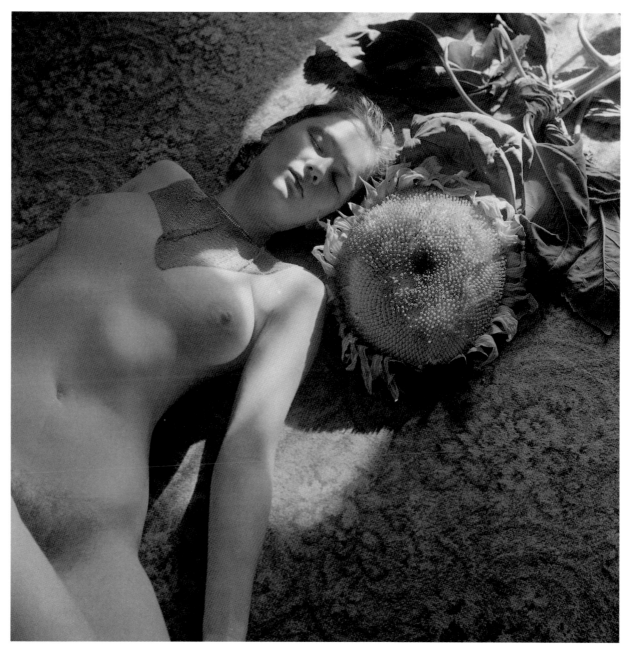

**Gypsy Ray**

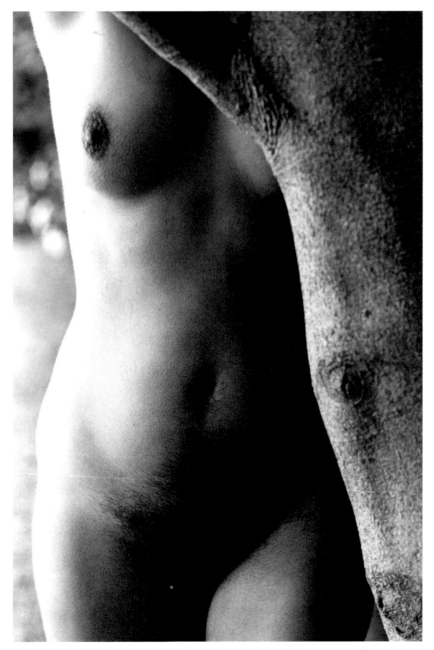

Hella Hammid

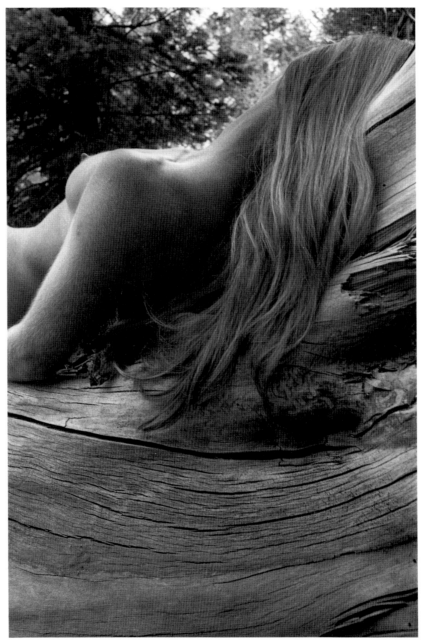

Morgan Cowin

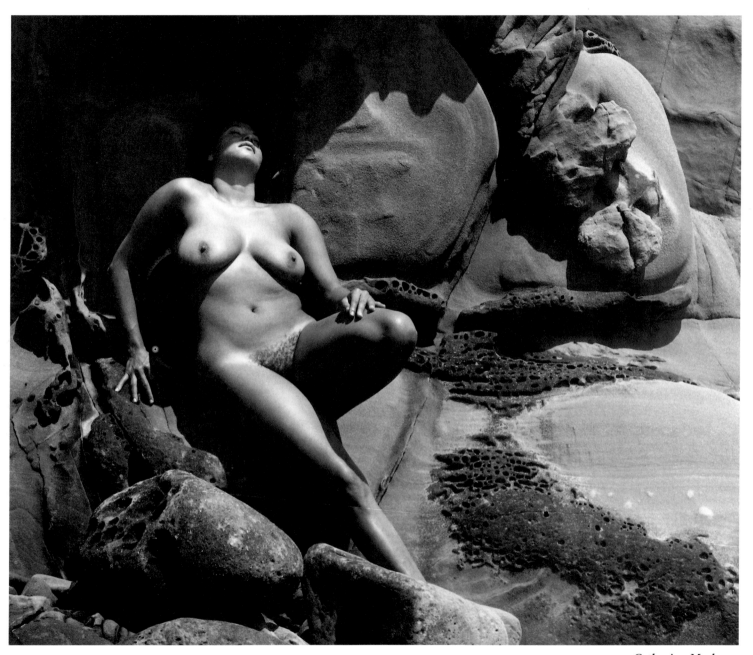

Catharina Marlowe

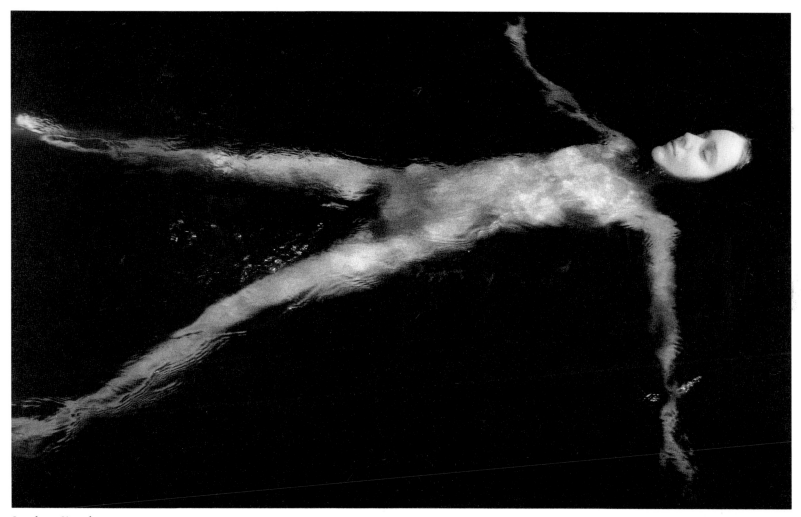

Stephen Siegel

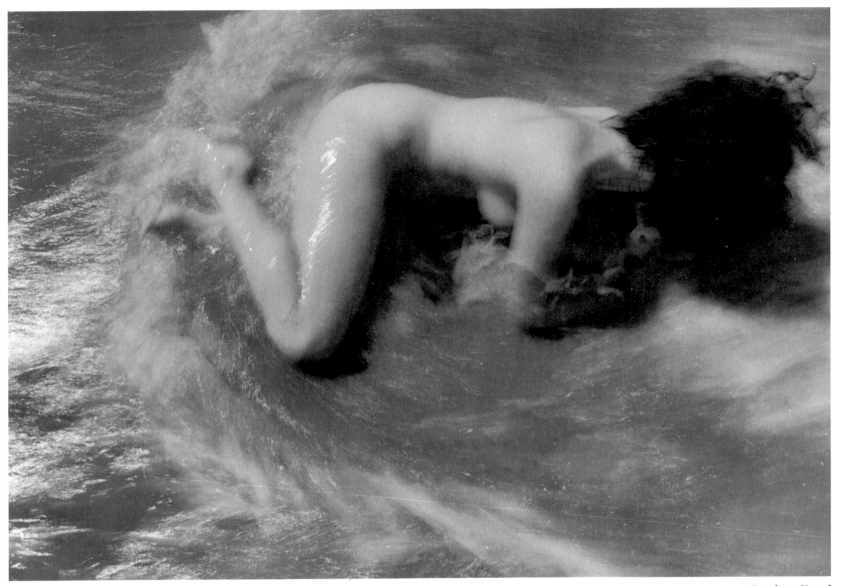

Stephen Siegel

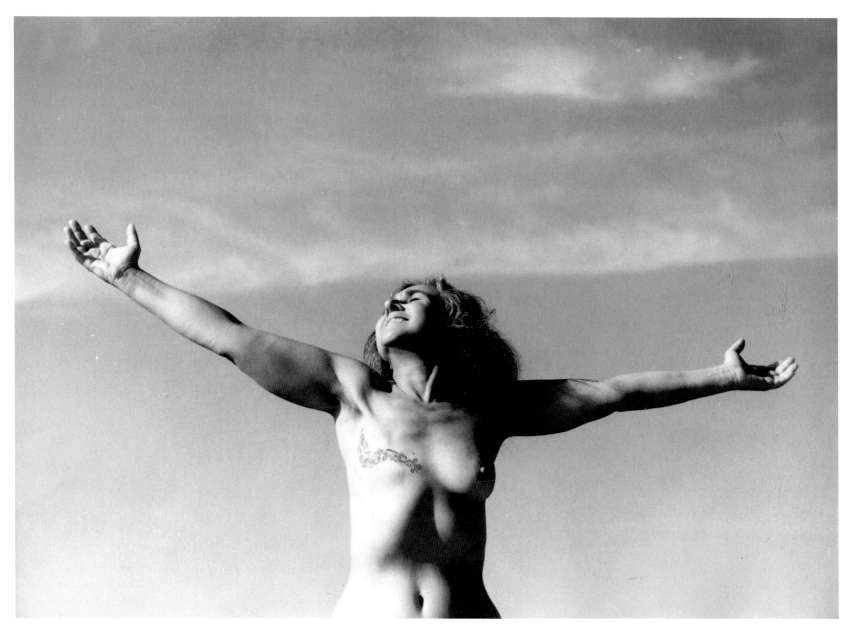

Hella Hammid

# The Birthday Dinner

I'm cooking this *for you*. Do you remember our coming down the stairs in that little inn on the Russian River? Such funny narrow steps with lumpy carpet, leading from the rooms upstairs down into the dining room. They were so steep, like climbing down from a castle room, the stairwell enclosed and dark, a tube holding that overpowering odor that made us stagger with renewed desire. I wish I could hear you describe it, you were always not so much imaginative as unique in your reactions—sometimes so refined, sometimes so vulgar, as when in that department store you shoved your hand into your pants, then brought your fingers up to rub beneath my nose, so quick that the clerk, who had just turned away to look for something, did not see.

But it was another fragrance there in the stairway, complementary, to be sure, with your almond essence. It was as deep, as variable, one of those odors that seems to exist in layers, into which one sinks—first tang, then salt, then something so creamily subtle it spreads the nostrils wide and opens the throat and sends the mind into a state of rapt attention—Ah, what is *this*? That was the odor in the stairwell.

We had fallen upon each other, up in that tiny corner room with its view of the rushing brown river, with a ravenous appetite, and stroked and sucked and bit until we arrived at a condition of splayed, dizzy, grateful satiety. We spread out on the bed, unable to lift an arm even, for fifteen minutes or so, and each cell throbbed happily.

We had reassembled ourselves sufficiently to think of eating dinner, to put on clothes—ah so soft on sensitized skin—and make it to the stairway: now as this odor enveloped us we turned to look at each other, astonished that we could be hungry once again for the liquid sliding, the touch of skin on lips, fingers in wet warmth.

Of course I would remember this now as I slice the onion, watching the white rounds fall over, one on top of the other, the smell opening like a flower in my head. Has no one ever written an ode to onions? Don't chuckle. There are many treasures in the world, ignored, casually used, denigrated. If you could hear this you would come out with that abrupt laugh of yours, from the belly. How I loved to join you in it. When you laugh you take a vacation from your sense of self-importance, that dignity which is really timidity. Ah, what light beams out of you then, what simple good humor so much more profound than your attempts at dignified composure.

Now the basil, sweet, high in the nose—flakes of khaki and brown and rust. I drop it in the pan after the onions. Oregano, broader, saltier, like a solid big sister there to back up the basil. Now the garlic, which I should have put in first: why do I always forget? I peel the paper covering from the clove, this see-through stuff that's delicate and strong. There is the flesh—firm, smooth, ivory-pale—and that smell like so many secret odors, fragrance of damp flesh folded on flesh, odor caught in coarse hairs over tender skin.

Truly there was no skin like yours. Silky and fine. I would run my hand up your back, hugging you, reach under your sweater to pet that fine warm surface. Pet it, yes, as one would touch a tiny kitten—so gently. And you would sigh, and turn sideways so that my hand slid around your ribs to touch your breast, that small round breast like the juggler's balls you liked to toss, their covers velvety. This velvety small breast with suddenly a hardness at its middle, tickling the palm of my hand. You would sigh, and start to squirm a little, and I would see your eyes, close up, staring intently at me. Big clear eyes of blue-green with flecks of chocolaty brown in them.

I stir, watching onions and spices and garlic sink into the thick scarlet sauce. I turn up the fire until the shiny surface roils and

bubbles, exploding in craterous eruptions. How deep and sweet the smell of the tomatoes, articulated now with the spices. I have put in a teaspoon of honey, as we learned to do, to soften the acid of this combination.

Now I turn to the vegetable awaiting me on the cutting block. What a gleaming queenly surface, a satiny robe of purple. The color is so deep that it seems almost black, like a gem, showing different tints in different lights. I stand it upright; it gives a substantial roundness in my hand. I make a cut at the top and slice down just under the skin, seeing the greenish-white interior damply exposed. The strips of skin fall on every side, and this gift is naked, ready to be taken, pulpy and opalescent-pale, with a greenish glow.

Didn't we do this for your birthday more than once? It is your birthday today. Of course I would remember. And how you stood before me naked that first night you came to visit me—a tall longlimbed woman with broad shoulders, your pink-white skin luminescent in the darkened bedroom. I knew how fine-textured it would be before I touched it.

Now I turn the cool bulk of peeled eggplant on its side, feeling its pithy texture, and raise the knife. One slice drops away and I see the brownish seeds embedded in a circle a little distance from the surface. Another slice. Until there is no whole but only segments, a pile of greenish-white slabs.

The oil is heating in the pan. I beat the eggs with water, watching them foam. Now I lift a slice and lower it into the yellow liquid, the foam spreading and then closing over it. Up and over and into the pan, the grease sizzling with a satisfied Husssssssssshhhhh. Another slice, coated, laid in the pan, received by the eager oil, which mutters happily now, spreading to surround each piece of eggplant. I wait until I see the brown flecks at the edges, then lift a slice to turn it. Such a crusty golden side is revealed, the oil rolling off it in shining drops. Striations of yellow and brown mottle an uneven glistening surface. The odor is of musk and sunshine, a smell far back in the nose.

I go to cut the cheese, in neat slices, white cheese, spongy and smooth as it comes off the knife, with a subtle smell. Patiently I wait for the eggplant slices to brown on the other side. You were so impatient, often, throwing your clothes on the floor, climbing on me where I lay on the couch, making small urgent sounds as you moved against me... until I gathered you into my body, held you against me and touched the places where you ached and yearned. Always caught unawares, you threw back your head—so soon!—and gave a startled cry.

The slices are soft now beneath that tawny crisp coating. I lift the first one, and bring it over the clay casserole dish. I lay it on the bottom, then bring a piece of cheese to cover it. The sauce bubbles busily in the pan, onions soft now, the spices lifting and ripening the tomato taste. I test a spoonful, letting it cool and then holding it in my mouth. Ah yes, just the right balance of sour and spice and sweet, the bright tomato taste alive as if springing up from underneath.

Carefully I dip a tablespoonful and spread it over the cheese on the eggplant slice. The sauce expands and rolls down over the crusty edges of the piece. Now the next slice—cheese—sauce. Methodically I build up the dish, layer by layer, watching the eggplant sizzling in the frying pan, laying the cheese slices on the eggplant in the dish, dipping the sauce. I am enclosed in this labor totally, all movement and coordination. I move one step this way, one step back, in a narrow dance. I reach and lift and stir, lift and place, turn and dip. An aureole of odors embraces me. They are together now but not yet merged. Intriguing. Titillating.

How we danced, you and I, our bodies knowing exactly how to move together, until admiring friends would exclaim, "You must *practice* a lot, to do that." We had no need for practice. Like the cheese growing soft on the eggplant slices, like the sauce sinking down among them, we moved from each other's heat, legs simply falling away and returning, bodies only as tense or relaxed as needed, neither of us leading the other.

The clay dish is filled to its brim now. I bring the parmesan and spoon it on, fluffy yellow like a dusting of pollen. All is ready now.

As the oven door closes, the expectation rises strong in me, a steady alert energy that gives me pleasure. In the living room I settle back in a chair and close my eyes. I used to feel this way waiting for you after each of us finished work and I knew you were coming to visit. I would enjoy that space of suspension. It was securely bounded by the certainty that you would come, and so I would lie back in it as if rocked in the essence of all our moments together. Then you were there, grinning from the doorway, slinging your orange daypack down off your shoulder, unbuttoning your green jacket.

Talk. Tea. Your laughter. All this entertained me and I did not desire you but merely enjoyed you as one does a treasured friend. Until at last we came to bed and there was your longlegged body covering mine, your skin, your bright direct eyes watching me. And then without warning we were lifted up and shaken by lust, and we sought out every part of each others' bodies, rubbing, sucking, moaning. Until I taught you to slow down, hold back a little, let the passion mature, let it gradually awaken every cell of our bodies, lift us almost to the point of release, hold it there, wait, begin again and lift it higher. I remember the sheen of sweat on your skin, your eyes intent and almost frightened at so much desire, as we looked at each other across a few inches of space that seemed palpable it was so full of each of our hungers. Then we moved again, carefully, skillfully. Stopped, staring in astonishment, moved again. Until we arrived at an intensity of arousal that would not be stopped. And there was a moment just before release in which we both held our breath, knowing at the next instant we would plunge.

Julie Ball

It is time. I go to the kitchen and open the oven, take out the clay dish and stand leaning over it. Its surface, pebbled with the yellow cheese, has puffed up, and the red sauce with its black flecks of spice bubbles around the golden slabs. The odor takes me, first the sharp tomato and oil of cheese and high spices, then the musky smell of the flesh grown yellow now in cooking. A great enveloping fragrance which enters my nose opening pockets in my brain, singing up around me like a symphony. It is a wide deep sufficient smell with all the lightness and heaviness I need, the articulation of tomatoes and spices, the surrender of mild yet distinctive squash. The anticipation intensifies now almost beyond my control. Only my knowledge of how hot this wonder is prevents me from plunging in a spoon and gobbling.

I lift a portion, steaming lustily, onto a plate, and go to sit at the table. While it cools just a little I breathe in, pleasuring myself with the smell.

The fork cuts easily, exposing the golden flesh under the sauce. I lift the forkful and move it toward my mouth, feeling the subtle prickles of heat on my upper lip as it approaches. I open my mouth and put it in.

Such a rooty, earth essence taste, all wreathed 'round with red deep pleasure and dark points of exclamation. My teeth caress this softness, my tongue receives this merging, this final yielding that leaves nothing separate or unwelcomed. It was like that with you, after the instant's pause, this plunge. I close my eyes and exist in the wonderland that is my mouth, giving in at last, riding this expanding ocean of joyous completion.

Sandy Boucher

# Cougar

Draped across a bench in her large, intensely private, walled yard, Cougar allowed her downy body to become beaded with sweat in the dry radiance of the overhead heaters. Her perspiration released an invisible vapor of perfumes from the oils that had been massaged into her skin. She let herself experience the sensual feel of the freed molecules as they wafted into her nostrils and teased her taste buds. Now and then a breeze, produced by hidden mechanisms at the edge of the yard, would spring up and evaporate the droplets of moisture, cooling her body as it caressed her breasts and thighs. Whenever the pacing presence of the newest lover-client, as he strode to the window of her house several yards away, intruded upon her meditations, she'd tense and have to begin over again. She was striving for a mood of heavy odorous sensuality for this stranger from the moon's sterile domed colony. Her intent was to be an overwhelming part of his welcome home to the lush fertile earth. He was one of the wealthiest mine owners; she wanted his patronage very much.

Above her a video flashed reproductions of erotic Victorian art. Cougar had spread her legs to let the breeze touch her genitals. The pictures were not arousing the sexuality she wanted. She stretched, turned her head to assess the situation in the house and then, looking back to the screen, her eyes widened. She stopped the frame, wondering why the sight of the slender darkhaired woman-child sitting in a walled garden, so pleasurably caressing her girlish slit with the ear of a sweet and tractible doe, caught her attention.

"Ah, yes," she thought to herself, "the zoo." She felt the blood begin a steady, tumescing flow to her vulva at the memories of animals mating, and hot, wet sex under a naked sun.

Some creature had been crashing blindly through the underbrush and Cougar and her companion, then-lover-client Zea, had leaned over the rail of their chauffered zoo transport to see better what it was.

An eight-point stag had burst into sight and had started trotting alongside their vehicle. His nostrils flared red, his eyes were glazed, and when he swerved into a clearing a little farther on, Cougar ordered the vehicle stopped. A doe stood in the circle of trees and brush, framed in the filtered sunlight. She raised her tail and turned her rear to the stag. Moisture was oozing from her vagina.

The stag's thick neck was engorged; the veins that created a thin tracery under his taught silky hide coursed with the hormone-filled blood that made him into a blinded rutting male. A pinkish, dripping penis was edging out of his hair-covered sheath. His rear end had begun a reaching humping motion as he slashed at the ground near the doe. At last he leaped her, grasping with his forelegs, and thrusting into her.

When it was done, Cougar could hardly speak. She and her companion and the driver fell to the floor of the transport and rutted as quickly as the two deer.

By the time Cougar had waded about in her reveries, her vulva were swollen and wet. When she went in to her new lover, she delighted him with her heat. As he moved in and out of her, she whispered fantasies to him, and he came in choking gasps to images of the golden sensual Cougar coupling with the tawny rutting deer.

The dark man was Sul Ad'd. Over the months he made her richer, and his passionate moodiness enchanced her own recent moods like a strange new spice. For prior to the advent of Sul Ad'd, Cougar had been spending more than half of her time muddling about in the sweet ennui of self-pity. By the time she was aware that she was delving too far and investing too much

in these emotions, her vocational role conditioning that she not show her feelings to clients had already overcome the possibility that anyone else would notice her personality slipping toward morbidity.

Cougar chose to believe she was suffering from "boredom— screaming, aching boredom." She would raise the thoughts to a subvocal level as she gazed into the mirror part of her bedroom wall. Practically incapable of wrinkling her face from its smooth porcelain-like cast, she resorted to expressing her emotions in a series of dialogues with herself. She never spoke out loud. Those words might go into the household computer for analysis. She told her wall she felt she needed more practice at the expressionless expression expected of her. Even as she let words flow through her mind, she stood there watching herself wonder if she should even allow herself the luxury of thinking.

"Wouldn't it," she grimaced internally, "wrinkle my brain?"

"Perhaps," she replied, "I should work at becoming as smooth inside as I am outside. Ah, but what difference? You," she told her reflection, "are a prisoner inside that fine-boned beautiful skull."

She felt mildly alarmed at a new habit of viewing herself as if she were standing to one side. She noted she was even doing that in crowds of late. So day after day she'd gaze at her sculpted face, viewing the pacings of her mind as she waited for Sul Ad'd to come have sex with her. Sometimes with him she'd forget about her prisoned mind. He'd tell her of life and death inside and out of a domed city. She'd tell him of her safe and never-once-endangered life. And she told him of Zea, the lover who had taken her to the zoo, who had given her the viewing crystal of ancient erotica, and who had delighted in feeding her strange ideas about men and women. That same lover had named her Cougar, laughingly saying her name would also become her totem. She had made the young Cougar stand in front of a mirror as she held up a portrait of the yellow cat so Cougar could compare it with the golden-skinned, golden-eyed primitive that stared back.

Sul Ad'd said her name was appropriate, but that sometimes she reminded him of the hot earth and a ripening wheat field on a blistering day. As he said those words, he visualized a huge stag grazing in the middle of the empty field.

One day Sul Ad'd arrived at Cougar's house laughing and leading a strange caravan that included a cage containing a tranquilized yearling deer.

"It's a cull from a zoo herd," he told Cougar. "I bribed the zoo keeper to put me at the top of the pet list." Pointing at the hapless animal: "They were going to feed him to the wild cats and I said I knew a Cougar who would like him alive. Do you like him? Do you want him?"

Cougar smiled a smile that said she was laughing with him, and walked around and around the cage staring at the staggering deer. "He's the most wonderfully beautiful creature I have ever seen."

"Good," said her lover. Then gesturing toward the other trucks: "That one has hay for him to eat, the next is the fencing and new plantings. I shall redo your compound for his new home." But as he watched Cougar staring in awe at the animal, he felt a jab of envy and impulsively told her so. At her puzzled smile, he felt his prick begin to swell. Then he went to work changing the yard area into a maze-like forest with a glen. Cougar was awed at the wealth that could transplant rare full-grown trees, and buy so many of the ordinary-looking shrubs genetically altered to mature within weeks.

Throughout the winter Sul would go to Cougar's and watch the growing relationship between the yellow-gold, lithe-muscled woman and her pet, now named Deer.

As Deer's first spring approached, his budding maleness erupted, showing first in the growing fuzz-covered antlers on his head. As the male hormones formed and filled his bloodstream, swelling his neck and thickening his shoulders, he started to respond to the estrogen-heavy perfumes of his owner. He would shiver in pleasure when she touched his flank lovingly, and would turn his head and bury his quivering nostrils in the hair beneath her arms, inhaling her odors, her perfumes.

When Sul Ad'd watched the two, raw lust would fill his mouth at the rut he saw building in the young deer.

Late in spring, with Sul Ad'd watching, her touchings and caresses found Deer's genitals. Pushing back the fur-covered sheath, she looked up at her heavily breathing and astonished lover standing on the porch. She slid her mouth over Deer's slippery penis. Deer plunged a bit, and then settled down into a gentle humping as she sucked and stroked his ejaculate out. Cougar became sexually hot, as she had as a pubescent girl watching and contemplating others at sex, thinking it something forbidden, nasty, and delectible. She put her fingers to her clitoris and exploded. Running her nipples along Deer's silky hide, she finally lifted her head enough to meet his puzzled gaze. She touched his snuffling nose. He was slashing at the ground with his hooves. Cougar flinched as he suddenly turned and bucked his way across the compound.

All summer his maleness grew. The antlers sprouted more and he rubbed and scraped at the itching felt-like covering. Not a tree or a wall was free of his mark. Each time Cougar sucked and played with his pink prick he'd hump into her mouth and hands harder. Cougar's own fascination grew until one day she told Sul how much she longed to have Deer penetrate her, and how afraid she was of his strength.

One time she spread musk oil on her cunt and leaned over in front of Deer's head. She didn't know if she was pleased or dismayed by the reaction. His nose shoving against her vagina nearly pushed her over. So she stood up and pulled on his balls and stroked the contents of his sheath until Deer's thick fluid dripped across her hands. Sul Ad'd went to her and entered her before she could make herself come. And as he stroked her and soothed her afterwards, plunging his fingers into her vagina as they lay on the ground, he came again—this time against her leg—while he looked up at Deer's damp sheath.

The next time Sul showed up at the compound, it was with another truck in tow. This one contained a pseudo-log, designed to hold Cougar's body face up at about the height of a female deer, yet safe from Deer's dangerous feet. He had it placed in the center of the glen, sideways to the porch where he liked to stand and watch Cougar and Deer. Then, scrutinizing Cougar closely, he brought out his next gift, a container of liquid. Setting it down on a table, he said it was the urine of an estrous white-tailed doe.

Cougar spent most of the afternoon watching Deer from her room. The bottle seemed to be in the center of her mind as a silent dare, while her eyes turned continuously to the log-shaped device in the center of the compound. Several times she walked outside and placed herself within the carefully contrived folds that hid her torso, arms, and legs from the potential slashing of hooves. Each time the sensation of having only her vulva exposed aroused her further. At those times Deer came up and sniffed at her, and once he ran his rasping tongue from her anus to her clitoris.

Sul was a silent backdrop. In his waiting he was perhaps more catlike than Cougar had ever been, in spite of her name. Finally he asked her what she was thinking. Cougar pointed to the battered trees with the remnants of dried skin from Deer's desperate attempts to clean his growing antlers. "He's so powerful."

But then she took up the container and a swab, and rubbed the contents around her genitals and into her vagina. She mixed it into her perfumes and added it to her oils, and had Sul massage them into her skin.

Deer reacted almost immediately when she went outside, her naked body glistening from the oils. He quivered at her touch, shoved at her with his head, nibbled her arm and neck, sidling his haunches in her direction. She ran her naked breasts along his side and again leaned over so he could smell her cunt. His tongue shot out to taste her, and as he wiped his tongue along her vulva she could feel him stiffen. He pushed at her and slashed the turf. When Cougar turned to see him, his nostrils were distended, the glaze of rut was spreading across his eyes. She moved quickly to the log and placed herself within its safety. Deer's confusion showed itself in his nervous dance around the log. His penis was beginning to unsheath, his rear

humping rhythmically as the odor of estrous doe filled his system. He tossed his head, his neck now a nearly straight column driving up from his shoulders. He had entered rut. Cougar's fear and awe gave way to the same lust she had felt in the zoo transport at the spectacle of single-minded sexual energy. She was shaking from her heat.

Deer reared above her, lashing out, and came crashing down with a leg on either side of the log. He was humping the air, seeking connection. The motion was so fast that Cougar froze. Her orgasm vanished in a surge of fear. For the first time in years, tears fell from her eyes and her face lost its eternal smoothness.

Sul was nude on the porch staring intently at Deer, his own hips moving in unison with Deer's. Sul's sex was engorged to bursting with buttocks squeezing together. His whole being was drawn into the sexual vortex of the driving Deer. At the moment the animal penetrated Cougar, Sul ejaculated, sending sticky drops onto the ground at the bottom of the steps.

At last Deer disengaged and stood, spent and spraddle-legged, a few feet from Cougar's head and closed eyes. Only the sound of heavy breathing filled the compound. Cougar heard Sul's step and turned her head to look at him. He was stroking his still-swollen cock between his two hands, his hips still moving— rhythmically fucking nothingness. His lips were drawn back in a rictus of lust. Letting go of himself with one hand, he went to the sated Deer and tugged at the retracting penis. He kept at it for whole minutes, trying to arouse the creature's passion again, still moving his hips, still squeezing his legs and buttocks together, pumping his own swollen prick.

When he gave up on Deer, he found Cougar's staring face and turned and placed his mouth on hers, his hands on her breasts. He pulled at her hair, her ear lobes, and pushed his fingers into her vagina, pressing the front wall against her ure-thra until she became again caught up in sex. When he started fucking her, putting his cock into the mixture of sweat and blood and semen, she finally came. As her orgasm subsided, the familiar sensation of stepping to one side to watch her life overwhelmed her. As Sul Ad'd stroked in and out of her, she saw her face regain its smooth, professional, and porcelain-like cast.

Wheatsinger

# Poems II:
# *One Velvet Skin*

## *Love-Lust Poem*

I want to fuck you
I want to fuck you all the parts and places
I want you all of me

all of me

my mouth is a wet pink cave
your tongue slides serpent in
stirring the inhabited depths
and then your body turns and
then your cock slides in my open mouth
velvety head against my soft pink lips
velvety head against my soft wet-velvet tongue
your cock / hard and strong / grows stronger, throbs in my
      mouth
rubs against the wet slick walls, my fingers hold you
caress through the sweat damp hair
hold and caress your cock that slides in my mouth
I suck it in, all in, the sweet meat cock in my mouth and
your tongue slips wet and pointed and hot in my cunt
and my legs spread wide and wrap your head down into me

I am not sure where I leave off, where you begin
is there a difference, here in these soft permeable membranes?

you rise and lean over me
and plunge that spit-slick cock into my depth
your mouth is on mine

and the taste on your mouth is of me
and the taste on my mouth is of you
and moaning mouth into mouth

and moaning mouth into mouth

I want you to fuck me
I want you to fuck me all the parts and all the places
I want you all of me

all of me

I want this, I want our bodies sleek with sweat
whispering, biting, sucking
I want the goodness of it, the way it wraps around us
and pulls us incredibly together
I want to come and come and come
with your arms holding me tight against you
I want you to explode that hot spurt of pleasure inside me
and I want to lie there with you
smelling the good smell of fuck that's all over us
and you kiss me with that aching sweetness
and there is no end to love

                                        Lenore Kandel

Betty Dodson

# *I want you*

I want you,
you whispered,
your mouth a pressure
against my ear,
the shape of your words
palpable,
distinct.
Your lips found mine.
I opened for you,
your tongue slipping
into the pool of my mouth
like a swimmer
coursing through water
each stroke deliberate,
discrete.
Deborah, you said,
*I want you,*
*I want you,*
your words became a mantra
my mind opened into,
entranced.
Your mouth moved down me
along the collar you unbuttoned.
I opened for you
like an animal
offering her throat.
You took my nipple,
your tongue grainy as sand

swirling in an eddy.
You laid kisses down my belly
interrupted by whispers,
*I want you,*
*I want you.*
Please have me, I answered,
my voice broken with pleasure.
I opened for you
my legs unfolding
like a child's fingers
around a small, shiny treasure.
*I want you,* you whispered,
your mouth arriving,
the heat of your words
on my vulva
making me come.

Deborah Abbott

# I Could Die With You

You sweeten my mouths
with the milk of you
My mouths so freshly sweet
with our moistures
part, open—fully open
soften to let all of you be

        Within me

O fertile generous milk
that you pour into my body
then drink back from my mouths

        Your milk

This rich milk of you
flows so readily
Its encircling heat—your heat

        Absorbs me

You, my cradle
rock the womb of me
connecting, covering us
with one velvet skin

From your bowels
your walnut voice

moans of our fusion

My being in surrender
melts into your lips

I could die with you

        Carolyn Kleefeld

**Greg Stirling Gervais**

# *heat drips from the*

heat drips from the
shutters    brilliant
yellow sun pulses
hot    shadows vanish
eyelids hang
heavy    disguises
melt    window
curtains blow open
balmy bodies
flow    trails of slow
smoke    hair falls free
sweat drops gather
slide    smells rise
heavy    rumble of
earth calling    your
thigh wants    I
follow salt down
sound of water closing
over head    all birds
still    the wind
stops    the world
we are gone

David Steinberg

Kaleiiliahi Henkelmann/Muller

# Nice

floating thru chairs
then opening
your hand
snakes in thru corduroy
my slip rides up the sun
makes the rug into a wool beach
sand    assapples    a wave of
thighs opening
skin prints a v on the rug your
knees go there
opening
and mouths suddenly too a
crack touch the pink smell
the sleek breathing flesh moans
a taste is nipples
bumping and your sail of blood
shove of bone tongue
travelling into this moist
lips opening the first bang of
hair and clothes rise from bodies
tremble the warm buttons rubbing
scratch of your mouth there
the damp nylon crotch
petals dissolving in a water my silk
hips you open and your fingers
under plunge so are pressing lips there
and your flesh
root shining

rocks your heat to my belly and my
legs spread so wide
greedy for the whole boat of you
in me your lovejuice dripping these
sloppy hills of cunt and you
put your good
hardness up me opening
skin rooms pounding
and circles slide your raw stem
my nails pull you
tighter in and the slap of licked flesh oil
waves lunging and teeth
that eat everywhere ramming
the slit wet
opening and spread so
wide and splitting bite the sweet hot ache swell
your bomb breaking
too sucks the whole room up
fur zippers beercans
and the sweat hair of groaning and sperm
till your cock bud throbs more
to ball me over and
again    better than summer
deep and nice
bringing everything
home

Lyn Lifshin

# Now I know

Now I know
what hair is for
I thought
as she hollered-whispered
"Pull it! Pull my hair!"
and I pulled and pulled
trying to pull hard enough
and not too. . .
as I wrapped it
around my brown hand
and pulled at its softness,
as I thrust my other hand
into her more-more-more,
as I found
that right spot on
her shoulder to bite,
as I pushed my hand
with my knee to get
there—to that "Yes"
that "Oh God" place,
as I pressed
the rest of me
close, close
to the rest of her,

as I felt her warm hair
in my hand
and she hollered
she whispered
"Pull it, oh please,
pull it!"

Dreaminhawk

## To Whom It May Concern

Not a word!
The eyes speak in rivers,
        the fingers in trees.
The body has a language all its own:
this time we will send the interpreter home.

I will open you
        petal by petal
        taking all the time in the world.
I will build with you a slow fire
        stick by stick
        and watch the color of your sunrise.
I will play with the wind of you,
        cover your body with smiles and games,
        promises and fantasies that disappear
        without a trace.
I will stir your secret core,
        witch's brew of potions and incantations,
        and feel you simmering, rolling,
        floating in my hand.
I will fill you slowly up,
        every crevice and curve,
        watch feel hear smell taste you
        growing full.

And when every part of you is one,
when you are saturated, suspended,
water trembling over the brim,

I will ride with you over the falls
        drown with you
        disappear all boundaries
        tumble over and over
          and over and over
until there is only the spinning dizzy
dance beyond dancing
and the great wave crashing to bits
everything, leaving us
strewn with the seaweed
in the sand and the sun
        to dry.

        David Steinberg

# Nightriding

*for Mule*

I like to lie naked
waiting for you
in the warm Southern night
when swags of fragrant wisteria swing
from the listening pine groves
and moonlight spills slowly from your searching hands

like how you open me like a rose
petal after petal tease
the pouting lips of the cleft
between my legs with your stabbing
tonguetip how you wake my pink pearl
with long wet kisses how you suck honey
from the quivering cup of my flowing cunt

like how I can taste my own wine
from your mouth when you raise your head
and smile kissing your way back I open
my eyes over your shoulder the moon is on fire
now starbursts stud your eyes

like how the mating calls of catamounts
wake the drowsing whippoorwills to startled song
how you cover me like sky thrust a blue butterfly pillow
under my squirming ass and spread my thighs

like unfolding wings opening
wide high thunder prowls in the north

what hunger is this nameless wonder
which drives us sets flesh aflame
blood smoldering I am burning burning
who can fill this aching emptiness
feed the living fire I hold and guard
plant seeds of light outdistance my belly's dark

like your thick root housed deep deep
the sweet raging torrents you wake
unleash how you fill out every valley
shatter the awful loneliness which screams
love's name down the corridors of tongueless need
like how you slam against my aching belly go deeper
how we crash like thrashing dinosaurs together
dive like falling stars welded into one flame
like the blessed dying falling away

like the night washing over the world
how you catch me against your hammering heart
call the gods by name as the living waters rise
flooding the fields of creation how arching you come
pumping pouring life into each crevice
of my thirsting heart reeling celebrant

like how you can never hold me close enough
sink deep enough like how flesh and blood remember
what hearts and minds dare not dream how you ride

night down to dawning's door how you
are always coming back to bury your face
between my breasts and smile still reaching
for me in sleep like how you shine
in my arms

                    Virginia Love Long

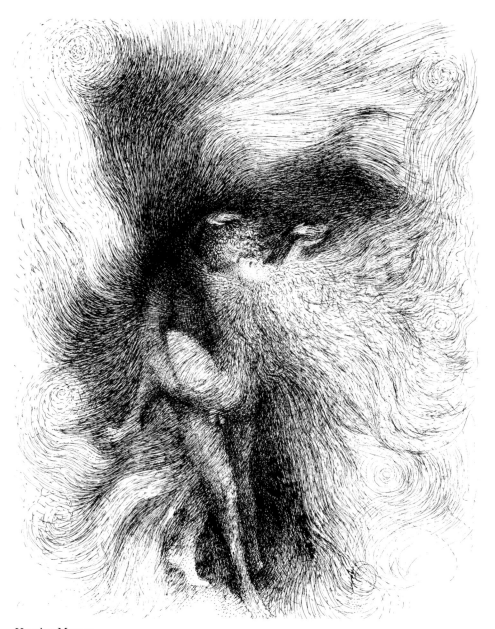

Harriet Moore

## Photographs VIII:
# *Close-Ups*

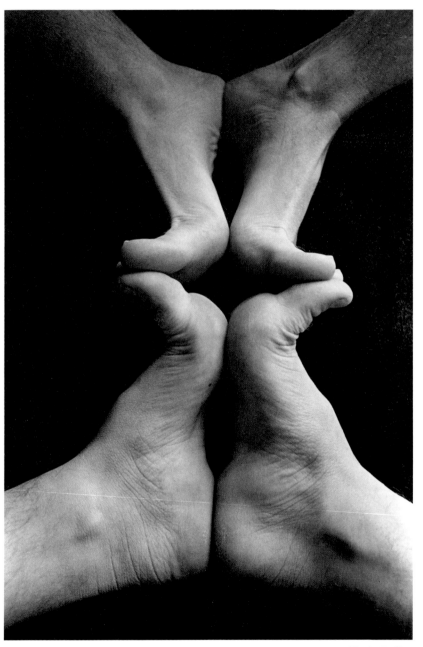

Clytia Fuller

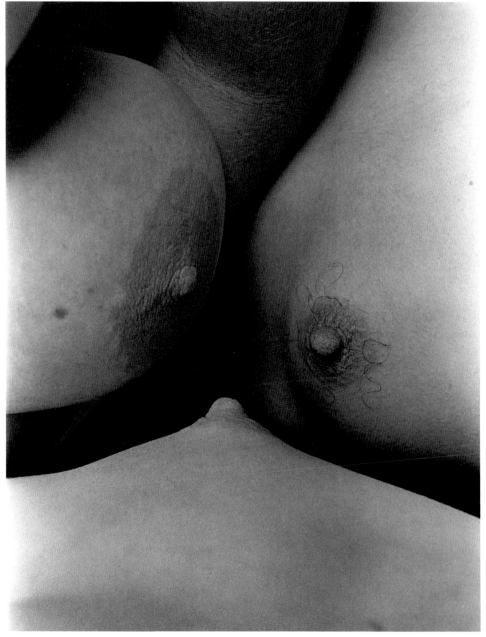

Clytia Fuller

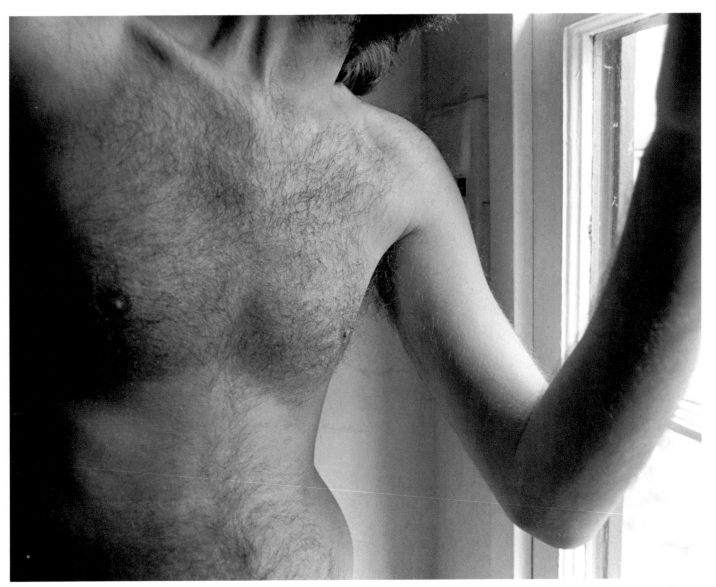

Marc Chaton

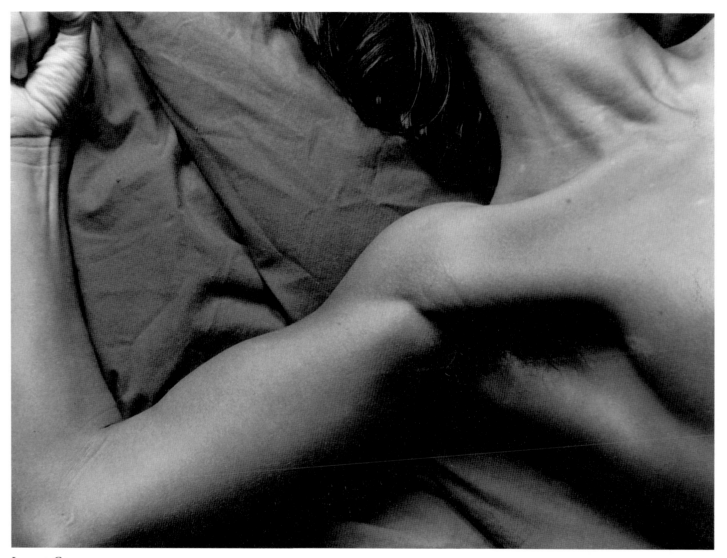

Lauren Crux

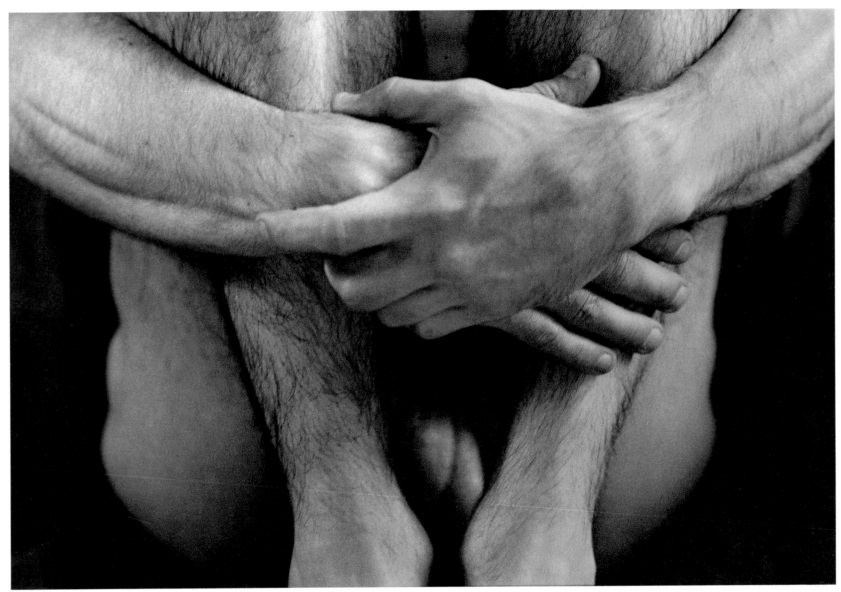

Martha Casanave

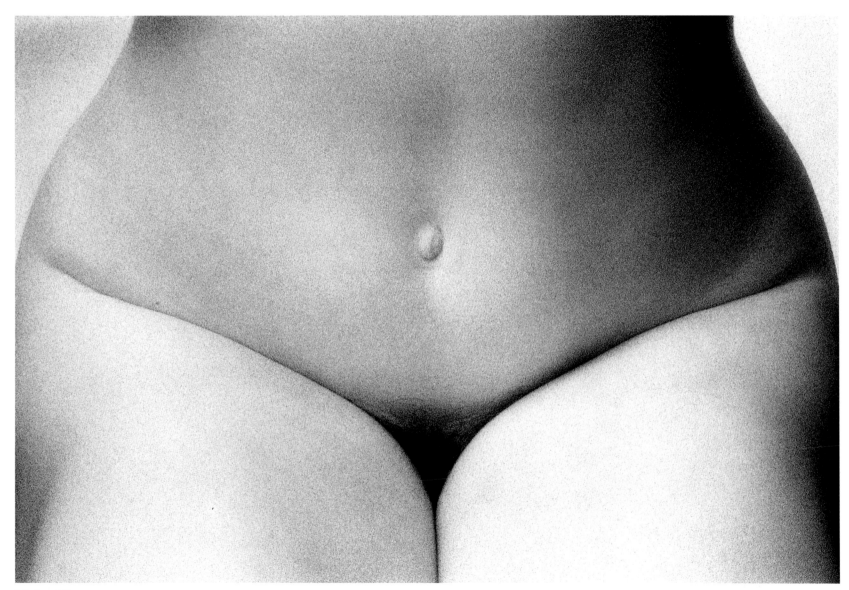

Michael Rosen

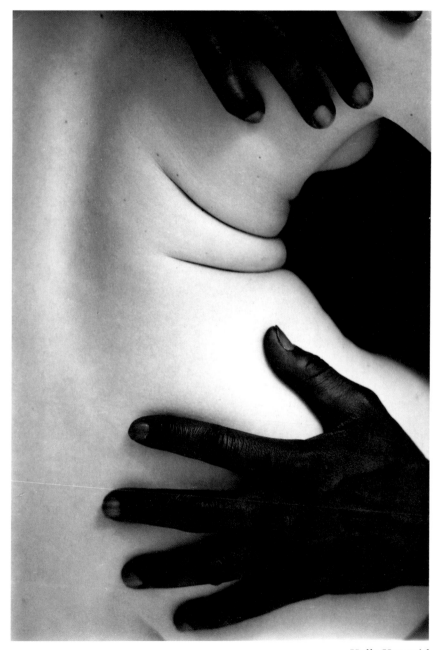

Hella Hammid

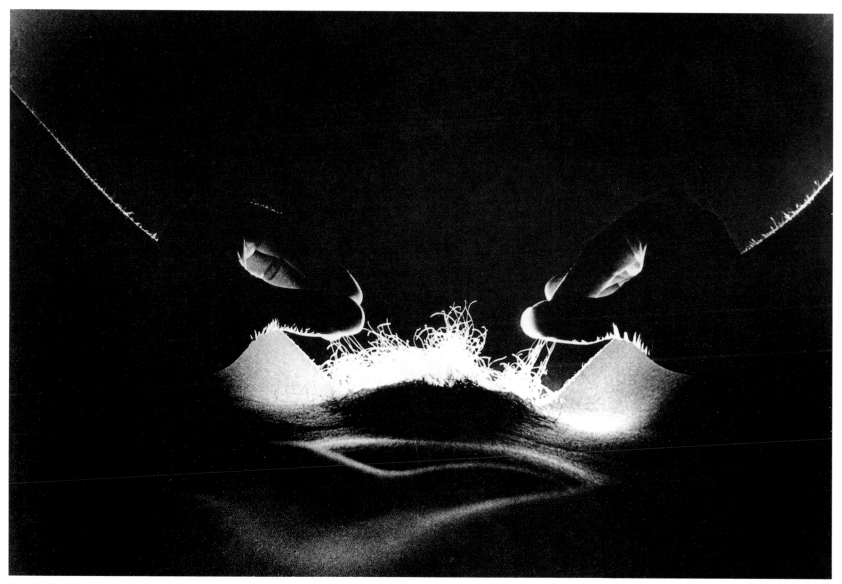

Ron Raffaelli

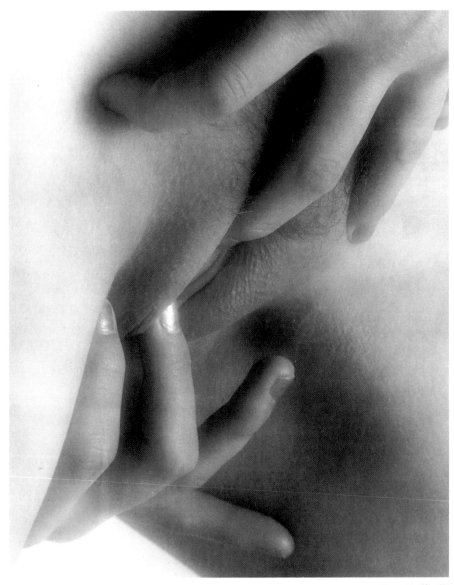

Ron Raffaelli

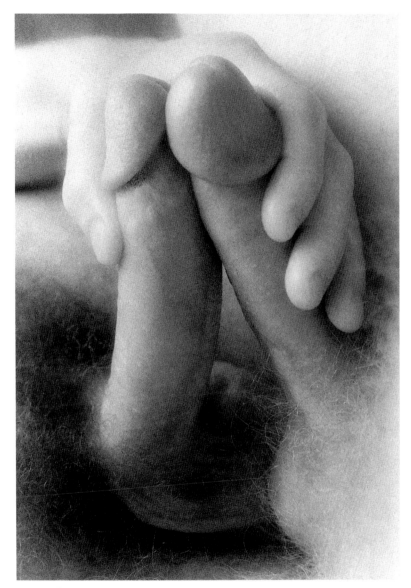

Steven Baratz

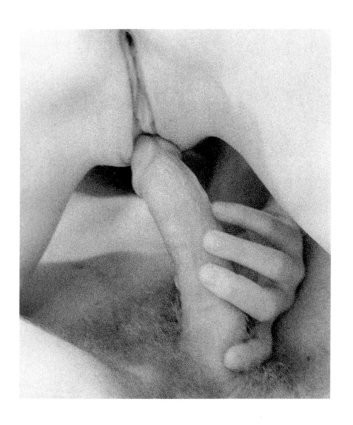
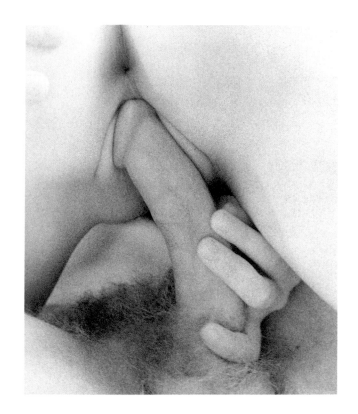

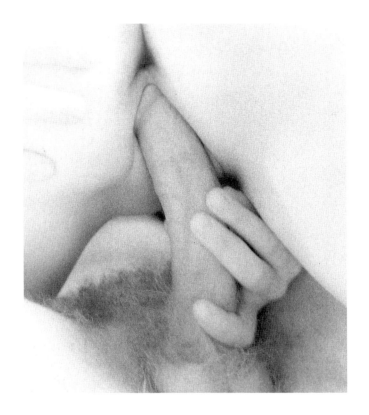

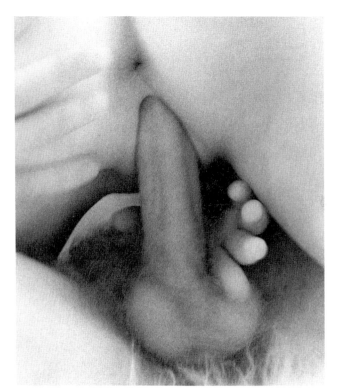

Ron Raffaelli

# The Pink Scarf

I guess I knew it wasn't wise to eroticize this scarf, that it would only lead me farther down the primrose path that I was already in up to my neck, especially since I got my hair cut so short again last week. But oooh, it feels so deliciously cool (and just a little bit cruel—like you know I like it) to slide that silk *sooo* slowly along my skin and around my chin like you did to me last week.

If my ex-mother-in-law knew what we do with that hot pink silk scarf she gave my daughter—which I immediately claimed as my own—she would *not* approve. It's been almost three months now, and the list of lewd things we have found to do involving it grows longer by the hour. (Even *I* find it rather shocking to experience what the previously contained imaginations of two forty-year-old ladies can set free under optimum conditions.)

I like it best when our wrists are bound together with that bright silk, when our bodies are touching so completely there simply is *no space*, no space at all, between us. Our tongues are wrapped 'round one another and our wrists (your left and my right) are enclosed, enfolded—along with our ten entwined fingers—in soft, tight, hot, pink silk.

Last night, during class break, you whispered to me in the hall, "I *have* to stay with you tonight. I *want* your body."

"Well," I replied, laughing, "since you put it *that* way, so poetically and all, what can I say but 'of course.'"

"Seriously, though," I added as I sneaked a tweak of your tit there in a dark corner of the hall, "seriously though, you know

you're *always* welcome."

Hours later, snugly in bed at last, I lay along you, slowly, deliciously going through the motions we have learned so well this past year. You were whispering in my ear, "This morning I suddenly remembered that moment on Sunday when you pulled that pink scarf out from under your pillow, and I could think of nothing more all day. Oh baby, oh my—how I *needed* you."

Needless to say, I was only *tooo* pleased to fulfill *all* your needs.

But then came today, when I had to go away early, leaving you so warm in my bed. Was that *really* fair of you to draw my pink scarf so teasingly down off my just-wrapped neck, across your white breast, over your broad belly, and all the while to look at me *sooo*, well, *you* know?

I mean, maybe I did like it *some* as I raced off to school, to think of you there with your hand atop the scarf atop your erect nipple. But, oh baby, oh my, now I have to go a whole 'nother night and day and almost night again with this aching in my cunt and that picture in my mind!

Today I wore our pink scarf, purely for warmth I thought. I wound it carelessly 'round my neck as I ran out the door—late, as usual, for work. For warmth, I thought, I kept it on throughout my busy day. Funny things began to happen.

I found myself stroking it absentmindedly as I talked to my students, as I walked across campus, as I studied in the library. Heedlessly I would stroke it, and then—every time—a vision of your wrist bound to mine in pink silk would flash before me. I would see your mouth open wide as you gasped with pleasure. Then a vision of your bottom would come—your bottom heaving up toward my eager mouth pressing down, pressing down, making bright red prints in your soft white flesh. The pink scarf stretched across your back, connecting one bound hand to another, as your *so* beautiful broad bottom rolled and jumped under my mouth coming down, coming down.

All day long, from classroom to parking lot, I had this vision

whenever I stroked our scarf. It kept me very warm, indeed!

Yesterday you lay on the bed in the eternal blue twilight of my room, and I wanted you as fiercely as ever before. I picked up the pink scarf from the table, where it has lain neglected for many months. (We have moved on to other games.)

Just passing it through my hands on its way to yours brought the blood rushing to my cunt, and it ached for your thigh, your hand, your tongue. Just passing it over your breasts brought such an urgent desire for my hand in your cunt that I threw myself on you fiercely, and came as you came, the scarf tossed hurriedly aside so that nothing, nothing, should come between us.

Dreaminhawk

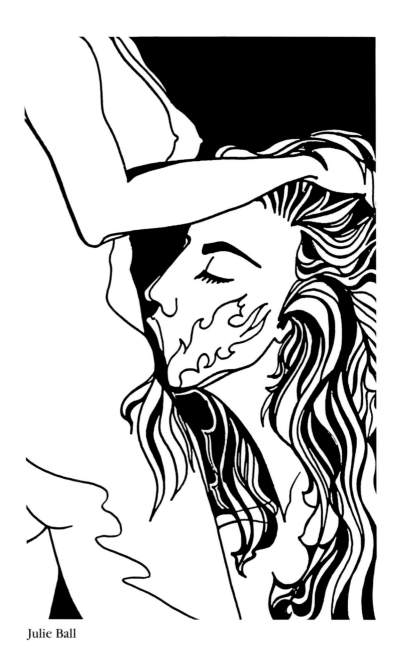

Julie Ball

Poems III:

# And the
# Juices Wet

## waking from a nap

waking from a nap
the afternoon light beginning to fade
I gaze into the mirror
and watch you undress
tossing the covers aside
I caress my belly
my middle finger traces
small circles s.l.o.w.l.y
through curliest of hair
to moist skin folds
that invite a deeper curiosity

our eyes meet
mirror image reflections

I watch your fingers
     your hand
     form a loose fist
     moving slowly
     going down
     over your penis
     now wet with anticipation
     teasing slowly squeezing
     up and down
     up and down
     in the pleasure of me watching . . .

you watch my fingers
open lips
exposing
purple shades
of pink sex
the excitement
as prominent
as nipples
aroused—erect
my mouth parting
tongue reaching
lightly licking
teeth nippling
fingers drawing
vulvic ovals
into vertical agitation
up/down
up/down
up/down
my breath
coming faster
coming faster
in the pleasure of you watching . . .

you lie on the bed
I watch your fingers
slide out
your mouth
legs opening
knees bending
fondling testicles

petting pulling
pubic hair
fingers circling
reddish pink
sea anemone
damp hair
curling away
wet against your skin
your other hand
rhythmically stroking
your penis
leaking damp excitement
sphincter yawning/yielding
finger sliding
slowly in
slipping out
pushing in
for the pleasure of me watching . . .

I find
I can no longer watch
I must act
I must move
to gently bite
your small male breasts
licking nipples
to attention
my teeth nibbling
down/down
inner thighs
exciting odors

of your sex
fill the air
my body on the edge
of orgasm
my feet flooding
with warmth
watching you
watching me

I turn my body and straddle your face
my finger playing a duet
with your mouth
your tongue lapping
plunging in/out
slow motion sucking
teeth hard on soft parts
t.e.a.s.i.n.g
to a full breathless moan
coming coming coming
gasping for air
I pinch my nipples
sending waves
splashing joining
intensifying orgasmic release

I rub my clit, my labia
on your chin, mouth, tongue, nose
taking my pleasure again and again

I move off and away

lying down
as your fingers
move inside me deep and fast
deep and fast
and wet, and wet, and the juices wet
coming again and again
until I say no more, no more
come inside, fill me with your pleasure
with the pleasure of watching you
watch me, watching you

Lani Kaahumanu

## Saliva

It starts from the ankles
advancing in a slow dallying tide
over shin and thigh
pausing long in the haven of my sex
covering belly, arms, breasts
with the tender veil of its gentleness
the tense dew of its maleness.
My entrails suck the sweet moisture
with hungry roots,
my blood consumes it with bitter torches.
The destiny of my body
is the touch of your tongue,
the wet melting moons of your tongue.
My mouth closes hard
on it at last
my stiff eagerness
curved to greet yours
to roll and twine
in the cave of our lips
to sing together
in the joy of our flesh.

Lili Bita

## The image was of me flowing through you

The image was of me flowing through you
everywhere,
all the membranes gone transparent,
the holding released
and so a washing.
I felt me pouring, and you.

You knew then all that I knew,
arms and legs circling,
the core enclosed,
the two/one of us
balanced and still.

Oh the welcome, the ease,
the walls saturated,
slithering into soft mounds.

We breathed,
we drank,
taking care not to tear the lace.

David Steinberg

# *At Beck's Motel on the 7th of April*

At Beck's Motel on the 7th of April
we went to bed for three days
disheveled the king size sheets
never changed the Do Not Disturb
ate only the fruits of discovery
drank semen and laughter and sweat

He seasoned my mouth
    sweetened my neck
    coddled my nipple
    nuzzled my belly
    groomed my groin
    buffed my buttock
    garnished my pubis
    renovated my phallus
    remodeled all my torso
until I cried out
until I cried
    I am  Yes
    I am your  Yes
        I am  I am  your
        Yes  Yes  Yes

James Broughton

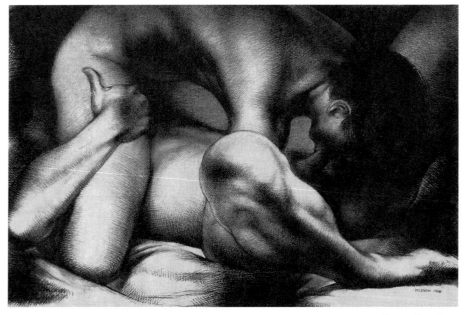

Betty Dodson

# *Thy Kingdom of Come*

The austere freedom she discovered in masturbation razed all desire for intercourse with others. She was liberated into a strange prison, one in which she was permitted to do, or say, or feel, anything she liked at any time the impulse moved her, but on one condition: that she remain alone.

That she had been gravitating toward this state during her entire adult life was something that could be seen only in retrospect. In the decade following the loss of her virginity at seventeen, she had moved through a period of such rampant promiscuity that it seemed she would never be able to get enough of people. It was impossible for her to remember how many men, women, animals, and dildoes had been inside her, how many gallons of sperm she had swallowed, which perverse actions she had not attempted or catered to.

Then, one night, as she lay writhing on a hooked rug before a roaring fireplace, her body a seething sea of red shadows, her fingers grappling her cunt, after hours of being fucked, whipped, pissed on, made to grovel, some delicate cord inside her snapped, and she opened her eyes to wonder why she was expending so much energy on what had suddenly come to seem a senseless melodrama. With ruthless honesty she severed truth from the appearances which camouflaged it, and asked herself the only real question which has any validity in the erotic realm: *why involve others at all?*

She went into seclusion to ponder the answer, and came to an astonishing conclusion. "Other people merely provide additional energy to increase the scope and intensity of the orgasm," she reasoned, "either by joining the fucking itself, or by watch-ing, or by providing necessary inputs at crucial times in the forms of slaps, caresses, or words." She perceived other functions, such as providing company or support or instruction, but she discounted these as pertaining to people who had not yet attained to any autonomy of personality.

"Orgasm is the quintessentially private experience," she continued, "and the notion that we must share it with others is the final corruption of what's left of civilization. The only time that people should fuck is to make babies. Everything else is sheer indulgence."

Accordingly, she locked herself in. She had her food delivered, she had her phone taken out, and she devoted herself to exploring a realm where many go with feelings of shame and defeat, but which she entered with a sense of triumph and arrival.

She prepared a single room for her ritual, sealed the window and painted every surface black, removed all the furniture except for a single mattress which she covered with a black satin sheet. Whenever she closed the door on herself, no sound or light could reach her. She was launched immediately into interior space, the turf of contemplation.

Immediately following her decision, a great peace descended upon her. The first artifact which fell away was the need to perform. It became clear at once that almost all her behavior was unconsciously geared toward some real or introjected audience, that far from being free, she had been a captive actress forced to play a multitude of roles for her parents, her lovers, her friends, her enemies, and even strangers in the street. At once her entire attitude changed, and a profound relaxation overtook her. No longer concerned with what anyone thought of her, including herself, the umbilical cord which had bound her to propriety, even when she was shrieking in wanton release running naked through a roomful of men, was cut. She saw that those actions which she had thought most uninhibited were nothing more than the strident proof of her inhibition. By herself she became truly wild, and in that wildness found a deep calm.

And when she gave herself to masturbation, unfathomable vistas opened. Not constrained to compromise herself in order to accomodate the expectations of anyone else, she flowered in the fullness of her being. She discovered a connection between her clitoris and her third eye. As she incessantly brushed the tip of that lower instrument of pure erotic pleasure, the world of psychic reality unfolded. She could peer into past and future by seeing the present in great depth. She was able, after a while, to transcend relative time altogether and abide in the sense of the eternal. She cried out in terror once when, from a region she could not have imagined existed, she beheld the ultimate reality, the single truth which embraced all partial images. Absolute Time seized her in its jaws and laughed as she danced along the ridges of its gleaming fangs.

Her memory returned. All the scenes and feelings of childhood, so long buried, came to the surface, and for the first time in her life she was able to see her life as a single gesture, a woven fabric with a unitary design. Her body found its most meaningful expressions. As she revved up the energy in her cunt, her spine would shake, her head roll from side to side, her tongue lap the air, her legs tremble and kick, her buttocks lose their tension. Three, four, five spasms would shake her frame, but instead of having a heavy body lying on her, or an importune hand feeling her, she would be blessed with the lightness of solitude, and would rise from the floor and dance, joyously, sombrely, beautifully, all to herself, in pitch blackness, relishing that no one could see, or would ever see, the real person that she was becoming.

She destroyed all the mirrors in the apartment so she would not distract herself with her own image; she had come to view perception as an impediment to vision. She was transmogrifying into something beyond all human standards to judge, a creature of fierce tangled beauty. She lost her conventional good looks and became sublime, the way a snarled tree ravaged by wind and salt air grows terrible in its aspect on cliffs overhanging the ocean.

Occasionally, that portion of her mind which had been socially conditioned stirred itself to condemn or worry her. "You are going crazy," it said. "You have no more friends or family, you never go out, you never see people. That's unnatural, pathological." And when she withered the superego with a scorn born of solitude, it changed its attack and used the final weapon in the arsenal of those who rob an individual of his or her personal reality.

"You have lost the ability to love," it said. "You are selfish, uncaring."

It was not too long before she saw that it was thought itself that was the real enemy, the thing that separated her from herself. During her spells in the black room, after a long long time doing nothing, letting herself be, and then gradually drifting into an awareness of her body, she would begin again the exquisite rite of masturbation. Unimpeded by the demands of another, she soared again and again into the heights of sexual ecstasy unknown by all but a few, those very few who have had the courage to admit that sex is the sister of death, and thus can only be known alone. The orgasms she experienced surpassed the paltry twitchings given to those who still require support for their pleasure, in the way that the flight of eagles goes beyond the spastic flappings of sparrows. And after returning from the mountain tops, the first thing to cast a pall upon her spirit was always language, the limitation of thought.

Her diary reads: "The space I call my *self* was clear. There was no split in me, no confusion. I was a single entity, a thing. Distinct from everything around me, yet part of it all, I had no identity at all. I don't really know how to explain it, since the experience was deeper than language. I don't know how long it lasted, for time was not relevant.

"Then something stirred. I sensed it the way one might be aware of the movement of a small animal in tall grass. I felt as though some precious balance were being lost, some vital equilibrium. And in the wake of that feeling, the words appeared.

"They flew across my mind like the banners tied to dirigibles which sweep across the skies on summer afternoons. I watched,

and for a few seconds they were just another phenomenon, no different from the beating of my heart, the coursing of my blood, the rhythms of my breath. The words had no special weight. They were merely aspects of the all.

"But some strange and hideous transformation began to take place, and they started to grow stronger, louder. It was as though they weren't content to be part of my being, they demanded dominance of it. I became annoyed and turned my attention to see what they wanted. And in that instant of shifting center, I realized that 'I' had returned. There was suddenly a platform of observation which was removed from the process being observed.

"Like a person caught in the net of a suffocating nightmare, I struggled. But as I fought, the words proliferated. They poured into my consciousness from a thousand sources, booming, crackling, sighing, shouting. Strings of sentences intertwined and formed fantastic patterns which came to constitute the stuff of images.

"And from that whirling energy concentration of exploding verbiage, pictures were born, faces of real and imagined creatures, denizens of memory and desire who proceeded to act out intricate dramas in which I was invariably a hero or a victim. I was swept into a maelstrom of abstraction, and was drawn, gasping, into the symbolic world, the fantasmagoric kingdom of concepts.

"I was *thinking* again."

As she approached a state of brute intelligence, a stark sensitivity to the fact of existence, rationalization fell from her like dead skin from a shedding snake. She emerged cleansed of all the impacted overlay of culture which had been grafted onto her soul from the very first moment she became a seed growing in her mother's belly.

On the day of her thirtieth birthday, she had achieved an unquenchable autonomy. As she took herself to her room to masturbate, she was so filled with herself that it seemed no external force could ever impinge upon her again. But as she reached down to cover her cunt with her hand, the space around her was slowly suffused with a golden light.

She stared in dumb wonder at the phenomenon. In front of the mattress, a curtain of silver needles shimmered and took shape, until a tall naked man, with green skin and long curly violet hair appeared, his red eyes piercing her gaze, his succulent cock throbbing gently. Her surprise was total, and she did not stir, but continued to lie there, her legs parted, her breasts lolling on her chest, her mouth wet and open, her fingers spreading the cleft between her thighs.

"Very nice," he said.

She blinked. "Who are you?" she asked, the first words she had spoken to anyone in almost three years.

He smiled. "I have been called many names, not all of them complimentary. I have been known as Zeus, as Jehovah, as Baal, as Thor. I am who I am, and all that, and have assumed a thousand forms. But most people nowadays refer to me as GOD."

"God?" she whispered. "But I thought there was no God."

"Many people have denied my existence," he said with a droll intonation, "even to my face. It's part of the overall perversity of human beings."

"But what are you doing here?" she asked.

"You have attracted me," he told her. "As your species falls further and further into conformity and mediocrity, I find fewer and fewer occasions to visit earth. In fact, I come so infrequently that there is a rumor that I have died. I used to stay here a lot, in the old days, when there were some fantastic people on the globe. And you're the first thing to arrive in a long time that's got that kind of quality."

"But of what conceivable interest could I be to you?" she said. After having learned to discard the company of people as something trivial, she was amazed that God would seek that very thing.

"Why, to fuck you, of course," God replied, and laughed, a deep baritone rumble. "Why else?"

She raised herself on one elbow. "To fuck what you have created? That doesn't make sense."

"Oh, I haven't created anything," God said, sinking to the floor and sitting on the edge of the mattress. "I'm just here, like the rest of you. The only difference is that you come and go, and I'm immortal." He scratched his head. "It's really very peculiar. I mean, I just woke up one day and found that I was God. I couldn't remember what happened before I was born, and didn't know where I came from, and knew that I would always be. I've seen universes come and go, worlds be born and die. I am old beyond any comprehension you might have, and yet I am always fresh, always new. I am the synthesis of all contradictions, I..."

He smiled again, and broke off. "But you've heard me described well enough by your own prophets and poets. No need to give you a resumé."

She sat up. "But if all this is true, why should you want something as limited as fucking?"

He reached forward and stroked one of her breasts. "Well, for me, everything is limited. To amuse myself I have to make my choice among limitations. And on the scale I see things from, one limitation is no different from any other. For example, I just came from watching an entire galaxy explode, a happening that had been building for seventy-nine quadrillion years. It covered a space your mind couldn't begin to encompass. And that was interesting. But then I wondered what to do next and I thought, 'I haven't been to earth for a while, let me go see if there's anybody around worth fucking these days.' I scanned the planet and was discouraged at first glance. I saw nothing but a plethora of such shallow sensualists that it made my cock-form shrivel. Why, the very sexes themselves are on the verge of total alienation from one another. But on a second look around, I saw you. And here I am. Although, in a sense, since I am everywhere, I have been here all along."

"And you want *me*?" she asked, beginning to be impressed with the enormity of the personage who stood before her. She put one hand on her hair and said, "I must look a mess."

He laughed again. "Your lapse into vanity is charming, my dear," he said, "but I wouldn't have come if you weren't beyond judging things by the standards of the crowd. I'm not interested in anyone until he or she has gone beyond the illusion of group standards and has hacked a hard-won path through all the tedious variations on the public sexual act, including that which requires fantasy for its completion. I want a soul that has striven to burst the bonds of common understanding and can appreciate the unique."

He lowered his head and stared between her thighs. "When you fuck me, you can experience everything you have when you are alone—everything. And I will infuse that state with such awesome power that you could never even dream of with your puny human faculties. With your mind, you can grasp the structure of the universe; with mine, you can see into the heart of the void from which all existence springs."

"And what do you get out of it?" she asked.

"Just a piece of ass," God said. "My tastes are simple."

She pulled her knees to her chest and wrapped her arms around her shins. "I'm not sure I want to," she told him, "even if you are God. I've worked hard to get where I am. Why should I give you pussy? I'm happy with the dimensions I already know."

He pursed his lips. "I can make it worth your while," he answered.

"Well, how good a fuck can you be? You're still in the form of a man. That thing between your legs is only a cock."

"I don't claim any special skill," he replied. "But I can offer you something else."

"You mean you want to *pay* me?" she asked.

"I can offer you Heaven," he said.

"Heaven?" she exclaimed. "You mean there's really a Heaven too?"

"Oh, nothing like they tell you about in Sunday school. It's a bit more chic than that. More like a private club, for my special friends." She regarded him suspiciously and shifted her weight. "You really do have a nice ass," he said. And then, with an abrupt change of tone, continued: "Whichever God made me God seems to have defined my powers clearly. I can't create

anything new, but I can change the nature of what already exists; I can do things with what's already here."

He waited a long time in silence, and then in a hushed whisper said, "I can make you *immortal.*"

Her jaw fell open. "Immortal?" she repeated. "You mean... to live... forever?"

"That's right," he said, his expression smug. He hunched over, and his words came out quickly. "The fact of the matter is, earth is the only place in all of creation that has fucking. And so, while it isn't the most spectacular activity available, its rarity gives it a certain value. I've granted the boon of eternal life to several thousand others in the course of history, and if you accept my offer, I will remove you to a planet that you will share with them. Once there, you can have the company of the greatest fuckers that the world has ever seen, or all the privacy you desire. And when I'm in the area, every few million years or so, I'll drop by."

"So I become your mistress."

"Call it what you like," he said. He looked into her eyes, holding her gaze, and went on in a chill voice. "The alternative, if you refuse, is to live out your days and end, like everyone else, in the grave." The last word sent shivers down her spine, and he finished, "What have you got to lose by saying yes, and what can you possibly gain by saying no?"

She waited a long moment and answered, "My integrity. A whore's a whore even if she's God's whore." And then she let the breath out of her lungs with a loud sigh and added, "This is just like the scene with the tree in the garden. Where's Satan?"

God laughed. "Don't you know? I'm Satan too. I just haven't bothered to split roles this time."

"Is this the only game you know?" she said, slightly disgusted.

"For humanity, it's the only game in town," he said. "If you are true to yourself, you will refuse the fuck, and die forever. But if you sell out, you get paradise as a reward."

She lay back down again, her whole being filled with the prospect of realizing the one dream that has haunted the species since it first became aware of death, the hope of immortality.

She balanced it against every earthly value she had come to cherish. His hands stroked her calves as she wrestled with the problem. And without being fully aware of what was happening, she sank into a lassitude that was the prelude to capitulation.

Her mind swam lazily in its thoughts. The single word "forever" sounded in her psyche like a gong. And finally, she succumbed. The temptation was too strong, the offer too compelling.

"All right," she said, "you win."

Her thighs parted and her stomach swelled with a deep breath. "You can fuck me," she told him.

God moved forward until he was between her legs, her wet cunt staring up at him, her hips beginning to rotate. But as he approached, she put her hands on his shoulders and held him for a second. She looked him in the eyes.

"Just don't get me pregnant," she said, and then took God's huge hard cock into her, opening the doors to eternal life.

Marco Vassi

*Photographs IX:*

# *Introspections*

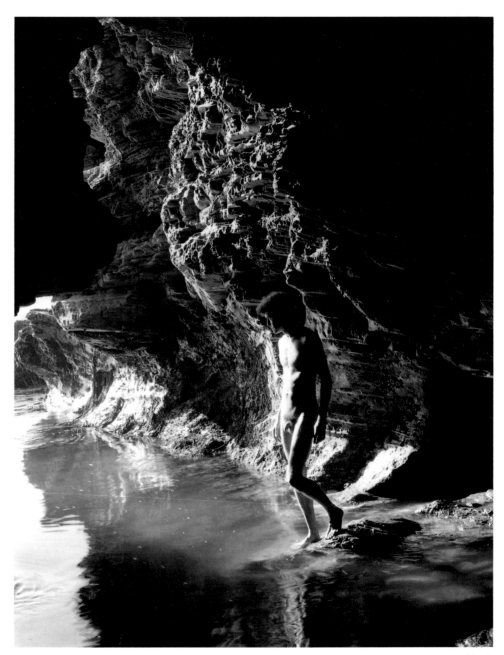

Edna Bullock

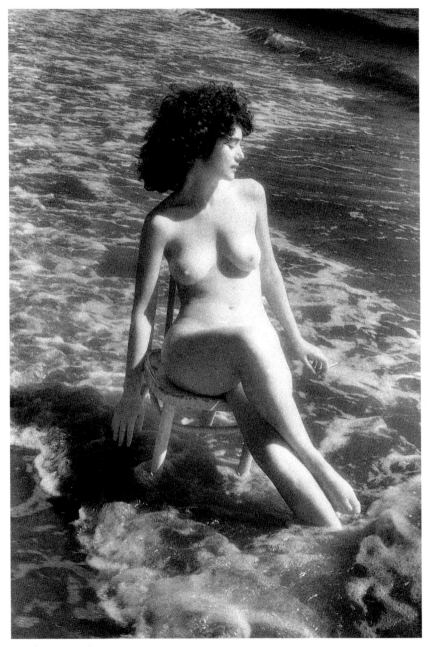

Stephen Siegel

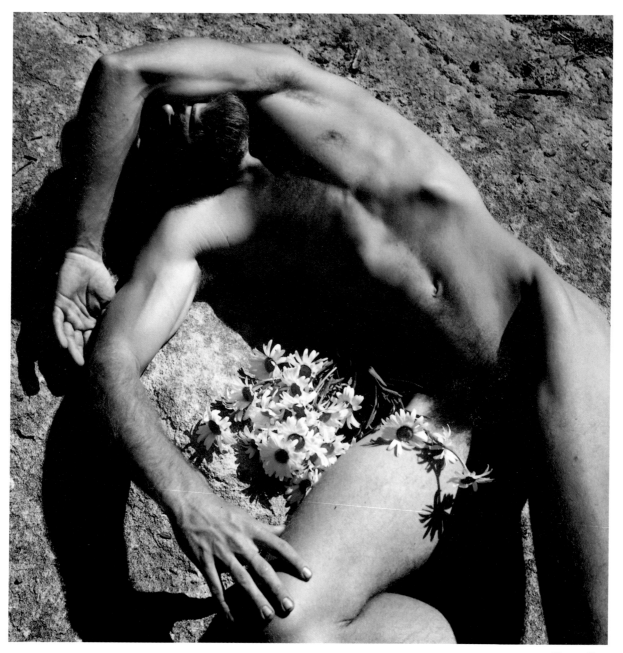

Gypsy Ray

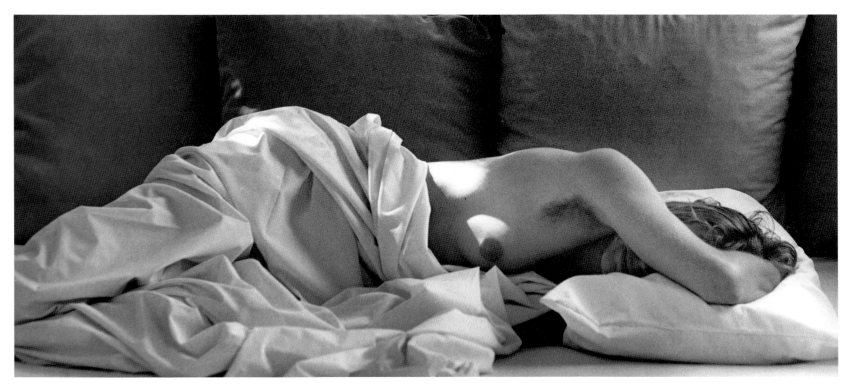

Hella Hammid

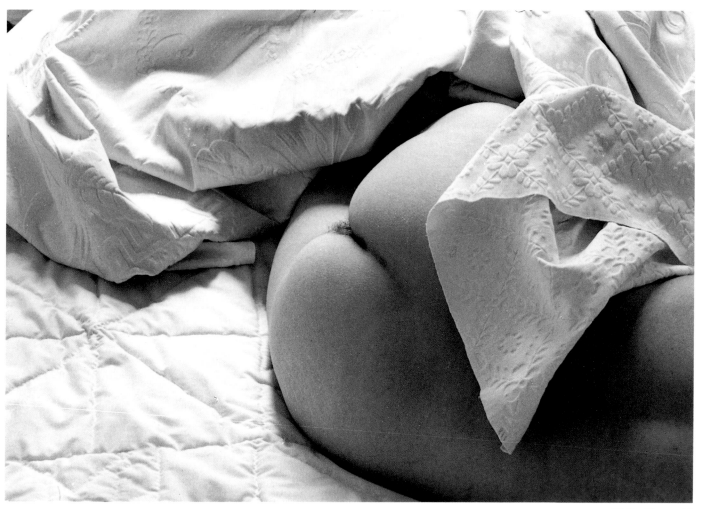

Hella Hammid

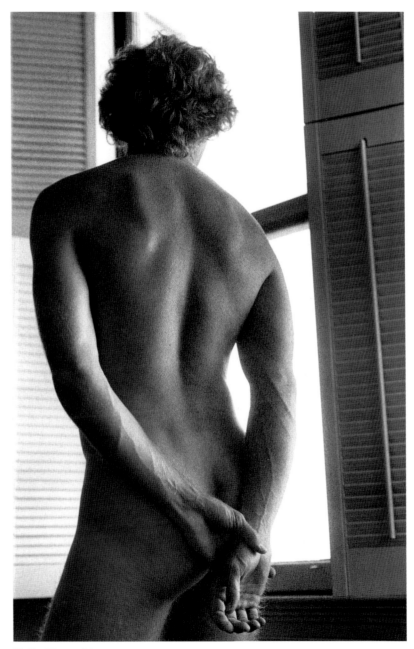

Hella Hammid

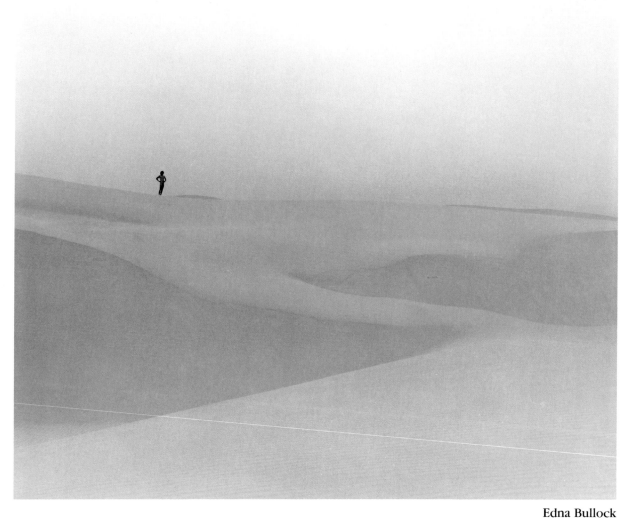

Edna Bullock

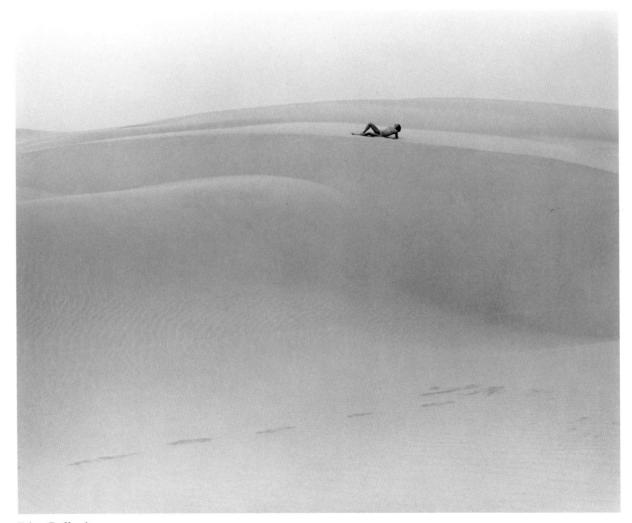

Edna Bullock

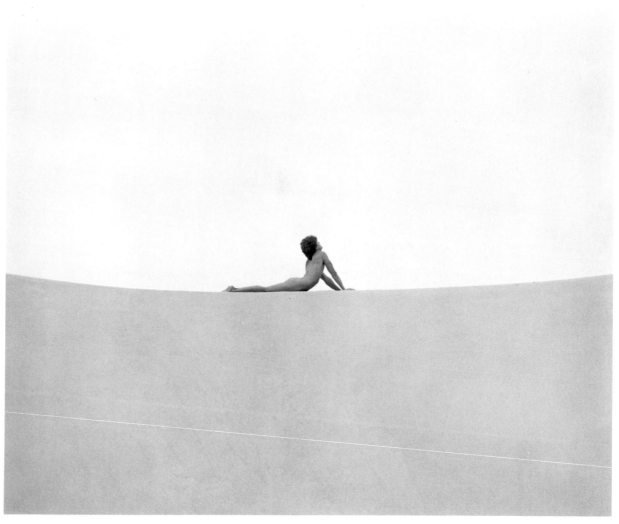

Edna Bullock

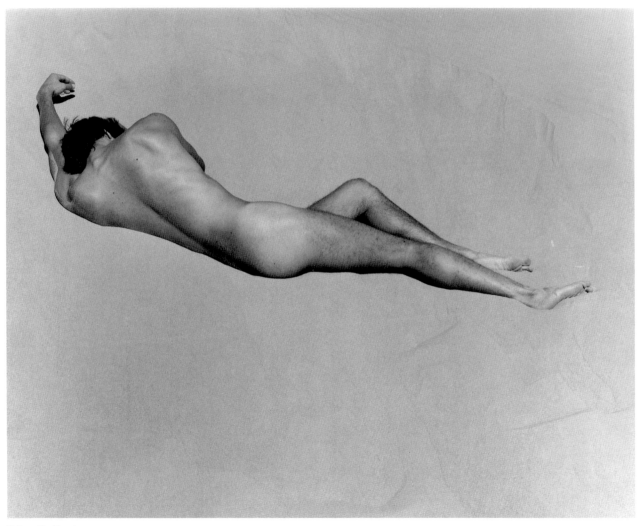

Edna Bullock

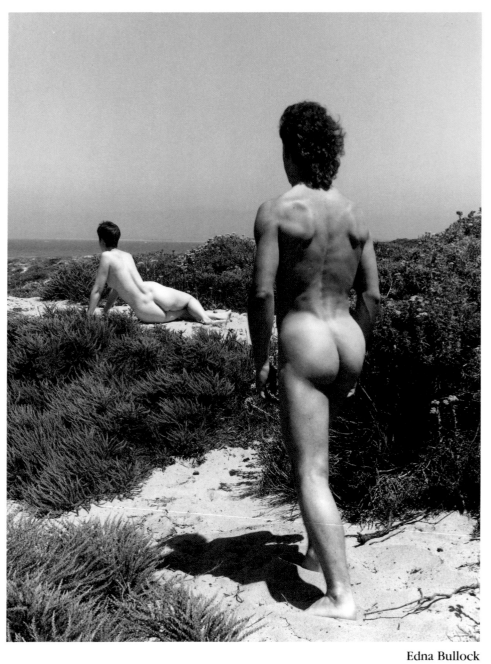

Edna Bullock

# Poems IV:
# *A Fountain*
# *of Flowers*

## 3:45 and I'm

3:45 and I'm
feeling a need for
you only you've been
asleep for hours slide
waterbed warm beside you
snake down your body to
awaken you one piece at
a time you oblige
ready I waste no time
anxious in mounting
my salivated lubricated
result feel you deep
feel you hard just feel
my hair is tickling my
shoulders back snap
down hard my body
smiles

Cheryl Townsend

## *All Day at Work*

All day at work
I carry the scent of you.
I touch my fingers to my lips.
I remember this morning
how your lips parted
as though there was some secret
you had been holding,
were finally ready to share.

The telephone rings.
I press my ear to the receiver,
just as I laid it last night
into the place between your breasts.
Your heart beats loudly;
I must ask the woman who has called
to repeat what she is saying.
I keep trying to distinguish her words
from the rhythm I have memorized in sleep.

I type letters in the afternoon.
I put the date at the top of each clean page.
Your thighs are nearly this white
and just as smooth.
When I am finished
I run my finger along the crease
as though even this fold
might arouse to my touch.

I drive home the long way.
The ocean is the color of your eyes.
There is a little boat off in the distance,
the faint image of a person aboard.
I am looking into your dark centers
where I see myself reflected,
standing close to the edge,
as though I might
at any moment
take in my breath and dive down.

Deborah Abbott

# The Flower That Blooms

i am
at the mercy
of the flower
that blooms
between your thighs
transfixed
i am
rooted to the spot
desire
pumping the blood
behind my eyes
make it grow
for me
a red rose
i want to eat
its petals
i will
keep talking
it makes
little sense
and your words, too
are slightly
incoherent

who cares
let it bloom
for me
your flower
let it bloom
shedding its petals
into me
if i wish it
hard enough
it will come true
right then and there
that we will melt
into
each other

M. E. Max

## My hands under her dress

My hands under her dress,
the warmth of a hundred million
fireflies.

                    Elliot Richman

## Sudden Flight

When I came into you
flock of sparrows

all at once
and yet quietly, too

                    Michael Hill

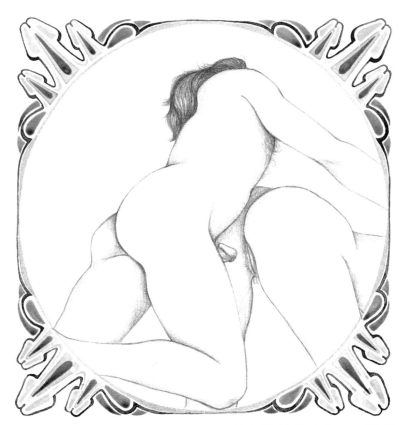

**Kaleiiliahi Henkelmann/Muller**

## Beneath your hands

Beneath your hands
I am a new woman
with peach satin skin.
You suck silver shadows
of breast curves; nipples
bloom in your mouth.
Flesh ripens and lengthens
at your touch.
White stars explode.
The milkyway spills
out between my legs.

Magi Schwartz

## Hands press thighs wide

Hands press thighs wide
and tongue dips in.
You melt from inside out
and when my face is wet with you
I think
heart of melon should be so sweet.

Michael Hill

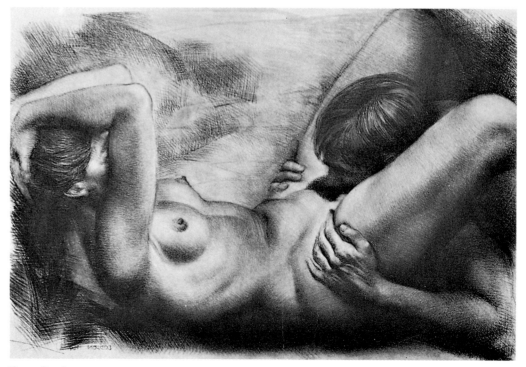

Betty Dodson

## Hot Summernight Cloudburst Rendezvous

The two boys embracing in the thunderstorm
Don't care if they get drenched
Don't care if as they strip each other
    their clothes drop in lightninglight
        into puddles
    and are kicked laughingly into the mud.
It's the first time either of them ever kissed
    a boy
And neither has ever kissed
    a girl
And neither ever kissed before
    with his tongue.
They had no idea
    how passionate
        passion could be—
    they can hardly believe it,
That merely putting their lips together
    could be so . . .
        ah.
For a moment they stand apart
    silently gazing at each other
        in the flashes and thunder,
Centuries of Boyhood, Aeons of BoyLove
    proud in their playful smiles,
Knowing just what they're going to do,
    even though they never did it before,

Knowing that before long
    each of them is going to jack off
        the first boy they ever jacked off
    beside themself,
Knowing both of them can come
    and giving in, giving themselves
    to boyfriendship's ultimate gesture,
Knowing they both know
    how to jack off real good
    and aren't going to stop frenching
        while they whimper toward the brink.
Sure, it's beautiful
    to see a boy you love
        ejaculate in the lightning in the rain,
Crying with pleasure while the thunder thunders
    and the sky ejaculates millions of raindrops
As you squirm in rapture
    on the muddy grass
        under the tossing trees.

                    Antler

## Seven of Velvet

brocade and tapestry, you lean back
your head against blue velvet
the sun dancing sparks of light across your naked skin
you lie there, your balls nibbled by teen-age succubi
and your hands on their snaky heads
their moonglow fingers twining around your rigid cock
and their little tongues darting and licking
as you stroke their smoky hair

across the room, I lie between the paws of a tiger
almost faint from the scent of his violent fur
he holds me to his belly and his paws bind me
his huge head purring like thunder at my shoulder
his white belly is velvet against me
and I am velvet to him

slowly, subtly, his paws tighten around me
and he enters within my body
I look at you from the embrace of the tiger
and our eyes meet in wonder
little tongues, little hands, move faster
and you cry out as you come
spurting a fountain of flowers
into the tiger's mouth

<div align="right">Lenore Kandel</div>

## Yellow Pears, Smooth as Silk

walking into the dawn, the dawn was apple-green
while I felt the gentle rain on my eyelashes,
my cheeks, my tongue
and underneath the soles of my feet the moist earth,
the puddles inbetween wet soil, bedewed grass,
and I keep walking into the dawn,
into the rain so generous with its caress,
the dawn was apple-green,
and all around me the orchard of desire,
the trees swollen with fruit
waiting for the loving touch of the migratory picker,
the dawn was apple-green, and I was stalking the ripe,
the damask daystar, the beginning of joy
walking into the dawn, into the orchard of desire,
before me, behind me, surrounding my timid flesh,
trees swollen with ripe fruit,
and underneath their flowering branches
bushels like empty bottles praying for the claret,
the peach wine, rose wine, cherry wine,
wine-red, wine-colored, blood-red apples,
peaches, berries, pears, yellow pears smooth as silk,
and the dawn was apple-green, walking into the dawn,
the dawn was apple-green when I first met you . . .

<div align="right">Rochelle Lynn Holt</div>

*Photographs X:*

## For Love

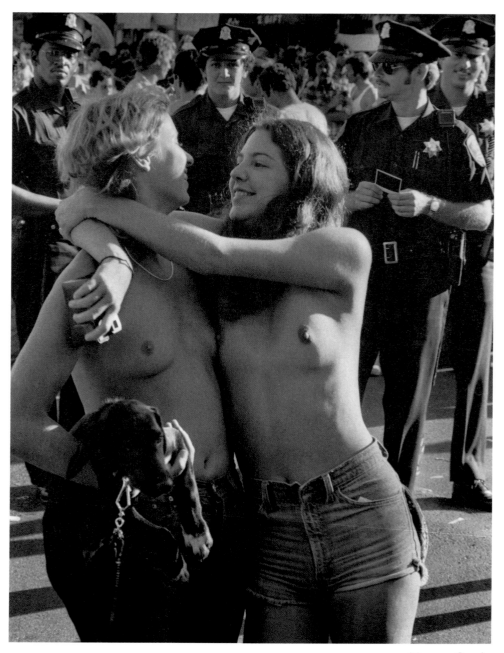

Morgan Cowin

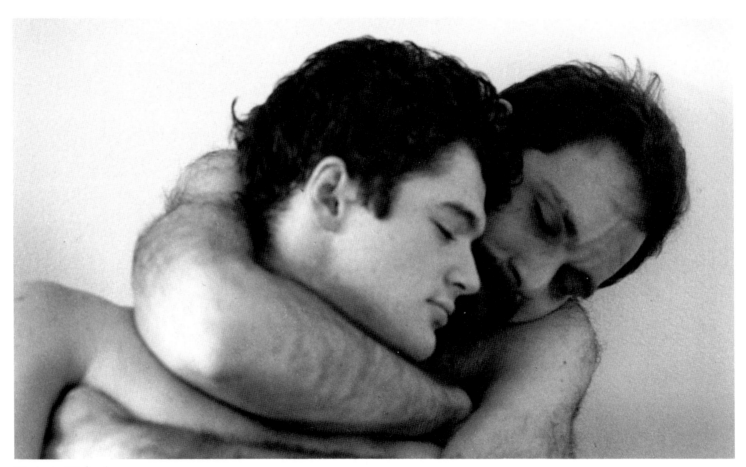

Marjorie Michael

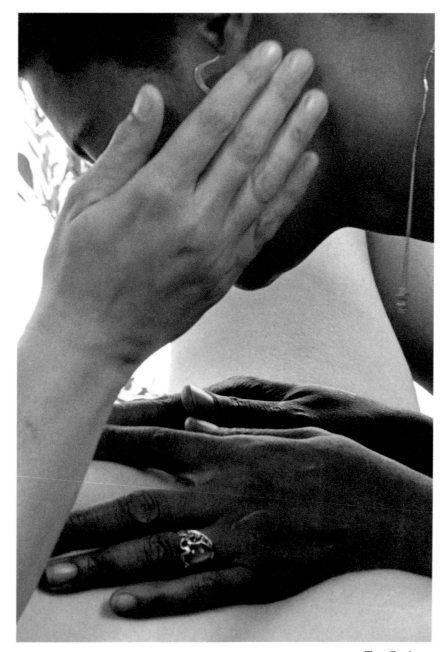

Tee Corinne

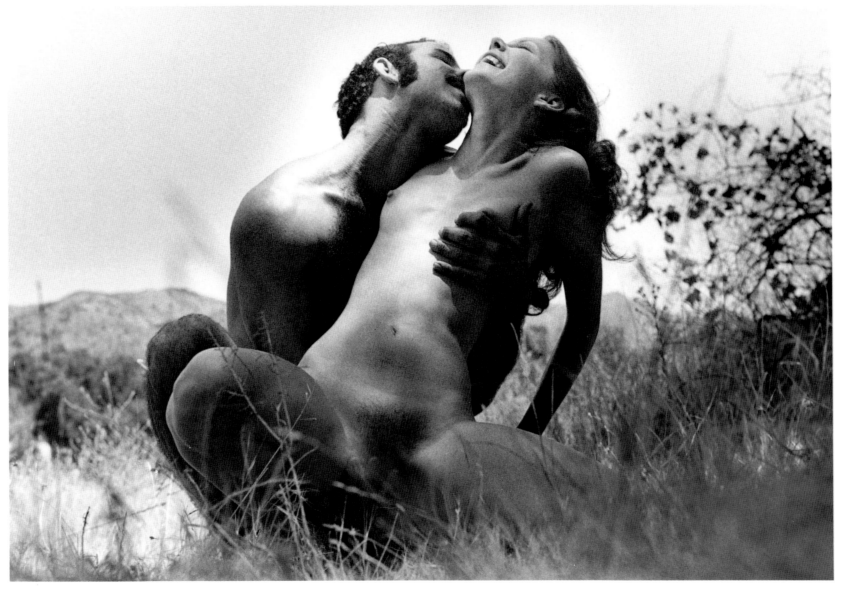

Ron Raffaelli

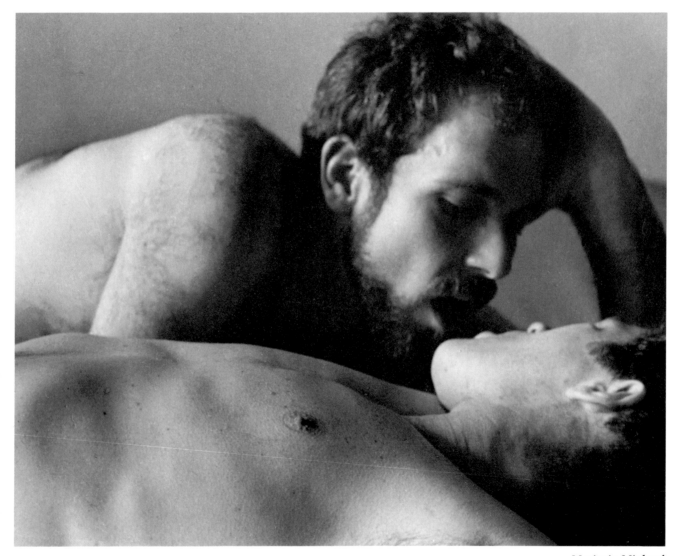

Marjorie Michael

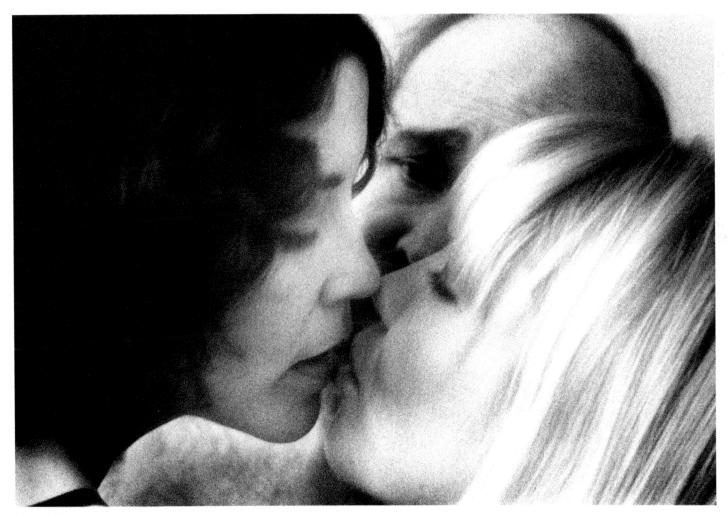

Michael Rosen

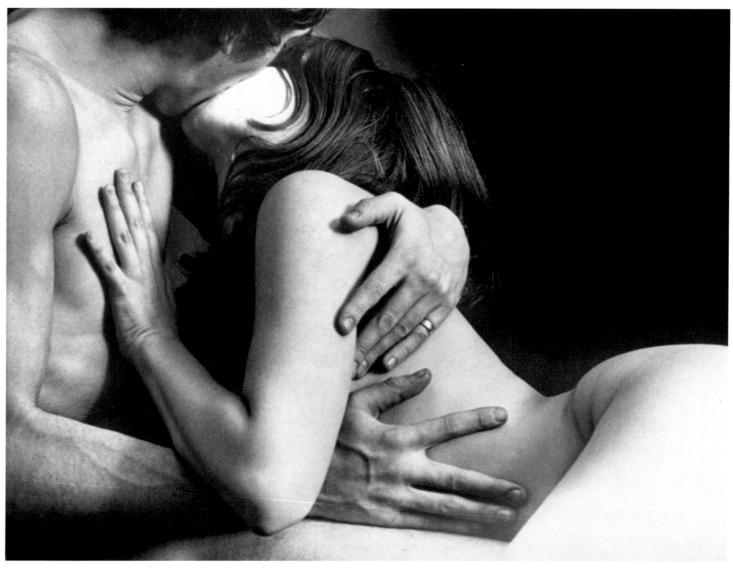

Ron Raffaelli

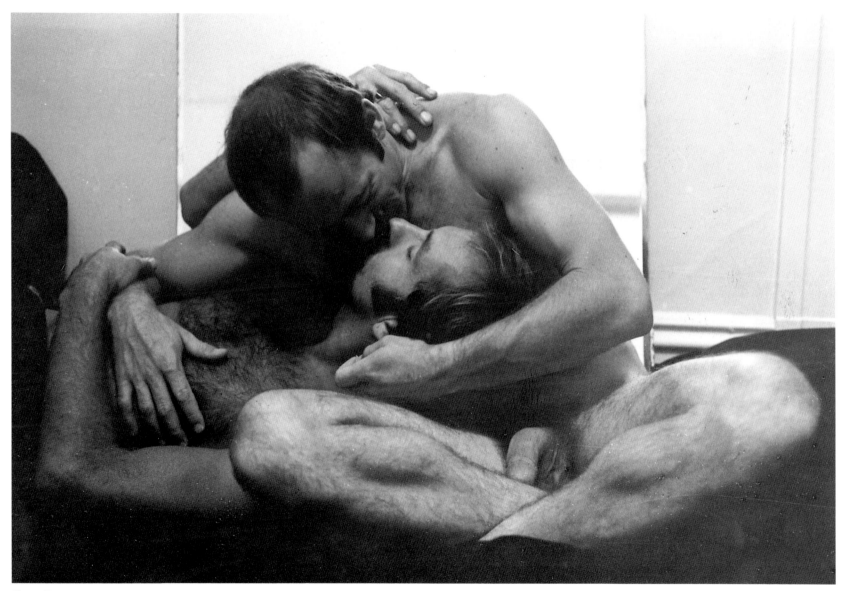

Greg Day

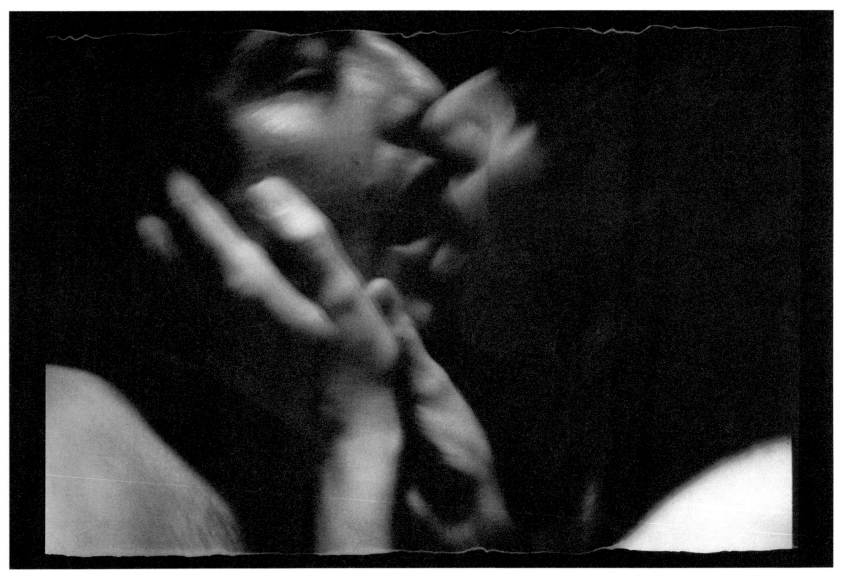

Tom Millea

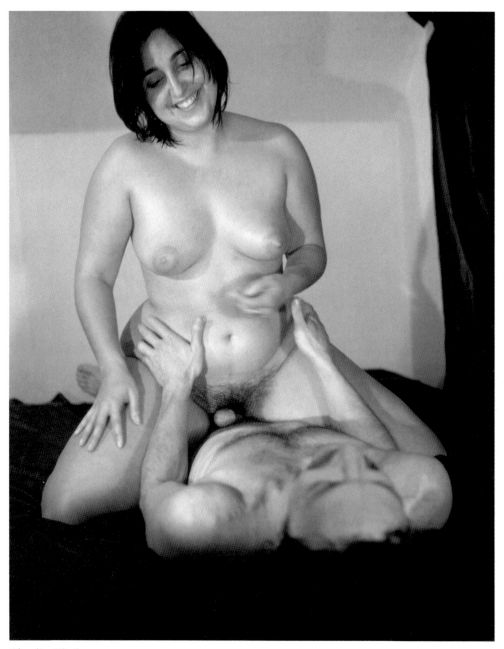

Charlie Clark

# *The High Priestess*

The high priestess sits at the entrance to the temple, her eyes open and still, her hands folded in her lap. From across the great chessboard plane I approach her. She never looks away, yet never looks at me, never moves, never gives a clue if she notices me or not. I ache to be seen by her, keep moving closer to her, despite her stillness, because of her stillness. As I reach her, she opens her arm to one side, spreading her robe into a curtain, taking me inside, into her temple, the home of wisdom.

Her robe is white and full-flowing, white and rippling with grey shadows. I pass under her arm into the folds, the billowing curtain all around me like wind in high grasses, like smoke in a still room, like Northern lights, like dance. And then there is nothing but the stillness, the stillness and everywhere the magic, which is everything and nothing. All direction is gone: I am snow blind. Even the ground is silken curtain calling, soothing, stroking. I am to be exploded into a million droplets of whatever I have been. I can feel the charge building. I ache to be blown apart, and also I am afraid. Only the texture, and somewhere too a scent, sweet and mysterious—only the texture and the smell of the flowing whiteness keep me from running away.

David Steinberg

*Photographs XI:*

# Metawomen

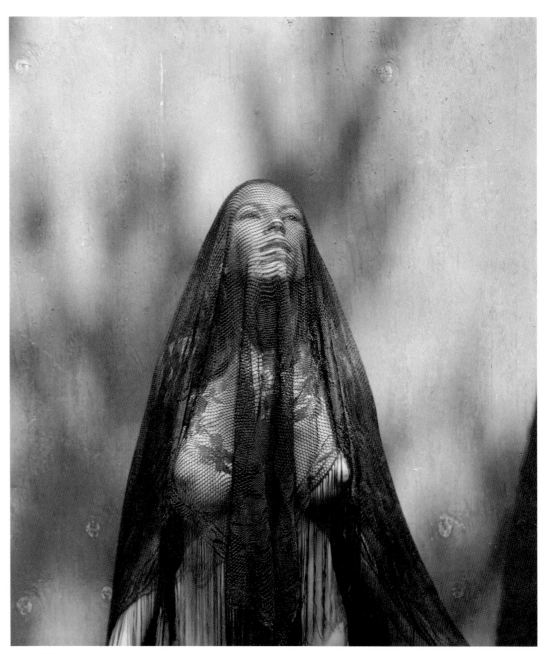

Tom Millea

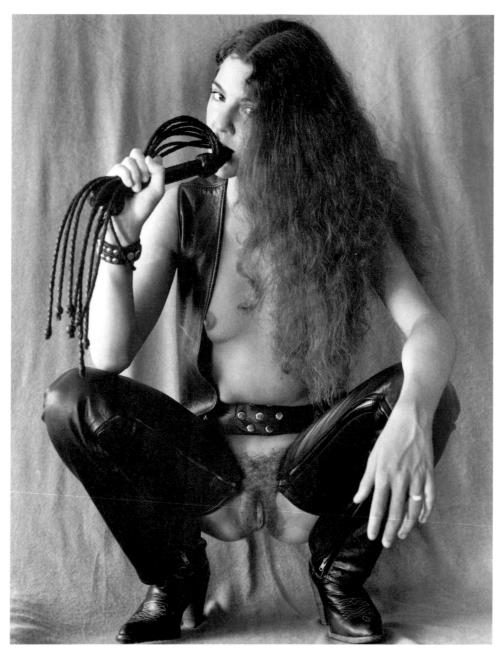

Morgan Cowin

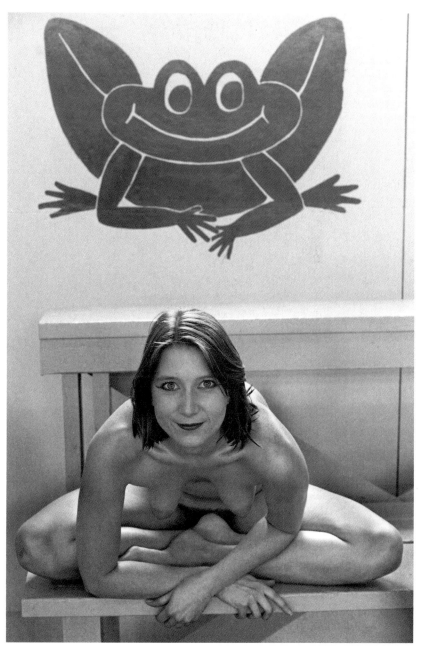

Morgan Cowin

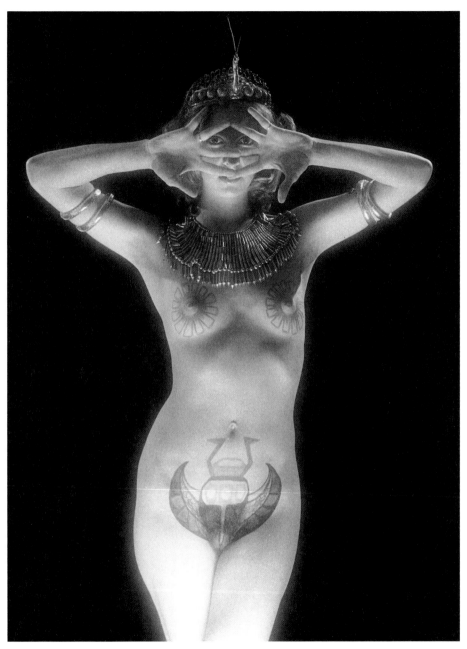

Ron Raffaelli

## Poems V:
# Come to Me with Magic

## Witch/Song

come to me with /magic/ glowing on your flesh
I am here, I am here where I always am
flowers in my hair, small orange lilies that
cry out for joy when they lie crushed between us
anointing our bodies with their perfumed lives
come to me, I am here, here where I always am
threading the stars that hang in the branches of the sky
shaping a garland of light for a love-gift
weaving a rose of glory to bloom in your misty hair
come to me through the corridors of night
where green girls dance
spinning their shadows into dreams
let your hands be as birds
and let them fly over me
I will take your breath as the summer wind
and I will give you that which I am
the gardens of my body
and the star-plains of my mind
be as the sun, and I will be the moon
and we will dance the iridescent skies
until the universe becomes one total pulse of joy
and neither lover nor beloved do exist
but only love

Lenore Kandel

## Moondraw

Wanting to dance you
to find the shape of you
follow the contours of your stream
gathering, spilling, gathering again.

With you there is the unknowing
the mindlessness
the wisdom of cells
millions of years gathering.
I want to listen to the whispering cells
your cells and mine
direct touch
no words.
(These words clumsy as bear
when I would be dolphin.)

That is the desire:
to dance dolphin with you
water-worldly
free of up and down
and so wet,
too slippery to hold,
the hollow of your side
the curve of your hip,
my arm a dolphin
to touch you there
until you breathe deep and I fall
into your belly

even as you later fall
into my mouth,
tongue diving deep
to bring back exotic seaweed
long buried in the muddy depths.
And now again the melting urge
to dive deep into you
close to the core.
These **are**, after all
but the surface mysteries.

I thought I heard echoes in your crying
in your rising wave,
the craving that comes
from the center of the earth.
We were, I thought
untangling the years
moving closer to the beginnings.
Melting into your melting
I let your waves wash away
salt tears already becoming crust.
Confirmation more than any words
to be taken in among the folds,
thoroughly and richly welcomed,
to find deep inside you
a love of woman
wondrous as my own.

David Steinberg

## the pleasure of feeling inside your body

the pleasure of feeling inside your body
and your body and your body and your mind
such ecstasy that has not been felt before
as though you were waves rising and falling
the motion of the sea
as though you were a bird
flying swiftly over the ocean
the moon in the background
a symbol of peace and serenity
as though ecstasy had been achieved
for the first time in a long memory
and one who could not play music
became a musician
a trumpeter a guitarist a pianist
a woman whose fingers played the harp
and became an instrument
or whose lips made the lips of the horn
melt and bend

as though woman became man
experiencing the pleasure of woman
coming over and over again
touching the center of her existence
and knowing the warmth of the sun
the fire of the moon
the rhythm of summer cicadas
butterflies bluejays

japanese beetles aglow like a jewel
emerald dazzling
fluttering frightening

Rochelle Lynn Holt

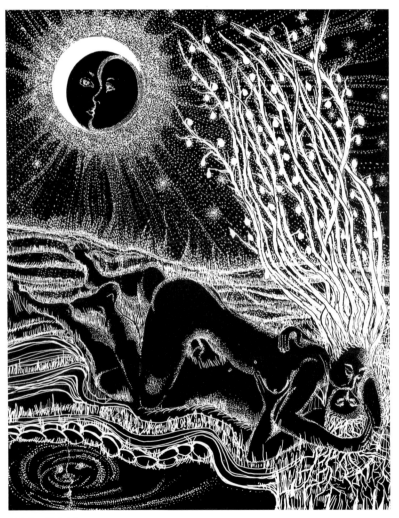

Adele Aldridge

## it is often referred to as the itch

it is often referred to as the itch, the urge.
getting your full satisfaction out of life.    out of
honey.    the sweet wet dripping down between legs.
after Satisfied.    after Sanctified.    After the rain,
no one complains.    just lie there, letting blood-filled
organs, tissues, brains re-do their molecular needs.
cellular renaissance.    voodoo dust.    like magic / is
born / a miracle.    two bodies gave birth and fed.
this is cock to cunt to cunt to cock counterpoint.
this is a blessing.    O lord.    O lord.    to bed.

                                        Leslie Simon

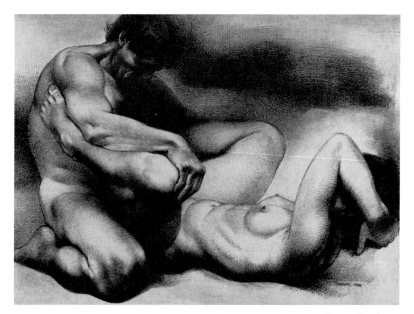

**Betty Dodson**

## do you feel me now

do you feel me now
feel me feel me feel me
now
how do i count
        do i count
        do i count
                the ways?
has this been said before
or is it love
    is it love
    is this love
do you feel me now
    this is love
    has been said before
count the ways
the times, the
arms and legs and
still,it is love

                                        Leslie Simon

# God/Love Poem

there are no ways to love but /beautiful/
        I love you all of them

I love you / your cock in my hand
        stirs like a bird
in my fingers
as you swell and grow hard in my hand
forcing my fingers open
with your rigid strength
you are beautiful / you are beautiful
you are a hundred times beautiful
I stroke you with my loving hands
        pink-nailed long fingers
I caress you
I adore you
my finger-tips . . .    my palms . . .
your cock rises and throbs in my hands
a revelation / as Aphrodite knew it

        there was a time when gods were purer
        / I can recall nights among the honeysuckle
        our juices sweeter than honey
        / we were the temple and the god entire /

I am naked against you
and I put my mouth on you    slowly
I have longing to kiss you

and my tongue makes worship on you
you are beautiful

your body moves to me
flesh to flesh
skin sliding over golden skin
as mine to yours
        my mouth   my tongue   my hands
my belly and my legs
against your mouth your love
sliding . . . sliding . . .
our bodies move and join
unbearably

your face above me
        is the face of all the gods
           and beautiful demons
your eyes . . .

               love touches love
               the temple and the god
               are one

               Lenore Kandel

# Song of Pleasure

Desire sweats between your legs and inner thighs. I kiss it. I smell it, rub my head and hair against it. I bury my face in your steaming genitals. Leaning forward, I wrap your penis for a moment in the ends of my hair and kneel beside you saying let me, just be still and let me.

The line of your shoulders, your chest tapering to slender hips, your thighs so hard and firm, move me, and I bend to kiss. Hair winds from your chest to your belly's gentle mound. My tongue licks at it. My mouth wets it. The moist hair wets my cheek. My hands take up your balls, scooping them like water to my mouth. Let me, I whisper, half upright beside you.

My whole body becomes a languorous tongue. I know you hardly dare breathe or stir. You submerge, eyes closed into pleasure, and slowing even further we drop deeper into your senses. Stalking, deliberate as a cat, my mouth seeks out your hidden places, the pores of your pleasure.

Your senses suck at me, slowing, slowing my breath. I slip down, lightly grazing your body with my breasts. My mouth wants more. My mouth wants your back, the fine thistle of hairs at its base where I kiss, moistening the path up your spine. My mouth wants your scent, returns down the curve of your back, follows the cool mound of your butt to the shadow at the thigh. My mouth wants the high hard muscle of your thigh, its smoothness where, softly biting, softly kissing, I explore a path to your taut belly. Still it wants more, and with small kisses I wet your penis down into the hair and up again, down and back, to the tip which my mouth wets with breath, which my mouth covers gently, slowly now, slowly sucking.

Rising to my knees, I arch and slowly place my thighs around you, take your penis firmly. Trailing it through the swollen lips of my cunt, I place its tip inside. With a shudder I seize you, my thighs tight to your hips. I draw you in and there is a sensation of coolness. I feel friendly, affectionate.

I hold you still, hold you motionless inside me. You place one hand on each of my breasts, tantalizing the nipples with the arch of your palm, touching them with your fingertips, rolling the nipples gently. I lift upward from my thighs, rise to my knees. Drawing you straight up with me until you have almost slipped out, I hold you with the tension of my jade room full of whirring birds. Then, lowering again, closing over you, I soak your penis.

Your hand lifts to caress me, but I turn it away. What rises to my throat is the body, its passion for movement and power. What moans at my throat is the body, carven and smooth as jade. My breast is against your mouth, your hair, and you fear me.

Catching your thigh between my legs, my hips saddle you, guiding, cantering, rocking your movements to mine. I hold your penis still, moving my cunt over it, letting the juices come. I press the tip to my clitoris, again and again, and only the wetness keeps us gentle. I love your cunt, you say, and like fingers, the words excite. I pour my cunt over you, shaping myself to you in undulation.

You are still, I in motion. Then I am still, daring you to ride into me. My cunt is supple and deep, eluding and containing your thrusts. Our hands sweat. Our skins stick. My fingers squeeze softly, open your buttocks slightly as you probe, as I challenge, as our bodies run together, speeding, slashing.

Then I slow you suddenly to another stride, lick you with my inner lips, soothe you with the muscled hand of my cunt to say there is more. I turn my back to your fore, still straddling you. I open my thighs even further, grow buoyant as we rise and fall like breath. I can feel your pulse ever harder inside me. I am vulnerable, my power exposed in every muscle, every line, every movement of my body.

Stronger and stronger, your blood beats at my cunt. You draw me down until I lie above you, my back to your chest, my hips still holding your penis, my cunt arched and accepting your thrusts. My nether mouth sings catch me, catch me, catch me if you can, and your thrusting grows more frenzied, more involuntary. I love the chase and shift again so that I am under you. My cunt bounces like sun on water, blinding, as your penis reaches out to seize. I want you fleet, or not at all. I want you swift as a shorebird, rhythmic as a gull. Before we are done, I will know you dancing to my body. Before we are done, I will know you soaring, your body sleek in its spasm. Before we are done, I will know you light and heady as woodsmoke. Before we are done, done, before we are done, I will know you fearsome, I will know you furious in grace.

So rapidly your tongue and mouth flash at different parts of my genitals. My strained body exhales again. Your mouth and tongue are cool, smooth as flint, rhythmically touching my clitoris, pressing inside like a cloud against a ceiling.

And now I love to play, knowing that the spasm is only a breath away, knowing I have no power, nor do you. I know the winding will begin. I know the orgasm is upon me. It whips its tail like a rattler, sending a sob of anticipation and pleasure through my being. The heavy throb comes once, goes, is gone. Is gone, oh no, gone, then throbs again, and goes again. I begin to move, seeking its rhythm, its hovering beat. It eludes, then becomes tangible, a throb of surprise and recognition from my cunt. Throb, throb, long and slow I undulate effortlessly in and out. The movement a snake within me, I lift and drop around you. No strain, nothing but this gesture—drawing you in, drawing away—repeated countless times, my eyes closed, my hips and legs circling your body.

You caress my inner thighs with your hair, and spread your fingers. My sap runs, the pulse of my cunt races, and I want it all. I want your strong thigh against my open cunt, your hair and fingers brushing my nipples and breasts, your tongue beating swiftly inside me, your fingertips at my clitoris, your penis smooth as my thighs close over it, your mouth moist all over my breast, your back damp and strong under my hands, your hair in my hands while your head moves to the rhythm of your tongue inside me. My senses gorging, gulping, I want it all: want your tight finger, the strain at my thighs, the soak and smell from my cunt, the clench of my clitoris, the pressure like pain, your light spirit tongue, your harsh arrow tongue, my hips lifting to give you the place, the place begging for your tongue which never stops, and my cunt spinning, growing like clay on a wheel, vibrating upward and down, the vibrations tremoring into my

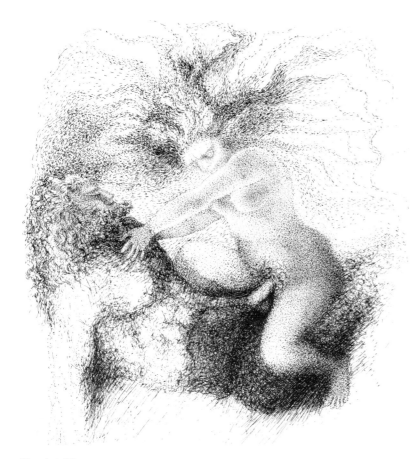

Harriet Moore

blood, my belly, my legs and feet, my fingers, my breasts, my back, my shaking head and shoulders, my cunt spinning so fast that I shatter and come, shouting.

Sensation breaks over me and holds me. I am lace or the rhythm of rain on a pond, and I know the shifting pattern will only draw me deeper in. I trail my fingers like a fin down your chest, to your thigh, to your penis, which I brush with moving fingers.

Our lips open and close more insistently against the other's. You stroke one of my lifted breasts. You drop to my hungry cunt, which sucks as though your finger were a nipple. The tension which moves my hips rings with an echoing, repeating clang from the muscles in my belly, in my butt, in my thighs flung with abandon as widely apart as possible. I stop the movement for a moment, and you lift your fingers to my breast. We conspire against orgasm, the pleasure at my breasts soothing the runaway head, the wild mane. My body whinneys, my cunt is the frantic scatter of birds before a storm. My movements, the touch of air at the inner lips of flesh, make me shudder with pleasure. My body is tinder again.

You press both hands to my inner thighs, then let them rise to my throbbing cunt. With a finger of each hand you stroke, then slide one finger inside, touching the other to my clitoris. The musk of our sweat, your semen, my secretions, mingle and intoxicate. I am blood. I am the first moment of breath. I ignite with a blinding explosion.

Breathing hard, my cries dying away, I yearn for your breath, your mouth moaning against my neck. I taste and caress you, warm and firm as a ripening in sun. My fingers are madness, my cunt against your thigh.

Then your body is over mine and my thighs spread wide again with welcome. Anthers drenched, I breathe myself open to your thrusts, then close as you draw away. I take your penis and touch it to my clitoris, move it, barely skimming, through my inner lips. Exquisitely slow, you enter again and cry out,

stunned by your hardness meeting mine. From a dark pinpoint, the eye of a shell opens, circling, enclosing, offering access to my cunt that flares open, quickens, sucks at you, at the air around you.

Your breath is hard, your body smooth, poised and taut. I

Harriet Moore

surge at you, cresting slowly against you with my cunt, then away. Coiling, my hips are sure and rhythmic, my cunt swallowing you, then drawing back. I stroke deeper and harder while you begin to answer, thrusting long, thrusting tense, your hips, your penis demanding, jabbing. I only grow more strong and fierce, calling you still further with the wildness of my movement.

You gasp, arch as though you'd been hit. Terror, hunger, the awful scorching into me, the rocketing through me to where I am a place, no longer a body. Thrust, thrust, I exult in every thrust. My cunt roars as you bear down, face hot against my cheek, breath ragged and low. Your body searing into mine, scalding against mine. Your body sobbing, jagged, hammering at mine. Again, again, again, again, and again. Then you are still, panting, so suddenly heavy.

As you relax, a small smile parts your lips. I kiss your tangled hair and laugh, the low sound strange to me. You lie beside me, one hand still at my belly, fingertips just touching the low mound of damp hair. I lift your hand and kiss it, cupped around my mouth. I smile, and your eyes open to watch my mouth, my tongue, my eyes watching yours. More naked than our bodies is the look passing between.

Donna Ippolito

*Photographs XII:*
## Surrender

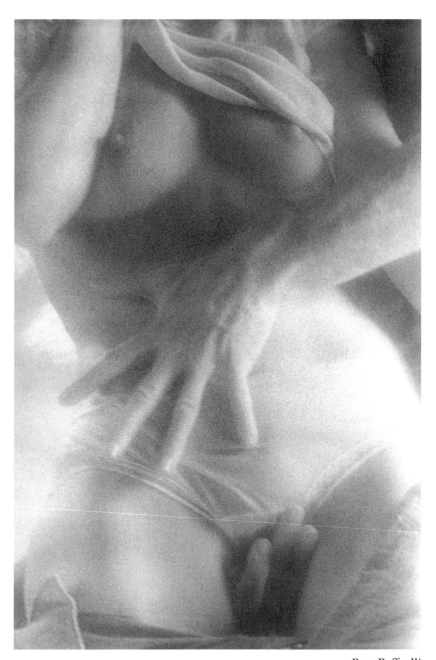

Ron Raffaelli

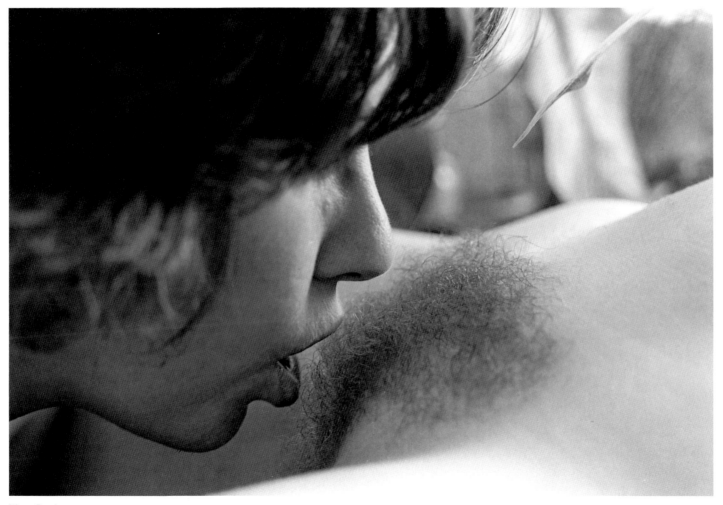

Tee Corinne

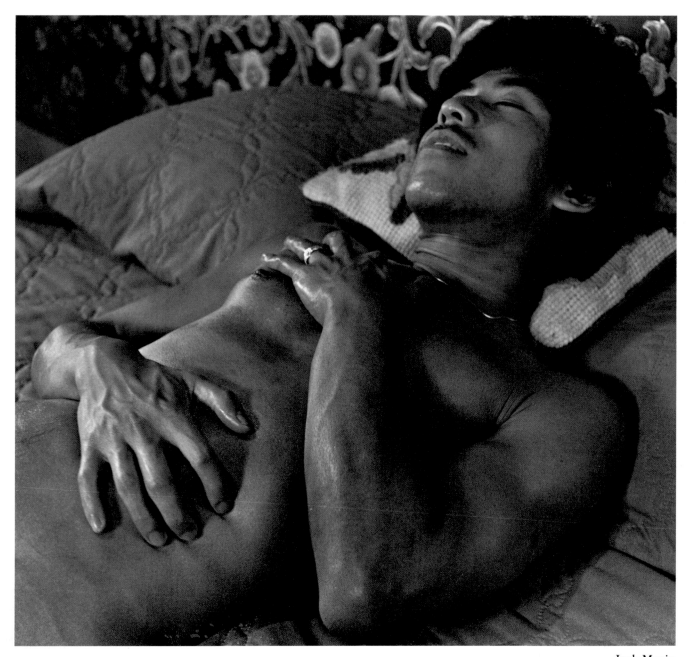

Jack Morin

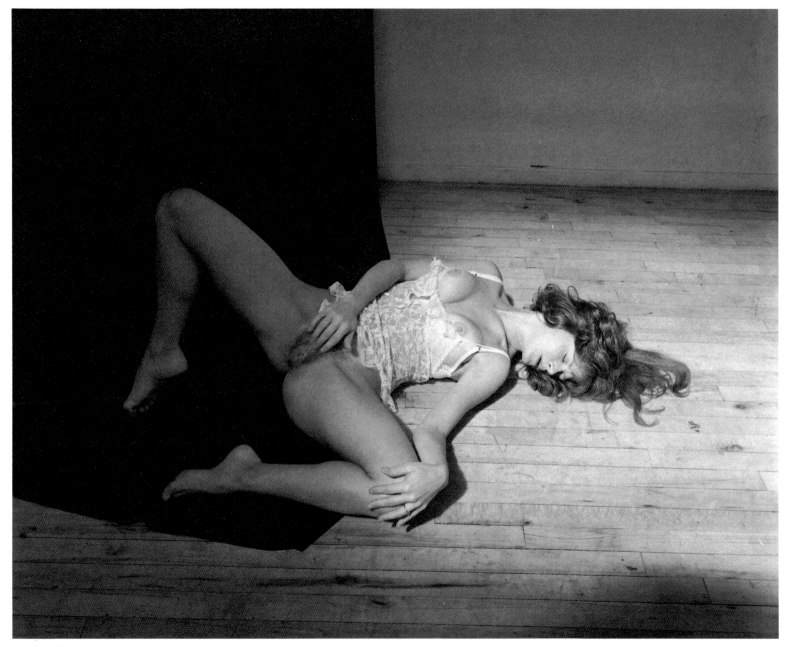

Tom Millea

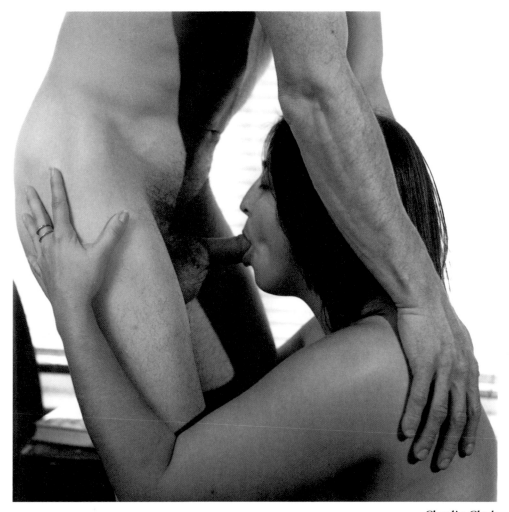

Charlie Clark

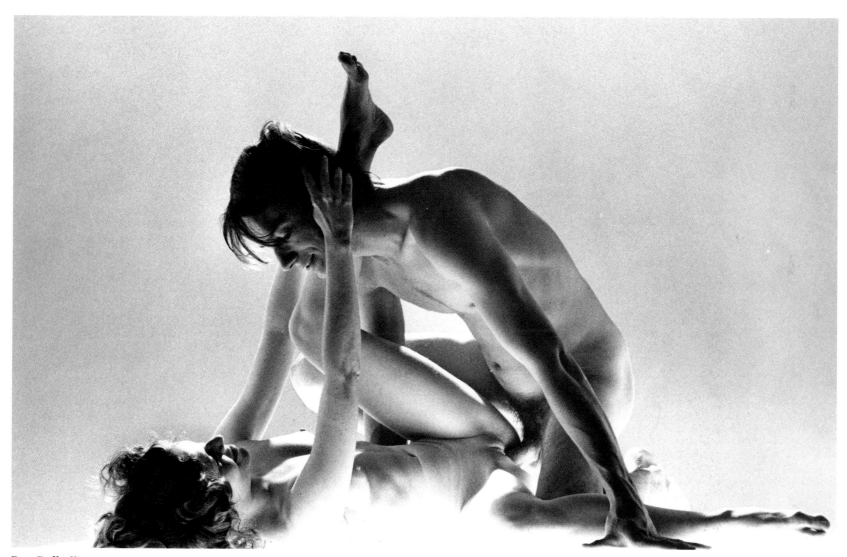

Ron Raffaelli

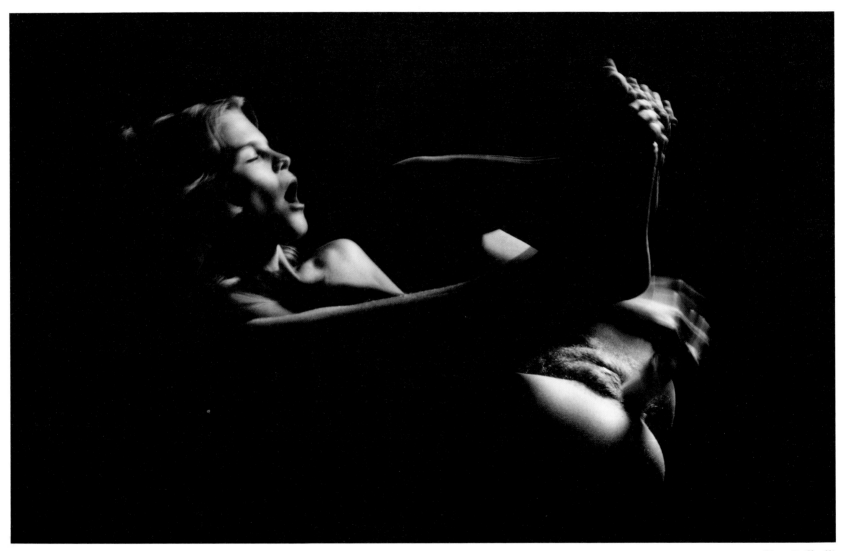

Ron Raffaelli

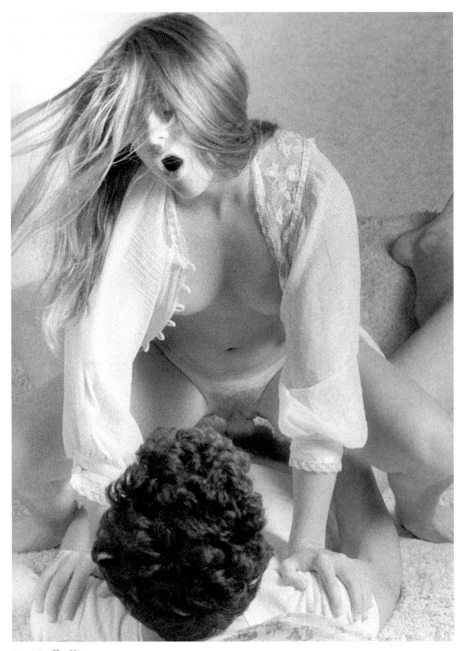

Ron Raffaelli

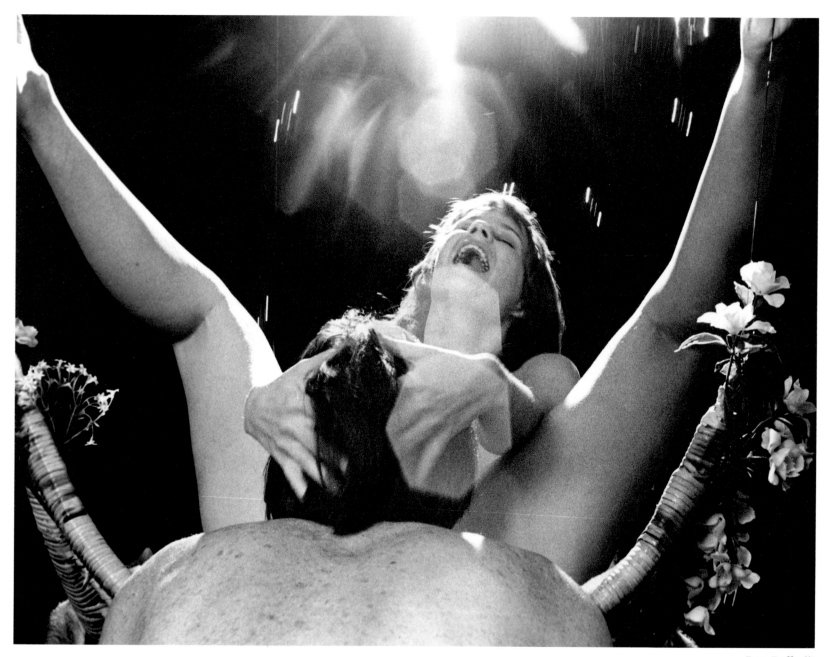

Ron Raffaelli

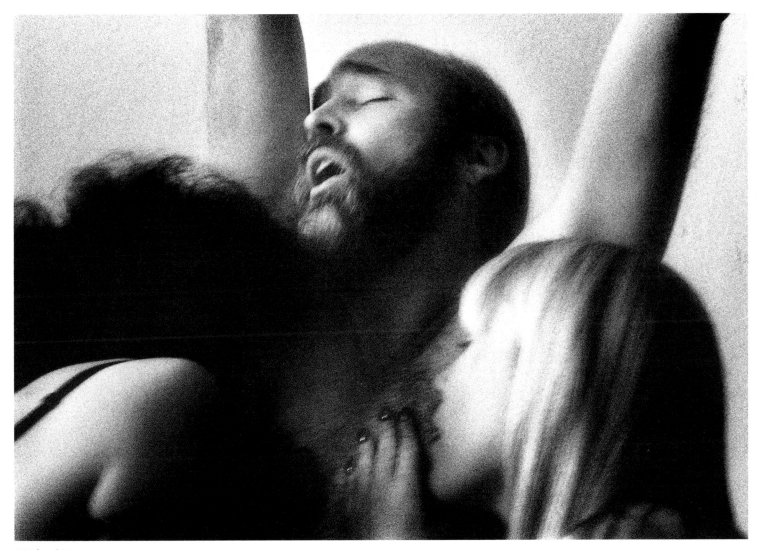

Michael Rosen

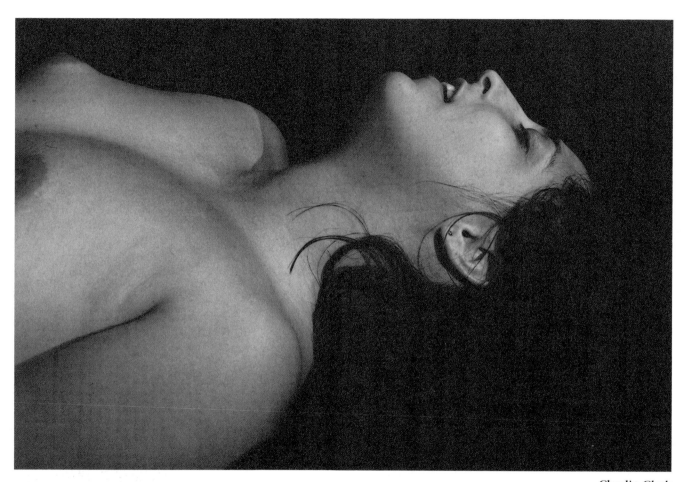

Charlie Clark

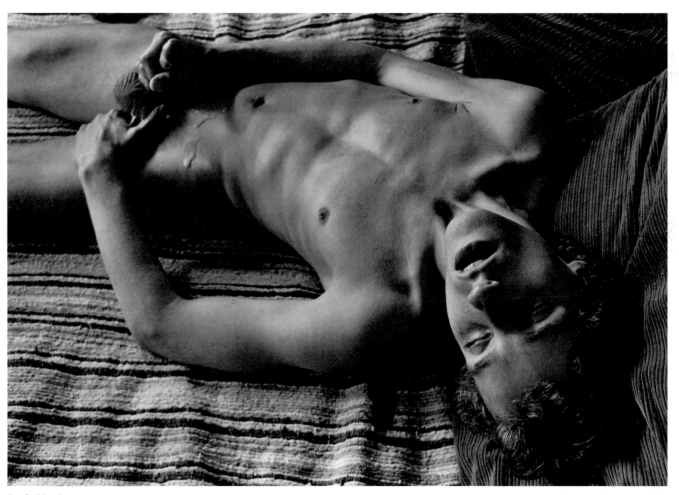

Jack Morin

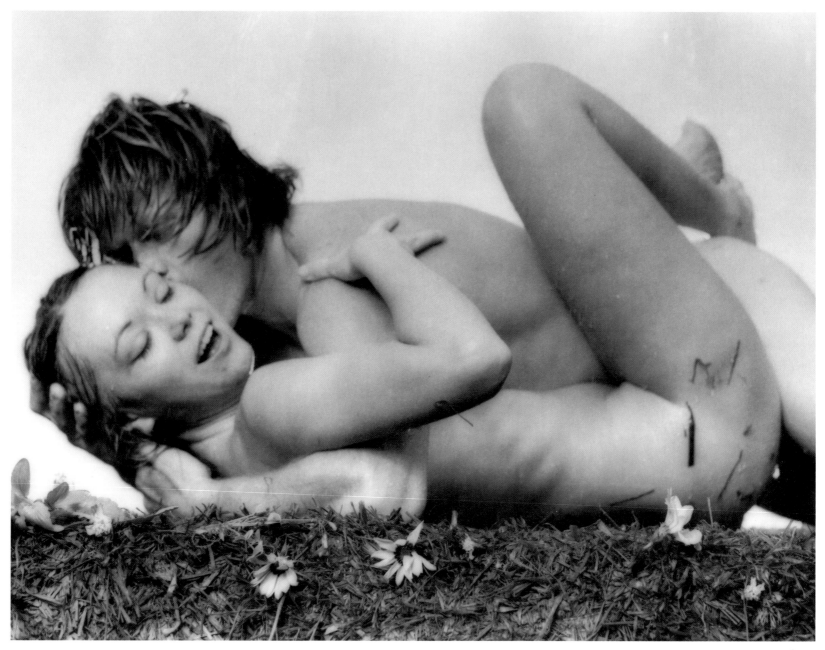

Ron Raffaelli

## I walk out, blindly

I walk out, blindly.
The stars have fallen,
the night is sharp black obsidian, cutting.
Stars are encrusted on the ground
around roots, and flower stems
crunch under feet.
My skin is wind-pricked.

In spite of myself I seem to be alive.

This life, splendid and terrible,
ambushes me from the thicket.
It is always that way.
And all the love and fear of me
tucked within you
or spilling from you,
and all that is remembered
or forgotten of us,
and all that yet crouches in the thicket
that is fierce and benevolent both,
and all the love
and all the fury,
and all the succulence and foolishness,
the truth and the ruthlessness,

what is within us and between us
and planted by each in the pith of us,
will overtake us and stun us
some day or night
no less beautiful than this.

# Contributors

**Deborah Abbott** has loved, worked and written nearly all of her 33 years. Her writing has been published in a variety of sources including *Friendly Woman, Matrix, With the Power of Each Breath—A Disabled Women's Anthology, Lesbian Words,* and *In Celebration of the Muse.* She currently works as a therapist, river guide, and parent to her two sons.

**Adele Aldridge**, 52, is a writer, poet, and artist who has shown her paintings and tapestries in galleries on both coasts. Her books include *Erotica, Once I Was a Square, I Ching Meditations,* and *Notpoems*

> "For me, making love and making art are about passion, rapture, roots, growth, regeneration, explosions, the cosmos. I often feel sexual energy while drawing, and creative energy while making love."

**Antler**, 41, has traveled widely reading his poems. He is the author of *Factory,* and *Last Words.* He received the 1985 Walt Whitman Prize, and the 1987 Witter Bynner Prize for Poetry. He spends several months each year backpacking and canoeing alone through North American wilderness areas.

> "Eroticism is our nature, in our nature—like rings of a tree, ripples on a lake, branching of antlers, or the zen and cosmicity of bird migration. Nature is the author of Eros, more than any single poet or photographer. The erotic is something much bigger than our individual love-ache yearnings."

**Julie Ball**, 35, a native of Melbourne, Australia, has been a California resident since 1974. Her illustrations have appeared in *Feminine Connections* as well as several other national and local women's newsletters. She has illustrated five books of poetry and prose, in collaboration with Linda Zeiser and Rochelle Lynn Holt. Her other creative pursuits include ceramics and photography.

> "In recent years my creative work has dealt with a description of line—both as illustrations on paper, and drawings on porcelain vase forms. With simple, sensuous lines, I hope to express gentle and tender forms of mutual caring. It is my fantasy that we shall all nurture one another's delicate bodies and psyches in loving and gentle ways."

**Steven Baratz**, 31, is a commercial photographer whose work has been exhibited in Massachusetts, New York, and California. He is a graduate of the Art Center College of Design.

**Lili Bita** is a Greek-born poet and actress, now living in Florida. She has performed widely, both in Europe and the U.S., and is presently touring with her one-woman shows, "The Greek Woman Through the Ages" and "Body Light." Her plays, stories, novels and poems have been translated into English, French, German and Spanish. Her books of poetry include *Lightning in the Flesh, Erotes, Fleshfire, Furies, Blood Sketches,* and *Bacchic Odes.*

> "I believe that Eros fights the dark sides of life, taking out the corrosion of time. Eros is the inspiration of God, necessary for the creation of Beauty and Poetry."

**Sandy Boucher** just joyously celebrated her first half-century of life, during which she has published *Heartwomen: An Urban Feminist's Odyssey Home,* and two books of short stories, *Assaults & Rituals,* and *The Notebooks of Leni Clare.* She teaches writing workshops, and practices a form of Buddhist meditation. Her erotic writing has appeared in *Erotic Interludes, On Our Backs,* and *Yoni.*

**James Broughton**, 73, has produced some twenty books, and as many independent films. He has received two Guggenheim Fellowships, grants from the National Endowment for the Arts, and a Cannes Film Festival award. His most recent books of poetry are *Graffiti for the Johns of Heaven,* and *Ecstasies.*

**Edna Bullock**, 72, has conducted many lectures and workshops through such auspices as the Ansel Adams Gallery, the California Museum of Photography, and the Oliver Gagliani Workshops. Her photographs have appeared in such publications as *Cutbank, Naked, A Portfolio*, and *Photographer's Encyclopedia International*, and have been exhibited throughout the U.S. She is the editor of *Wynn Bullock: Photographing the Nude*.

> "I believe the human body, the male specifically, is the most fascinating and ever-changing of subjects. The male nude in outdoor situations has long been neglected. I wish to remedy this by creatively recording the relationship of the nude body to its immediate environment. I want the model to respond to the environment of his own volition, and will only direct a change in body placement or tension if it is in discord with that environment. I want my photographs to be partnerships between photographer, subject, and viewer."

**Martha Casanave**, 41, is a free-lance photographer and teacher of environmental portraiture and figure photography, working through the University of California Extension, the Ansel Adams Gallery, and Friends of Photography. She has led photographic workshop tours to the Soviet Union and Eastern Europe, and is involved in bringing the work of Soviet art photographers to the attention of the West. Her work has appeared in such journals as *Camera Arts, Popular Photography, American Photographer*, and *Modern Photography*. She has received the Imogen Cunningham Photography Award.

**Marc Chaton**, 30, is a freelance photographer and restauranteur whose work has appeared in galleries along California's north coast and in *Changing Men, M*, and *Making Waves*.

**Charlie Clark**, 40, is a graphic design and printing consultant. He began his photographic work by documenting daily army life while stationed in Southeast Asia in the late 1960's, and for the last decade has been working with nudes and specifically sensual images.

> "My erotic work is an outgrowth of my dissatisfaction with the too plastic, or too sexually graphic, images of women found in

the media. I have been seeking to produce nude images of men and women which are neither overtly sexual nor oppressive, experimenting with forms based on the works of Edward Weston and Ruth Bernhard, using friends, mostly in their 30's and 40's, as models. I feel that perhaps half of my images in this book represent the direction I hope to pursue, while the balance are experiments needed to reach this place."

**Tee Corinne**, 43, is a photographer and writer whose books include *Yantras of Womanlove, Labiaflowers*, and *Women Who Loved Women*. Her work has been published in such journals as *Our Bodies/Ourselves, The Advocate, Sinister Wisdom, On Our Backs, Off Our Backs, Sojourner, Penthouse, The Blatant Image, Telewoman, Yellow Silk, EIDOS*, and *WomanSpirit*.

> "The celebration of sexuality in visual erotica has been central to my work in the last 14 years. I'm interested in the magic of this kind of imagery: the shield and heraldic forms of labia; the grace with which we touch our own bodies and others'. I love the power of sex in art, the bringing forward of what in Western societies has been both hidden and forbidden. My goal is to produce loving, beautiful, sexy images—pictures that call me back to something essential about the connections women can make between and among ourselves. I also want the images to be a turn-on, to create an adrenaline high, a rush of desire so intense that the act of looking is sexual, the image itself visually consumed, creating a lasting change in each viewer's awareness of self, sexuality, and art."

**Morgan Cowin**, 41, is a free-lance photographer who has taught photojournalism at the University of Nairobi, and classical guitar at the Kenya Conservatory of Music. His work has been published in *California Living, Co-Evolution Quarterly, National Geographic World*, and *Sierra Magazine*.

> "I have always been intrigued by nude bodies. Most of my subjects are not classic beauties (I even have a 92-year-old woman friend whom I long to photograph), but I see something worth celebrating in each of them. Recording their loss of inhibition and their growing freedom to express themselves in an intimate fashion is fascinating to me. I regard the photographic experience as a collaborative effort. I want my subjects to feel good

about the end product, and about our time together. While most of my subjects are women, I welcome the opportunity to photograph men, couples, and families with children. All races and ethnic groups are of interest to me."

**Lauren Crux**, 39, earns her living practicing the art of psychotherapy. Her photographs and writing have appeared in *Women in the Wilderness, Lesbian Words II, Women's Sports, Fitness Magazine, Sinister Wisdom, More Golden Apples: Women and Athletics*, and *Will the Circle Be Unbroken: Women Healing the Trauma of Family Abuse*.

**Greg Day**, 42, is a native of the American South. His photographs have been exhibited at the Smithsonian Institution, the High Museum, and the Oakland Museum, and have been published in the United States, Canada, Great Britain, Norway, France and Spain.

> "My photographs are, to a large degree, 'found objects.' I am obsessed with the spontaneous, with the social context of communication. I often find myself waiting for the moment when seemingly opposite ideas overlap and merge. To me, the unification of opposite symbols is a central theme in lesbian/gay culture. It derives, I believe, from the realization that male and female qualities are essential parts of the whole person."

**C. M. Decarin**, 38, has been published in such journals as *Yellow Silk, Heresies, The Advocate, Plexus, Riverside Quarterly, Coming to Power, The Little Magazine*, and *Inscape*. She is a winner of the Writers of the Future science fiction contest, and is co-editor of the lesbian and gay science fiction/fantasy anthology *Worlds Apart*.

**Betty Dodson**, 58, is a native of Wichita, Kansas. Her 1968 and 1970 New York exhibits of erotic art, including her four life-sized classical nudes masturbating, drew record-breaking crowds, shocked the art world, and provoked a media blackout. Her work has also been exhibited in Los Angeles, Chicago, and at the International Museum of Erotic Art in San Francisco. She is the author of *Liberating Masturbation: A Meditation on Self-Love* (republished as *Self Love and Orgasm*), and *Sex for One:*

*The Joy of Selfloving*. She has lectured widely on erotic art, sexuality, and self-healing, and currently conducts workshops for women on body image and masturbation.

> "I have always painted the nude, but I originally thought of the nude as sensual, not really sexual. The first year after my divorce, I felt so incredibly good about myself and life, and was so sex-affirmative again, that it was the most natural thing in the world to say: 'Of course! I'm going to put my nudes together on canvas. I will do huge magnificent drawings and paintings of humans celebrating physical love.' I have always struggled against society's restrictions and censorship. But the worst kind of censorship has been the kind I've been conditioned to apply to myself. Now I understand that once I am able to put down on paper whatever it is I fear, I've won."

**Dreaminhawk**, 41, has been published in various feminist publications, including *Ms., Women: A Journal of Liberation, Wild Iris*, and *On Our Backs*. She is presently working on a lesbian detective story.

**Gary Epting**'s work ranges from commercial art and commissioned portraits to his increasingly well-known erotica, which has appeared in *Yellow Silk* and *Cupido*. His next project will be a "profusely illustrated" edition of the memoirs of Giacomo Casanova. He is 35.

> "My erotica has always been a personal matter. I do paintings, sculpture, and single-edition illustrated books. Because of my background in both animation and painting, I find myself utilizing cinematic devices in my art: zooms, cuts, close-ups, and serial imagery."

**Clytia Fuller**, 38, has been a lesbian feminist photographer for over 11 years, with an emphasis on photographing those aspects of women not traditionally shown. She has been published in *WomanSpirit, Plexus, Lesbian Health, Matters, Lesbian Words II, The Blatant Image*, and other feminist publications. She has two children.

**Greg Stirling Gervais**, 40, writes: "Some of my drawings are hanging in the homes of my friends; once in a while they are

hung in friendly cafés or galleries. I like to draw for children. I like to sing to children. I'm considering becoming a clown."

**Jerry Hagins**, 30, runs an advertising agency for non-profit, public-service clients. His poems have appeared in *Rolling Stone*, *Painted Bride Quarterly*, *Yellow Silk*, and *City Paper*.

**Hella Hammid**, 65, has been a free-lance photographer for such publications as *Life, Town and Country, Ebony*, and *The New York Times*. She has published several books, including *The Sensible Book* and *A is for Aloha*, and has photographed such personalities as Benjamin Spock, Edward Weston, Imogen Cunningham, Alexander Lowen and Anais Nin. Her work has been exhibited in many galleries and museums, and is included in *The Family of Man*.

> "My nudes are about ephemera—sensual trigger-points for the imagination."

**Kaleiiliahi Henkelmann/Muller**, 38, is a graphic artist whose work has been exhibited in a number of California galleries, including Hale and Van Haus Gallery, Michael's, and Gwynn Gallery.

> "I view sex as holy communion, and erotic art in the same manner. Erotic art is the expression of one fine art form by another."

**Michael Hill**, 30, is a registered nurse, free-lance Buddhist monk, and half-time single father of "an impossibly wonderful nine-year-old girl." His education includes a stint as an evangelist, three years of being homeless, three years as a househusband, and a number of years working with terminally ill people.

> "I want to be faithful to all the faces of eros: in friendship, in fathering, in the dear arms of my lover, in my spiritual practice, and in the dialogue of psyche and sensuality that is poetry. When patriarchy throws its net of double binds over my body, I want to be the fish that slides lithe through the net."

**Rochelle Lynn Holt**, 41, is a poet, dancer, painter, sculptor, and teacher who has traveled widely, giving over 350 readings of her work over the past twenty years. Her most recent publica-

tions include *The Suicide Chap, The Elusive Rose, Prescriptions for Psyche, Extended Family*, and *The Blue Guitar*. She received the 1986 Willow Bee Publishing House Award for Literature.

> "No doubt Aphrodite had other children besides Eros, but the seventh sexual sense is as highly revered in my life as all the other sensitivities. Without sight, smell, sound, taste, touch and ESP, sensuality will be less keenly felt by those without imagination. I believe that Love is the password to experiencing the essence of Life: love of self, other humans, animals, nature. If you do not love intensely and say Yes to the universe, you are not alive."

**Donna Ippolito** is a dancer and writer, and author of *Erotica*.

> "Seeking to discover and affirm what was really mine, I went back to the body. Moving deeply into the physical, I searched for my spirit. I was attempting to inhabit myself fully, to open into myself and let the inner woman take flesh. I began to explore my deepest feelings about desire, passion, touching, being touched. When I was lyrical, I accepted it. When I was vulgar, I accepted it. When I was tender, I accepted it. When I was angry, I accepted that too. There was no contradiction between instinct and love when I simply let both flow."

**Paul Johnson**, 52, has been creating nude and sexually explicit photography sine 1965, including the photography for *Sex in Marriage* which, when challenged as obscene, first established the legal legitimacy of sexually explicit photography in the U.S.

**Lani Kaahumanu**, 43, is a feminist activist who began writing in 1974, when she made a major career change and left full-time suburban housewife/motherhood. She writes and performs with *Mothertongue*, a feminist readers' theater, and holds degrees in Women's Studies and Psychology from San Francisco State University.

**Lenore Kandel**, 55, is a California poet whose erotic writing has been well known since 1966, when publication of *The Love Book* resulted in international praise and controversy. She is also the author of *Word Alchemy, An Exquisite Navel, A Passing Dragon*, and *A Passing Dragon Seen Again*. She has been published in

magazines and anthologies in Germany, Switzerland, Denmark, Italy and Japan, as well as in the U.S.

**Carolyn Kleefeld**, 39, is the author of three books of poetry, *Satan Sleeps With the Holy, Climates of the Mind,* and *Lovers in Evolution.* She is presently writing, parenting, and working with video and computer-generated art forms.

> "For me, the erotic is the protoplasmic seed of all germination, the essential fuel of passion—whether experienced in the transcendental spaces of one's nature, or in the ultimate, sexual, fusion of fire between lovers. My art is given breath from living the Oneness, is inseparable from the sex of it."

**Arthur Knight**, 49, is the author of numerous books, most recently *The Golden Land, King of the Beatniks, A Marriage of Poets,* and *The Beat Vision,* the last two co-edited with his wife, Kit. He is editor of *The Unspeakable Visions of the Individual.*

**Ron Koertge**, 47, is the author of 14 books of poems, the latest of which is *Life on the Edge of the Continent.* He has published two novels, *The Boogeyman,* and *Where the Kissing Never Stops,* and has written a script for the television series *Hill Street Blues.* He presently teaches writing in Southern California.

**Norman Lavers**, 52, a dedicated amateur ornithologist, has traveled all over the world watching birds and other wildlife. He has published short stories, photographs, and articles on birds, and is the author of *The Northwest Passage, Jerzy Kosinski, Mark Harris,* and *Selected Short Stories.* He has received the O. Henry Editor's Choice and Hohenberg awards for his short stories. He is married, has one child, and presently teaches creative writing in Arkansas.

**Lyn Lifshin** is the author of over 70 books and chapbooks, including *Upstate Madonna, Black Apples, Remember the Ladies,* and *Naked Charm.* She has edited a series of books of women's writing, including *Tangled Vines* and *Ariadne's Thread.* Her poems have appeared in many topical and literary magazines, notably *Ms., Rolling Stone, American Poetry Review, Ploughshares, Massachusetts Review,* and *Chicago Review.* She has

taught writing at universities, colleges, and high schools throughout the Northeast, and has received more than a dozen writing awards and grants, most recently the 1984 Jack Kerouac Award for her collection of poems, *Kiss the Skin Off.*

**Virginia Love Long**, 46, is a North Carolina poet whose erotic work has appeared in *Human Sexuality: The Argument of Art* and *Amorotica.* She is the author of *The Gallows Lord, Shared Journey: A Journal of Two Sister Souls* (with Rochelle Lynn Holt), *Squaw Winter,* and *After the Ifaluk and Other Poems.*

**Vivienne Maricevic** is a self-taught art photographer whose work has been exhibited at the International Center of Photography, Marcuse Pfeiffer Gallery, Neikrug Gallery, and Cameravision. Selected portfolios of her work have appeared in *Women See Men, The Male Nude in Photography, New American Nudes, Erotic Photography, Lieben Zu Kafen, Camera Arts, Photography Annual, EIDOS, Penthouse, Oui, Foto, Photo French,* and *Photo Japan.* She has received a 1987 Artists' Fellowship from the New York Foundation for the Arts.

> "Seeing very few images of male nudes in magazines led me into the exploration of erotica. My first erotic series, *Naked Men,* consisted of photographing men at home. My *Male Burlesk* series led me into clubs featuring male dancers. *Live Sex Shows* was spent exploring clubs in the Times Square area. Meeting performers at these clubs evolved into my *Porn Stars* series. I am currently working on a series of photographs of transsexuals. The sensitive nature of erotica gives me the determination, patience, and curiosity to explore these arenas, and to be able to share my photographs with others in a positive manner."

**Catharina Marlow**, 40, is a photographer and psychologist whose photographic work ranges from female and male nudes to a social documentary on the homeless.

> "My photography consists of three distinct sets of work: landscapes; work with the female form; and, in the last four years, blending the two, allowing one experience to influence the other. Recently I have broadened my work to include the male nude as well."

**M. E. Max**, 54, has written poetry, fiction, and non-fiction "unremittingly" since she was five years old. She is presently working on an erotic science fiction/fantasy novel, and on a story of passion between people over fifty. In addition to writing, she enjoys woodland hikes, swimming, zen, and creating pottery.

> "I see the erotic as both bright and dark: bright for the beauty and pleasure that spring from it; dark because it touches our deepest, sometimes violent, instincts and convictions. While much modern fiction is saturated with facile sexuality, we need more writers and artists who will explore the eroticism of our time in depth."

**Deena Metzger**, 50, is a poet, writer and healer whose work has concerned itself with the relationship between eros and peacemaking. Her books include *The Woman Who Slept with Men to Take the War Out of Them, Tree, The Axis Mundi Poems, Dark Milk,* and *Skin Shadows, Silence.* Her plays include *Dreams Against the State, Not as Sleepwalkers,* and *The Book of Hags.* She has received a Creative Writing Fellowship from the National Endowment for the Arts, the First Annual Vesta Award for Writing from the Women's Building, and the first California Federation of Teachers Academic Freedom Award. She is the mother of two sons, and lives at the end of a dirt road with her wolf, Timber.

> "I've devoted my life, personally and professionally, to the exploration of the relationship between eros and peace, eros and healing. The erotic, in all its dimensions, is the force that binds us to each other, and so it has personal, social, and political consequence. Nature is eros itself, and culture—when it is vital— is grounded in eros. The heart depends upon eros. Perhaps it is now our task to eroticize Mind."

**Marjorie Michael**, 67, attended Meredith College and The Corcoran School of Art, studying under Hans Schuler and Robert Laurant. After marriage, six children, and many moves, she returned to her sculpture and eventually to photography. Her work has been published in *The Advocate* and *A Woman's Journey*, and exhibited in New York and Tennessee.

> "It is a long way from a Southern family, where my nude life drawings were hidden from sight by my parents, to enjoying and being immensely proud to have done a series of photographs of gay men. As I affirm their lives, I affirm my own."

**Tom Millea**, 42, is a California photographer whose work has appeared in numerous galleries, including the Weston Gallery, Friends of Photography Gallery, San Jose Museum of Art, Center for Creative Photography, and the Marcuse Pfeiffer Gallery. His work is represented in the collections of the New York Museum of Art, the Australian National Gallery, the New Zealand National Museum, and the Polaroid International Collection.

**Harriet Moore**, 66, is a painter, sculptor, and teacher. She has studied sculpture with Simon Moselsio, Luis Monasterio, Jose de Creeft, and John Hovannes. Her major artistic effort has been illustrating Dante's *Divine Comedy* through painting and sculpture. Her work has been exhibited at the New York Museum of Modern Art, Grace Cathedral, St. Peter's Lutheran Church, and the Vorpal Gallery.

> "My work expresses the closeness of passion to cosmic rhythms. The personal center of intense passion flows, thrusts, throbs outward to become part of all nature."

**Jack Morin**, 41, is a psychotherapist in private practice and a teacher of courses in human sexuality. He received his doctorate from Saybrook Institute, where his research focused on the development and testing of new sex counseling techniques. He is the author of two books, *Men Loving Themselves* and *Anal Pleasure and Health*, and is currently researching the psychology of sexual excitement as expressed in both fantasy and actual behavior.

**Ron Raffaelli**, 44, is a widely-known producer of erotic still photography and videotapes. His photographs have appeared in various one-man shows, and in a Smithsonian Institute exhibition on American advertising. He has produced album covers and still photographs for the Beatles, the Rolling Stones, Jimi Hendrix, the Doors, the Osmonds, and Liberace. He has published three volumes of erotic photography, *Rapture, Desire,*

and *Temptations*, and has produced over 70 erotic films.

"The first time our parents punished us when we were caught in the innocent act of sex-play, a sensual Garden of Eden vanished which it is the responsibility of the erotic artist to recreate and vivify. The laughter, fondling, licking, and kissing are natural human manifestations, but once abandoned they are difficult to rediscover. The role of the erotic artist must be more than simply to entertain: I must strike an innocent, long-silent chord in the viewer's imagination—that part of us which unabashedly plays with our sexuality, experiments, laughs at our awkwardness, and celebrates every sensuous success."

**Gypsy Ray**, 38, is a California photographer whose male and female nudes have been published in *Creative Camera* and *The Male Nude in Photography*, and have been exhibited at the Marcuse Pfeiffer Gallery in New York, Focus Gallery, and in various group shows. She is currently working on a documentary exhibit of photographs and personal statements of people affected by AIDS.

**Elliot Richman**, 45, has been published in numerous literary journals, including *The Black Bear Review*, *Impetus*, and *Deros*. "My hands under her dress" was written when he was 21.

**Michael Rosen**, 45, is a photographer whose abstract and grainy photographs of nudes have been exhibited acrosss the U.S. He is the author of a book of erotic photographs, *Sexual Magic*.

**Terry Rozo**, 35, is a staff photographer for *Provincetown* magazine. Her work has been exhibited in many group shows, and is part of the Bell Telephone Art Collection. Her one-woman show, *West Side Story*, was curated for the Museum of the City of New York. She has received the Jack Gilbert Award from *Popular Photography* magazine.

**Michael Rubin**, 50, is the author of five published novels, including *Whistle Me Home*, *In a Cold Country*, *Unfinished Business*, and *An Absence of Bells*; a journal, *In the Middle of Things*; and an anthology of men's diaries, *Men Without Masks*. His

stories have appeared in *Redbook*, *Cosmopolitan*, *Family Circle*, *Antioch Review*, *Kenyon Review*, and other literary journals. He was a Fulbright Scholar, and has received a grant in literature from the National Endowment for the Arts.

**H. M. Ruggieri** is editor of *Uroboros* magazine. Her books include *Concrete Madonna*, and *The Poetess*. "The Girl Next Door" is a chapter of an unpublished novel, *On the Road to Accident*, which she wrote as "therapy for a passing-forty, mid-life crisis." She also writes poetry and gardening articles, and sells potpourri.

"Erotica has been found as far back as the Sanskrit of the fifth century. It seems to hold that middle ground between love stories where sex is avoided, and pornography or obscenity. When I think of Sappho, Catullus, the Song of Songs, Chaucer, Keats, Byron, Lawrence, Joyce, Miller, and Jong, I love putting Ruggieri at the end of the list!"

**Susan St. Aubin**, 43, is a secretary half the time, and a writer the other half. Her stories have been published in *Yellow Silk*, *Short Story Review*, *The Reed*, *Wind Chimes*, *Plexus*, *Women Talking*, *Women Listening*, *Fiction Monthly*, *The San Francisco Chronicle*, and *The Pacific Sun*.

"I started 'Other People's Houses' when I turned 40, mainly because I realized I was finally a grown-up and was tired of reading all those stories of adolescent and post-adolescent yuppie angst so prevalent in *The New Yorker* and similar publications. I don't usually plan to write erotica, but sometimes it turns out that way: a woman walks into an empty room and finds a man, or turns a corner and sees a woman she's always fantasized about, and the ordinary world becomes erotic. I don't see much of a difference between my erotic and non-erotic writing, since the non-erotic is potentially erotic, but the distinction seems important to others, especially editors."

**Magi Schwartz**, now in her mid-40's, was born and bred in Baltimore. After a long period devoted to home, hearth, and having four sons, she moved to Florida, where she is an editor of the *South Florida Poetry Review*. Her poetry has been published

in such journals as *Big Beautiful Women, Palmetto Review, Gryphon,* and *Impetus.*

> "Frankly, making a public commitment to erotica has been a
> way to thumb my nose at a repressed sexual upbringing. Inside
> I was always a potboiler; outside, the mores of my family were
> sitting on the lid. Divorce and parental death freed me to explore
> my sensuous nature and erotic mind-set. I blossomed from a
> tight clitoral bud into a wild flower of sensations. Delighted to
> have reached this state, I share the elixir with whoever cares
> to sip from the cup."

**Stephen Siegel**, 43, is both a professional photographer and a
composer of classical music. His photographs have been published in such magazines as *Today's Photographer, Photo,* and
*Penthouse Forum,* as well as in the book, *Focal Point Gallery:
A Ten Year Retrospective.* He is now working on a series of photographs, photomontages, and photocollages entitled *Five
O'Clock Shadows,* depicting the New York City rush hour, and
completing a commissioned work for solo piano.

> "My intention in photographing the nude is to depict the body
> as an expressive subject, rather than as a static sculptural object.
> In order to achieve this I have often attempted to destroy the
> sense of anatomical correctness which one often expects from
> a photograph. I hope to confront the viewer with images of states
> of feeling, and not with facts alone, however beautiful. These
> bodies are alive; they have nerves and brains; they move and
> speak; they muse and laugh and sing; they are you and me."

**Leslie Simon**, 40, teaches literature and women's studies, and
is coordinator of a collegiate Rape Prevention Education Program. She is the author of three books of poetry, *Jazz/is for
white girls, too, i rise/you riz/we born,* and *High Desire;* and is
currently working on a novel and a paper on feminist alternatives to pornography.

**Ron Terner**, 38, has traveled through India, Nepal and Mexico
as an itinerant photographer. He is the founder of Focal Point
Gallery and Press. His recent photographic work includes development of the "phototern," a process of bleaching, redeveloping, and painting with photochemicals on a developed and fixed
photographic print. He has published one book of photography,
*Nudes: 1975-85.*

> "The nude has always been an endless source of inspiration for
> me. Whether seeing the portrait of a body, or exploring the reciprocal properties of line and space, the nude has helped me discover a universal language."

**Cheryl Townsend**, 30, edits *Impetus* magazine and publishes
"various oddities" through Implosion Press. She is the author
of three poetry collections, *An Ordinary Girl, Special Orders
to Go,* and *Dancin' On Your Fingers.* Her work has also
appeared in numerous literary magazines, and in over 30
anthologies.

**Marco Vassi**, 49, describes himself as "one of the old bolsheviks
of the sexual revolution." He has worked as a writer, teacher,
psychotherapist, and translator from the Chinese. Author of 16
books and hundreds of articles, essays, and stories, he is generally acknowledged as one of the foremost erotic writers in America. His books include *Mind Blower, The Gentle Degenerates,
The Saline Solution, Contours of Darkness, In Touch, The Erotic
Comedies,* and *Lying Down: The Horizontal Worldview.*

> "Sex is a key to doorways of knowing. For me it has been a yoga
> through which new qualities of self evolved. Like the alchemist
> who works with potions for decades and in the process brings
> about a transmutation of his essence, I have spent all my conscious life since the age of eight mixing elements in the crucible
> of sex, sifting enormous amounts of material to produce a few
> grams of pure substance. I have perhaps delved as deeply into
> eroticism as any human being. After completing the entire route,
> I find it was all simply a doorway to devotion."

**Wheatsinger**, 47, writes, edits, and does public relations work.
Her writing has appeared in numerous periodicals, including
*Working Woman, Los Angeles, Westways, Playgirl,* and *Penthouse
Forum.* She writes science fiction, edits a newsletter on energy
issues, and recently co-authored a paper for the *Mount St. Helens
Five Years Later Proceedings.* She also "regularly meets with

a circle of cronies so I can celebrate life, maintain my sense of self, and increase my ability to experience the eroticism of creation."

"Sex to me is the most serious subject matter in our culture. I like doing sex. I feel exalted when I do sex the way I like. Sometimes I have felt demeaned by doing sex, but that was when I was younger and exploitable and didn't know better. Besides being fun, sex is sacred, so I write about sex as an hilarious sacred act. One of its purposes is to reach an altered consciousness—levels of prophecy and oneness with the universe. When I write about erotic sex, I feel sexy—I get consumingly horny. I want my readers to react the same way."